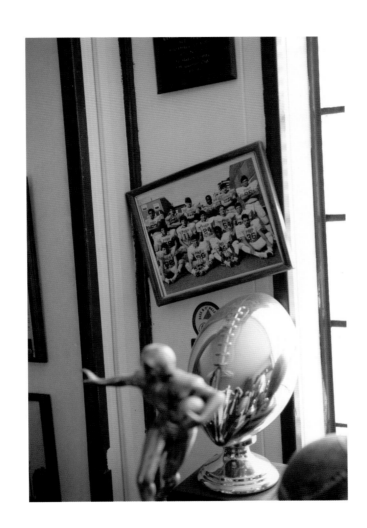

PREP

THE SPIRIT OF A HIGH SCHOOL FOOTBALL TEAM

PHOTOGRAPHS BY RICHARD CORMAN

FOREWORD BY COACH JOE PATERNO

DESIGN BY YOLANDA CUOMO

 powerHouse Books Brooklyn, NY

FOREWORD

Growing up in Brooklyn, I was fortunate enough to have been influenced by the Jesuits. Discipline and hard work served as the cornerstones of my education at Brooklyn Prep. The Jesuit Fathers demanded we give more of ourselves than we thought possible. We were driven and were expected to respond. We were held accountable and were expected to stand up for our actions. I remember my days being long and challenging—the classroom was an academic tinderbox. But we all emerged better students, people, and athletes. The lessons I learned served me well throughout my life—on the football field, as a husband, father, and grandfather, and hopefully as a role model for our great athletes at Penn State.

This book captures discipline and hard work in action—it provides all of us with a visual of what a Jesuit education is for a group of talented young men. These young men have been challenged and held accountable, and they have responded. It enables us to see the great game of football, in all its beauty and grace, through the eyes and hearts of the dedicated players and coaches of Saint Peter's Prep. It's more than just a game at this urban haven in downtown Jersey City called Saint Peter's. Football is an extension of the classroom, of the Jesuit philosophy that is embodied in each and every member of the program in all they do. The Jesuits wouldn't have it any other way! I believe you will enjoy seeing the game *through* and *with* this legendary program, its great people, and its Hall of Fame coach.

—Joe Paterno
Head Coach, Pennsylvania State University football program

As a father of a ten-year-old boy, who wants to prepare himself for the inevitability of raising a teenager, I became intrigued by the incredible bond shared by a diverse group of young men playing football at Saint Peter's Prep in Jersey City. For twenty-six years, the remarkable Coach Rich Hansen has inspired humility, integrity, and grace through education and competition.

I photographed these boys and their coaches over the better part of the 2007–2008 football season. In doing so, my own apprehensions about rearing a teenager lessened as I watched powerful relationships develop before my eyes, nurtured by a mutual respect for one another. Although wins and losses will always matter to kids at this age in a competitive environment, the most memorable moments over this past season, which I am privileged to have witnessed, will forever inspire a spirit of selflessness and camaraderie for these teammates, and for me to share with my son, William, as he grows.

—Richard Corman

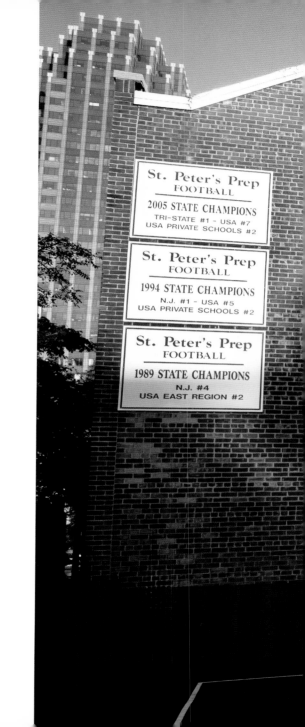

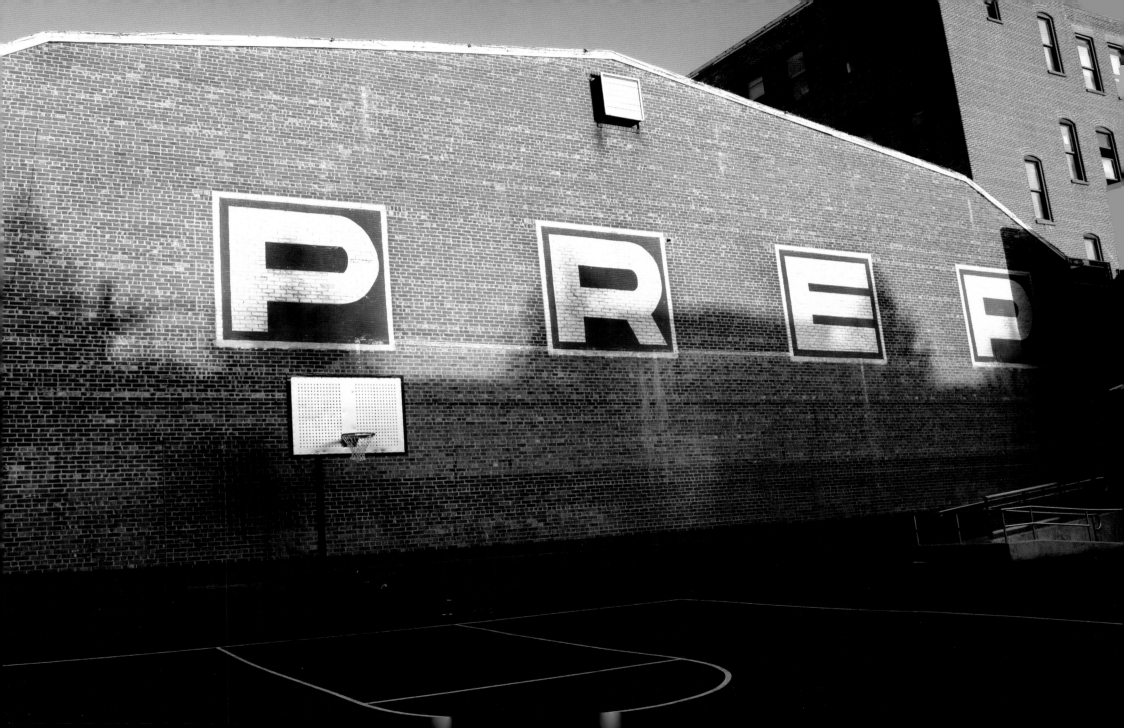

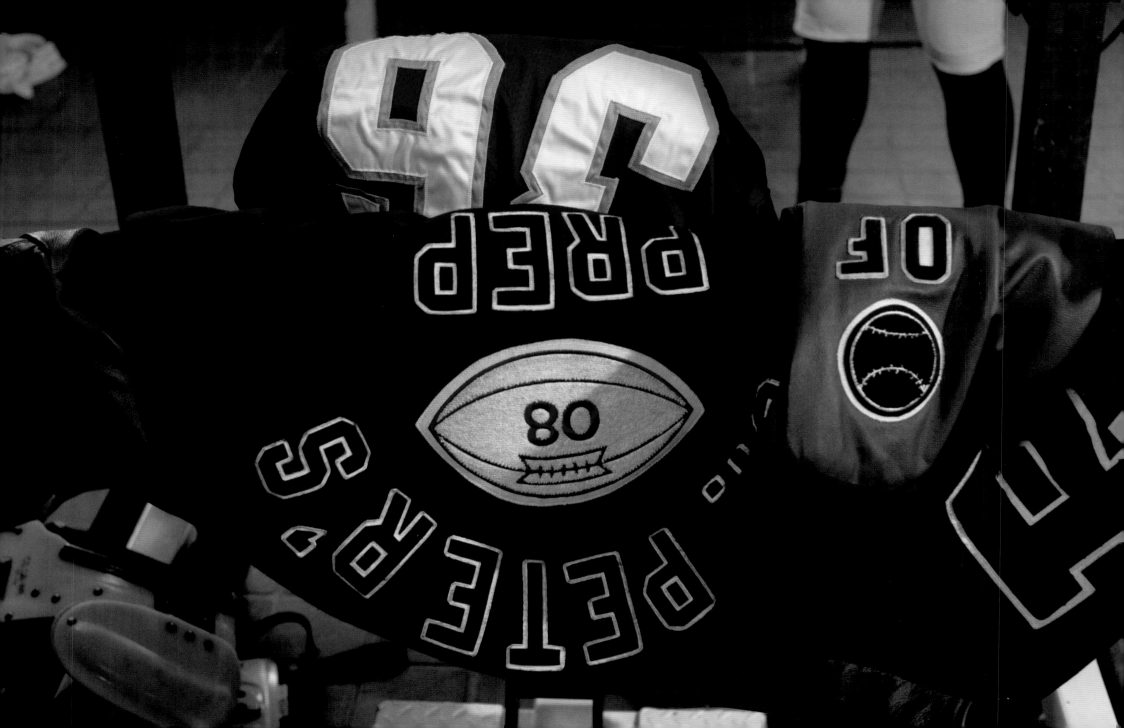

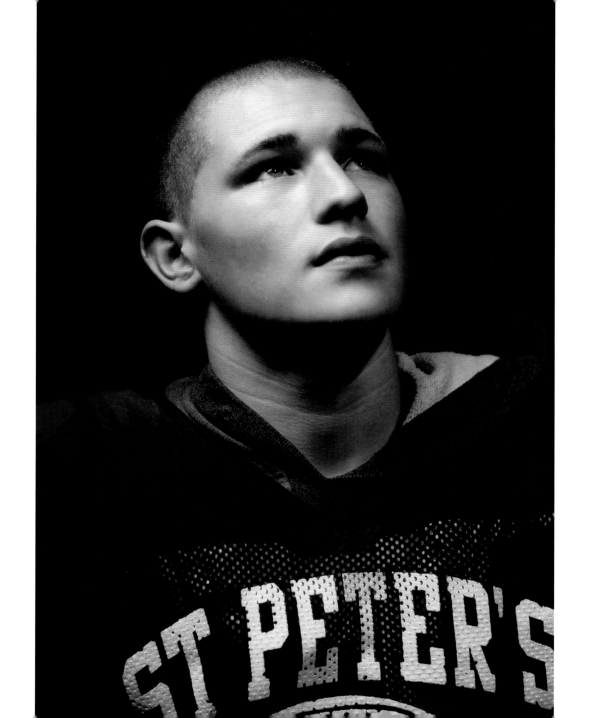

INTRODUCTION

Prep Football's origins date back to the early 1900s. The fields were comprised of dirt only, littered with rocks and bits of glass. The players competed in plain, simply designed uniforms, minimal padding, and, of course, no helmets to speak of. The football itself was shaped somewhat differently, but nonetheless was revered as it is today, as a symbol of athletic royalty. The players themselves were tough, hard-nosed Hudson County warriors. They played the game with a ferocious intensity, poignant focus, and, most importantly, glimmering pride—Saint Peter's Prep brand football.

One hundred years later, some things have changed. The dirt has been replaced by a state-of-the-art synthetic surface with perfectly traced field markings and a total absence of dirt and litter, except for the occasional windblown neighborhood debris. Those simply designed uniforms are long gone, replaced by the latest and greatest adornments. Padding, including helmets, represents today's professionally engineered football products. I'm grateful for all of that, but truly proud of the fact that the Prep player has remained intact. Perhaps because of our acute awareness and appreciation for our tradition, the Saint Peter's Prep football player still plays with that same intensity, focus, and yes, Prep Pride. The insatiable work ethic of the current Marauder is drawn from the unshakeable foundation laid by our football forefathers. It is passed on to our players from generation to generation, and the responsibility is accepted with that same fervor and honor displayed throughout time. "Protecting our Program" and "Expecting to Win" aren't just simple slogans to us—they are genetically inherited templates for success, regardless of scores, records, or championship titles.

This book provides a keen perspective into our program through the eyes and hearts of our players, coaches, and staff. The team and our program are sources of tremendous inspiration and satisfaction for many—we are humbled to share that with the world. Know that all you see and read is a product of our love for one another and the great game of football. It is out of respect for our school, community, and those who have donned the "silver helmet of pride" that we share with you the passion of our lives: Saint Peter's Prep Football.

—Coach Rich Hansen

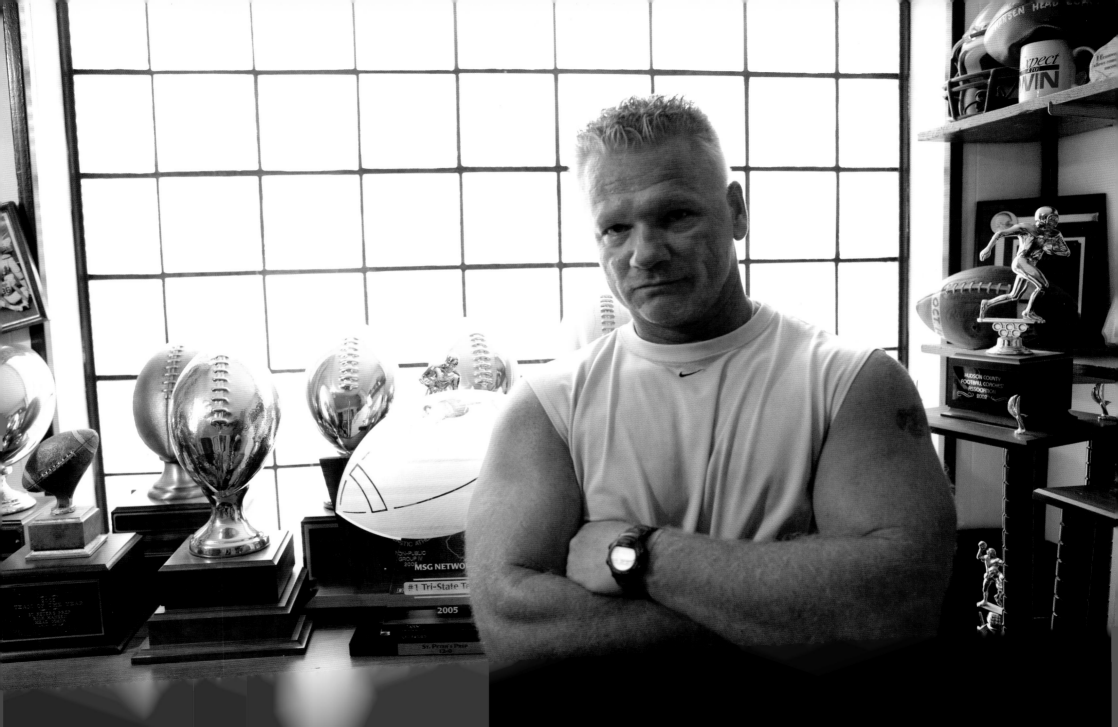

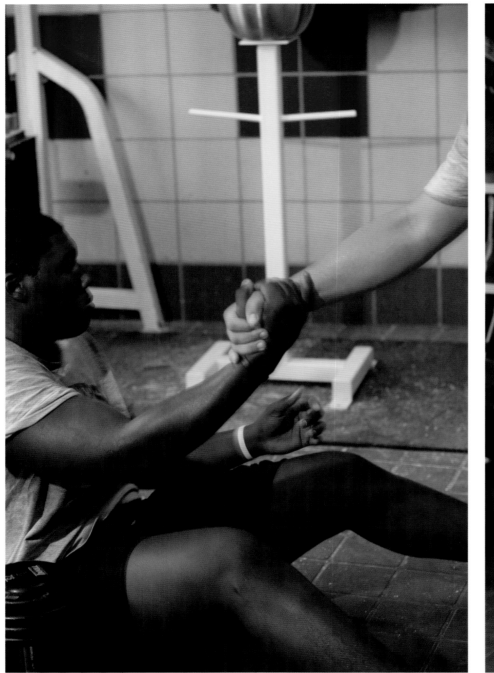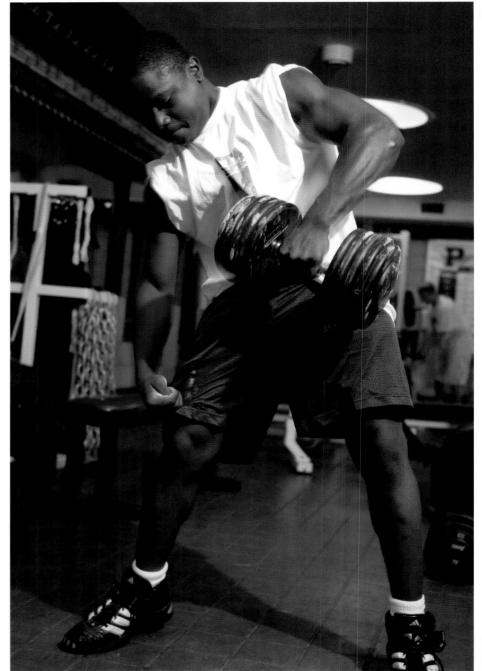

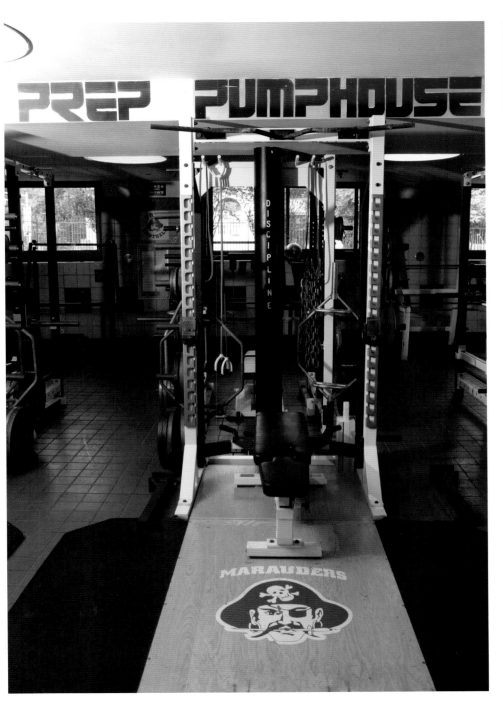
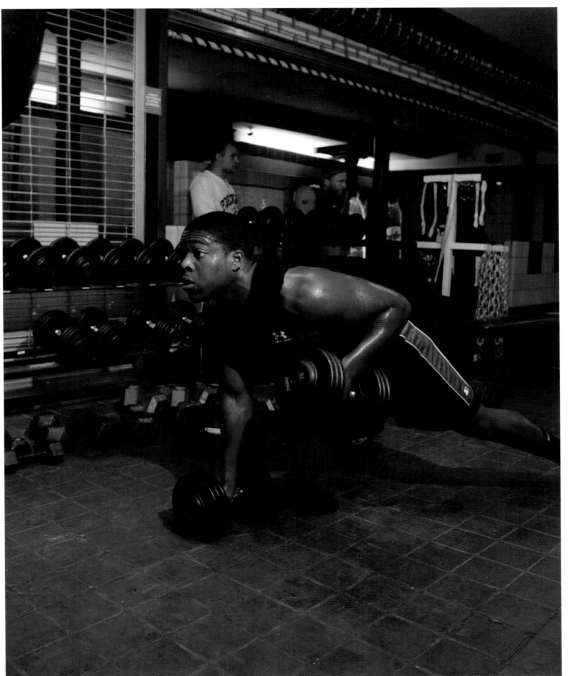

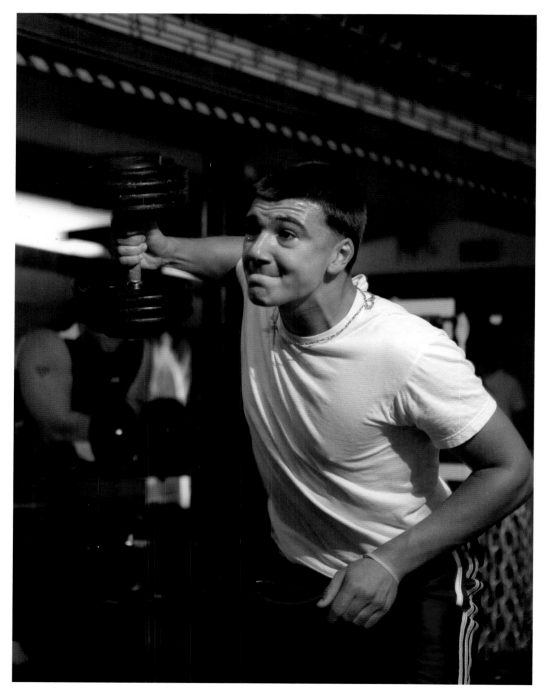

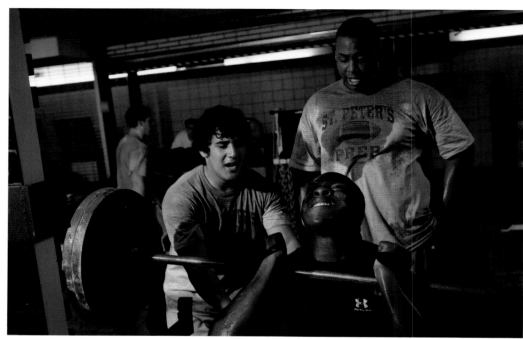

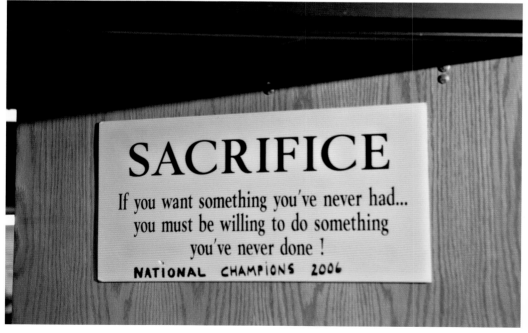

SACRIFICE

If you want something you've never had...
you must be willing to do something
you've never done !

NATIONAL CHAMPIONS 2006

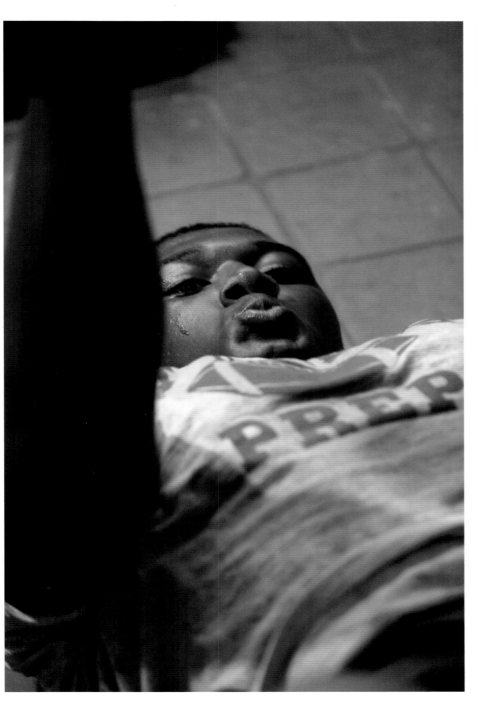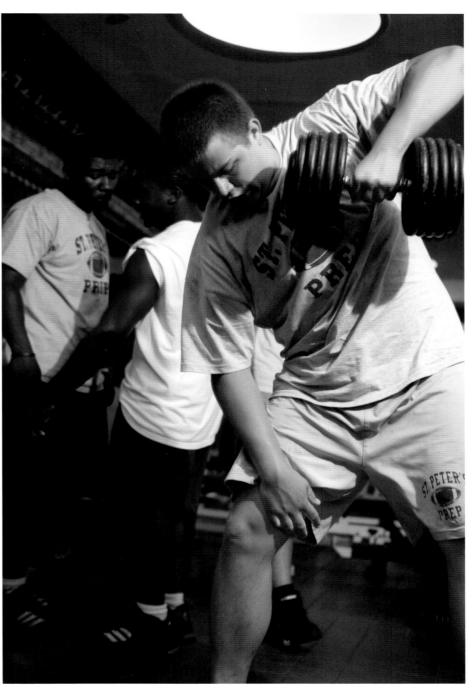

The moment you become complacent, it's all over.

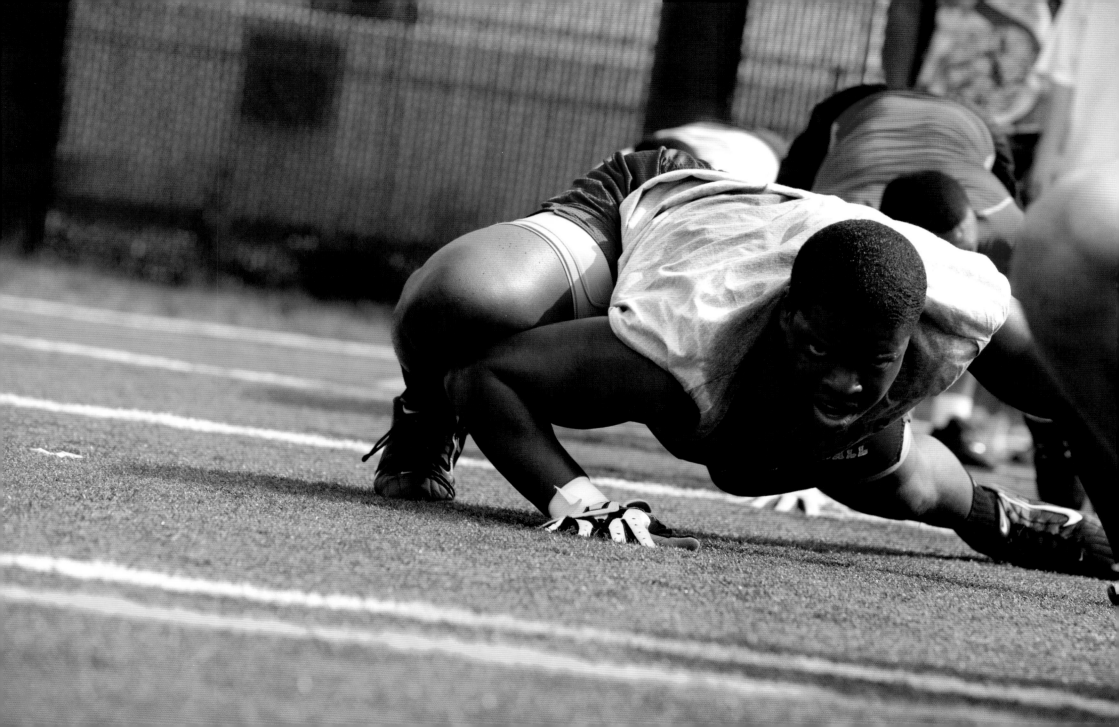

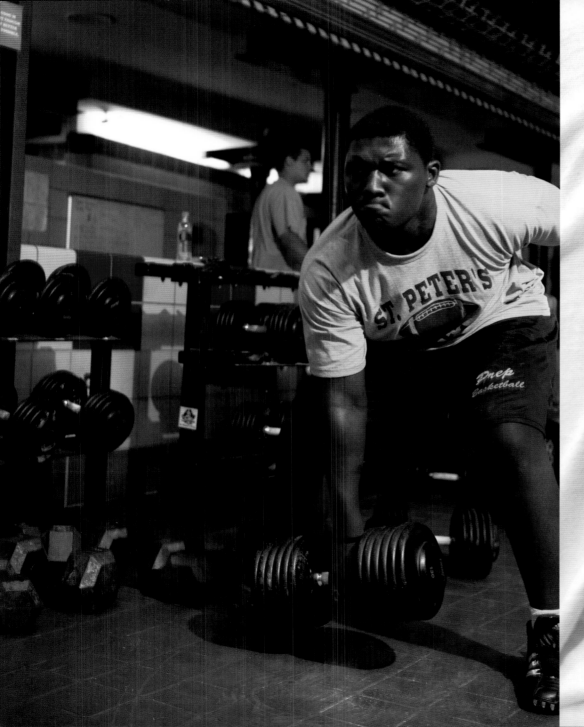

MOTIVATION
GETS YOU STARTED

DESIRE
KEEPS YOU GOING

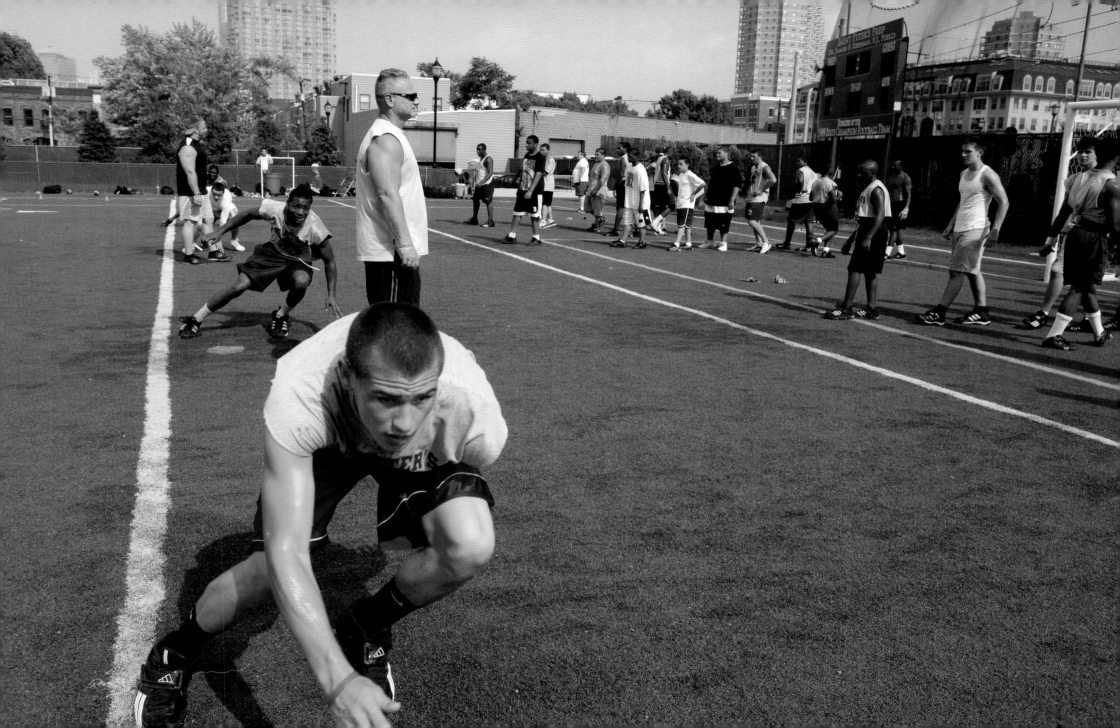

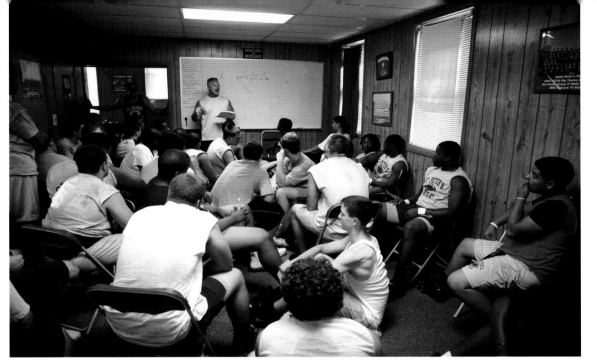
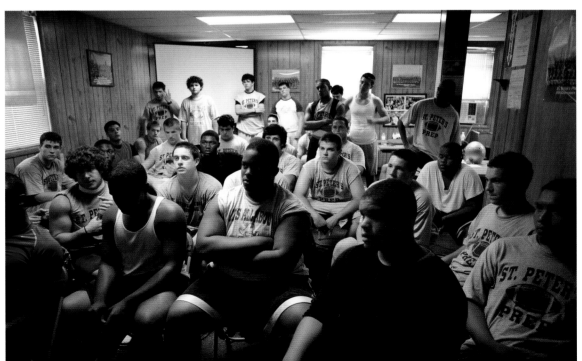

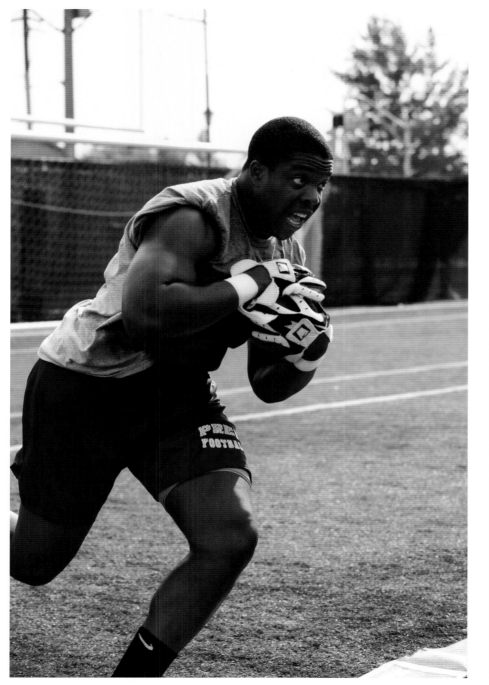
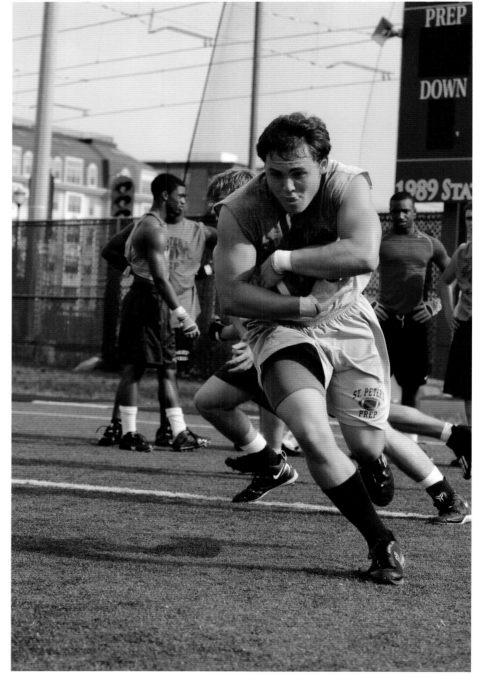

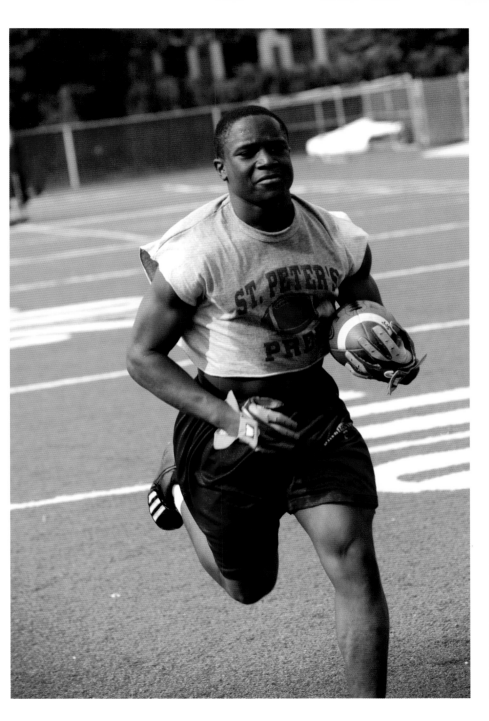
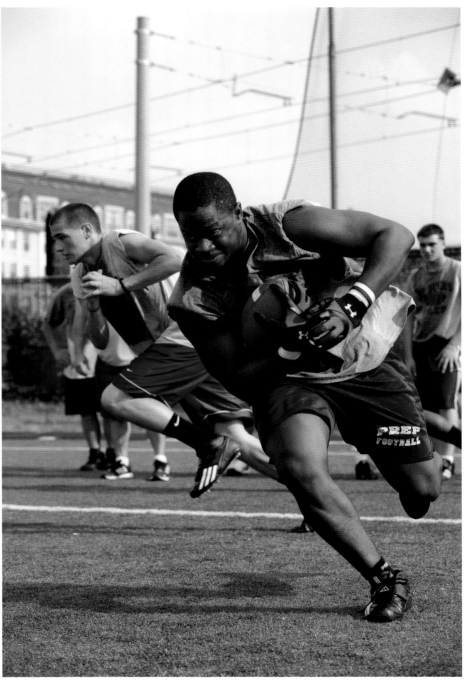

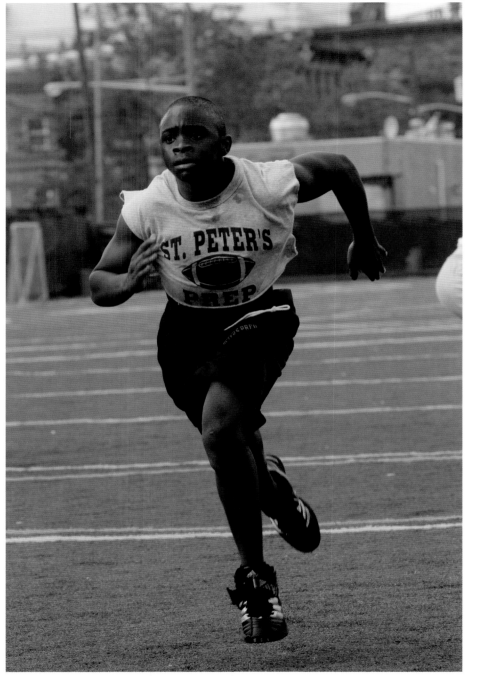
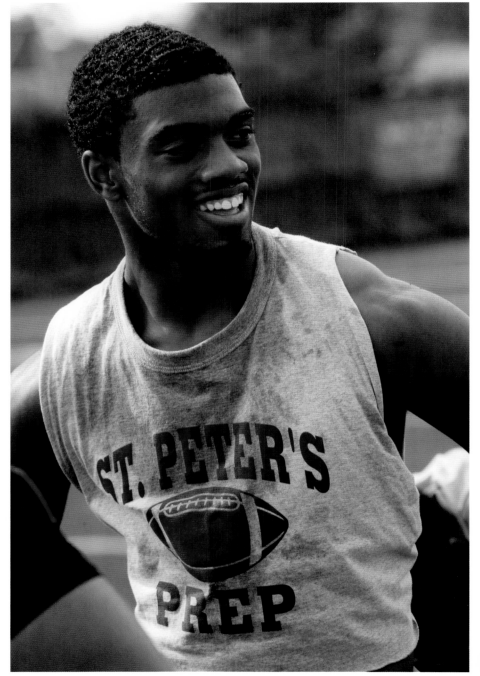

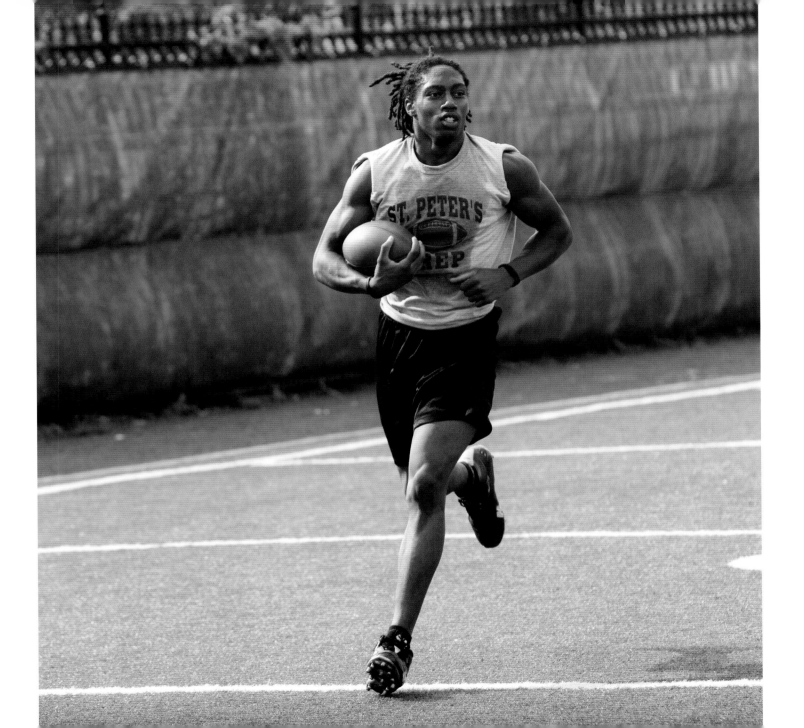

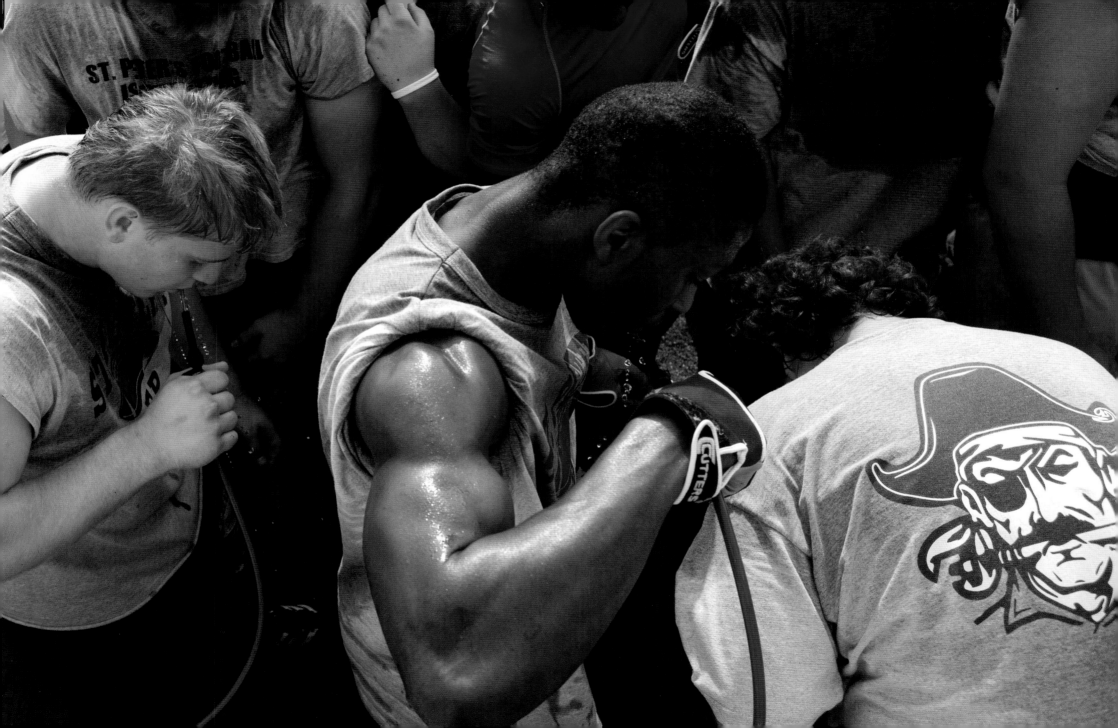

TAR HEEL FOOTBALL

"The ultimate measure
of a man is not where
he stands in moments of
comfort and
convenience,
but where he stands at
times of challenge and
controversy."

-Martin Luther King, Jr.

Kenan Football Center • P.O. Box 2126 • Chapel Hill, NC 27515-2126

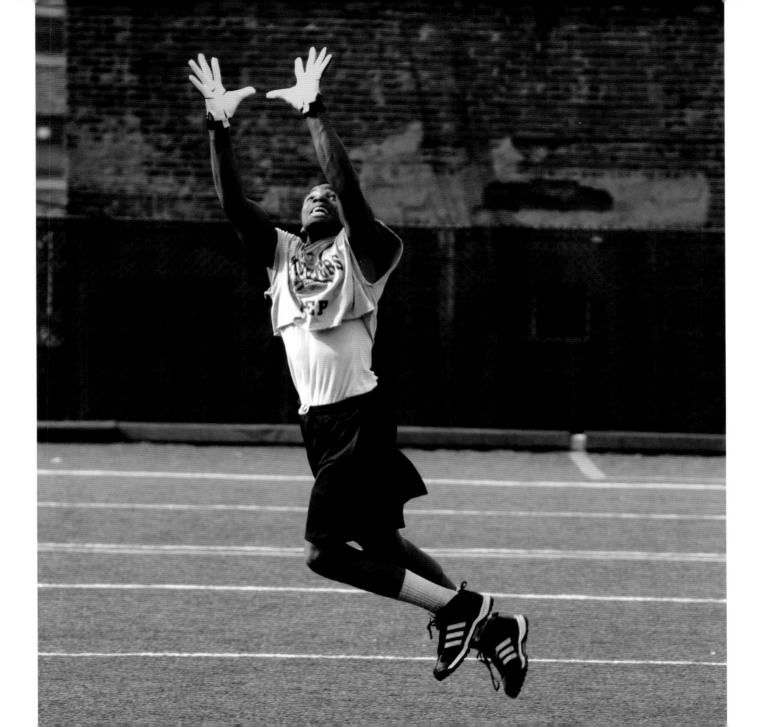

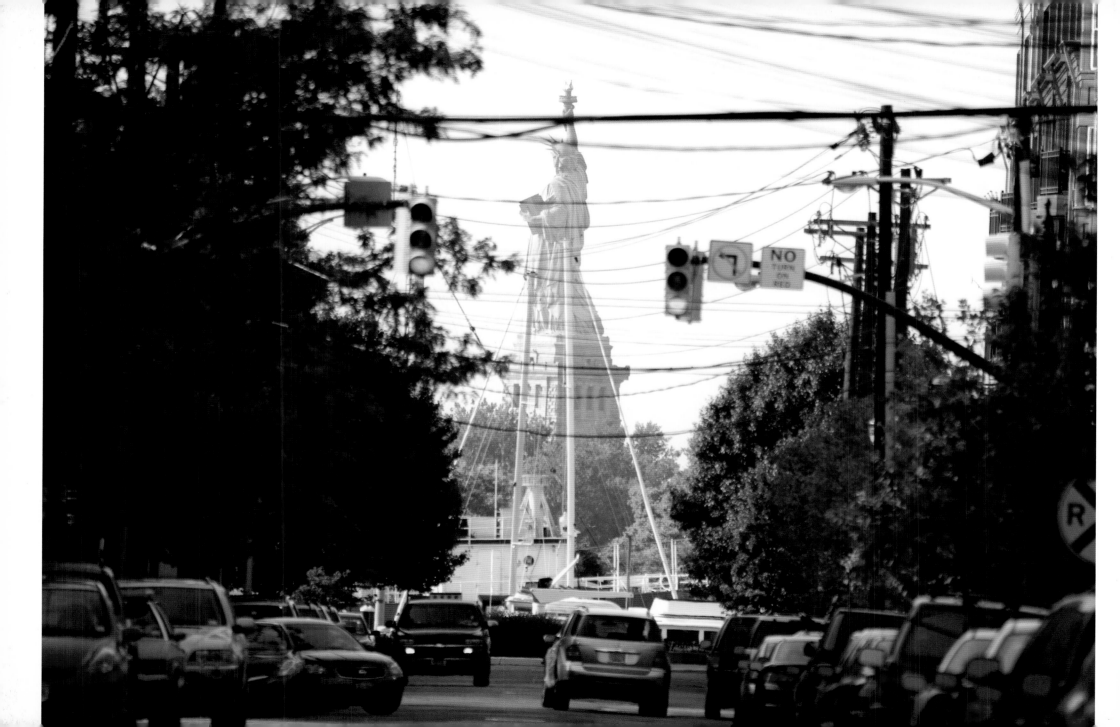

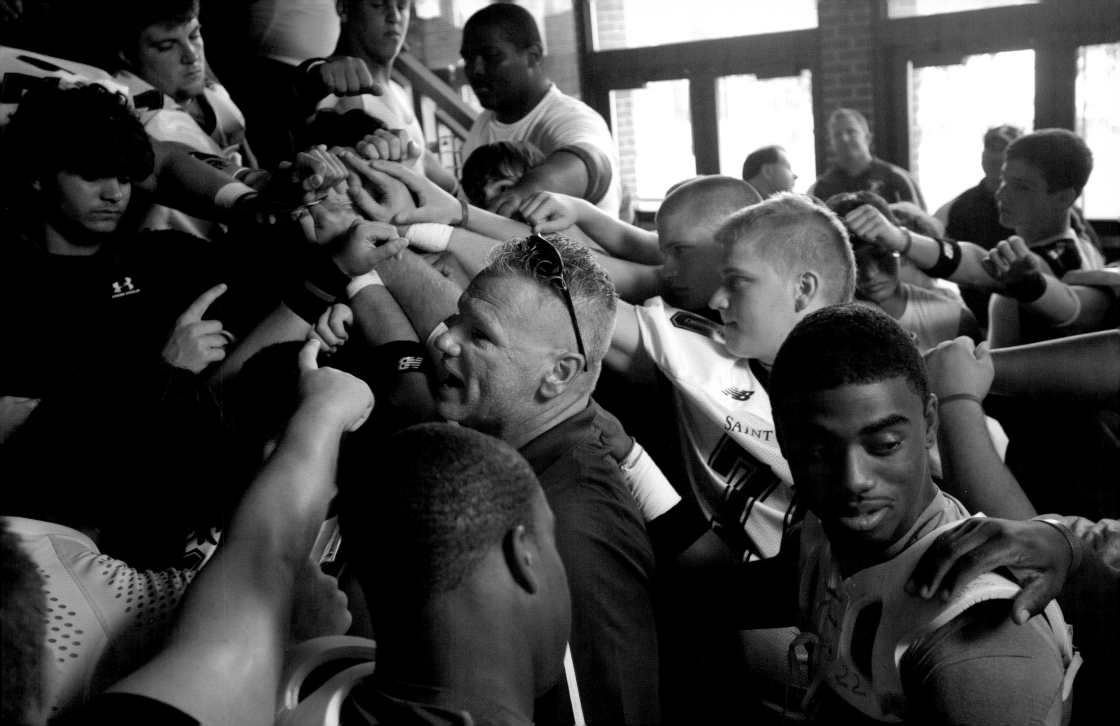

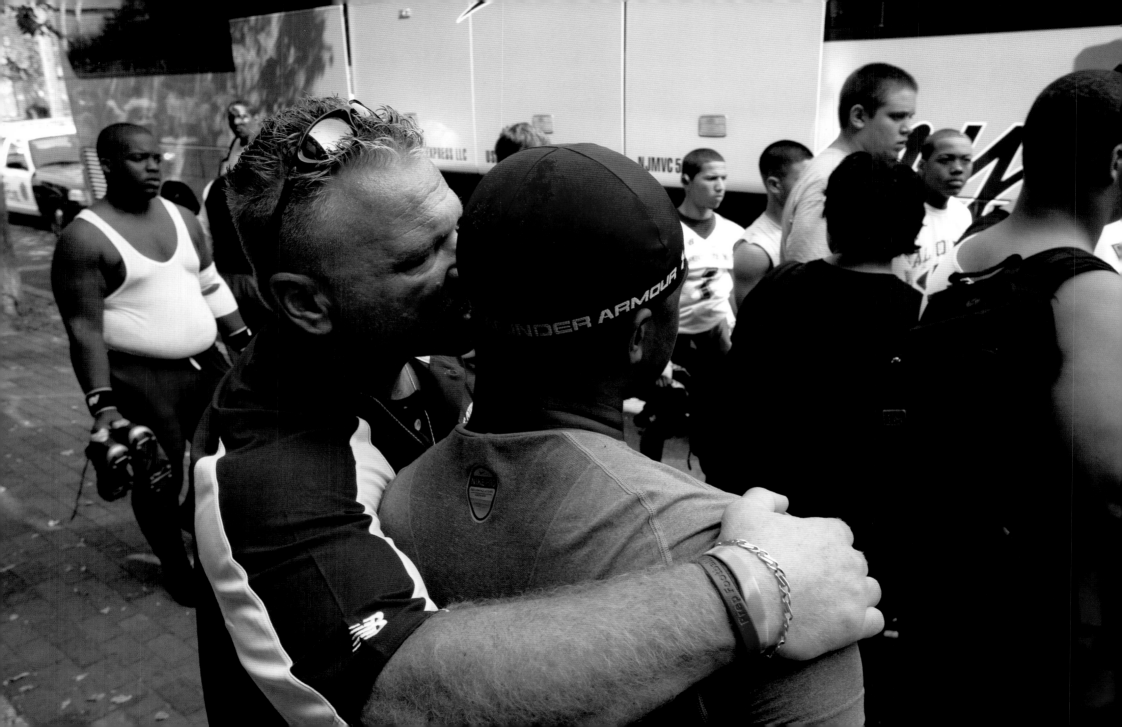

A LEADER HAS THE COURAGE TO STAND ALONE

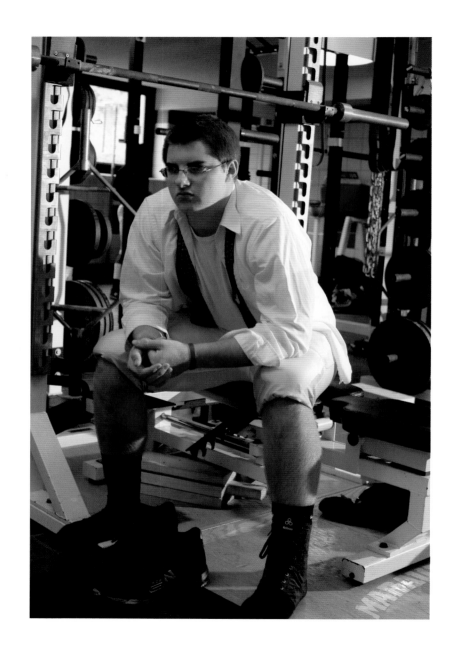

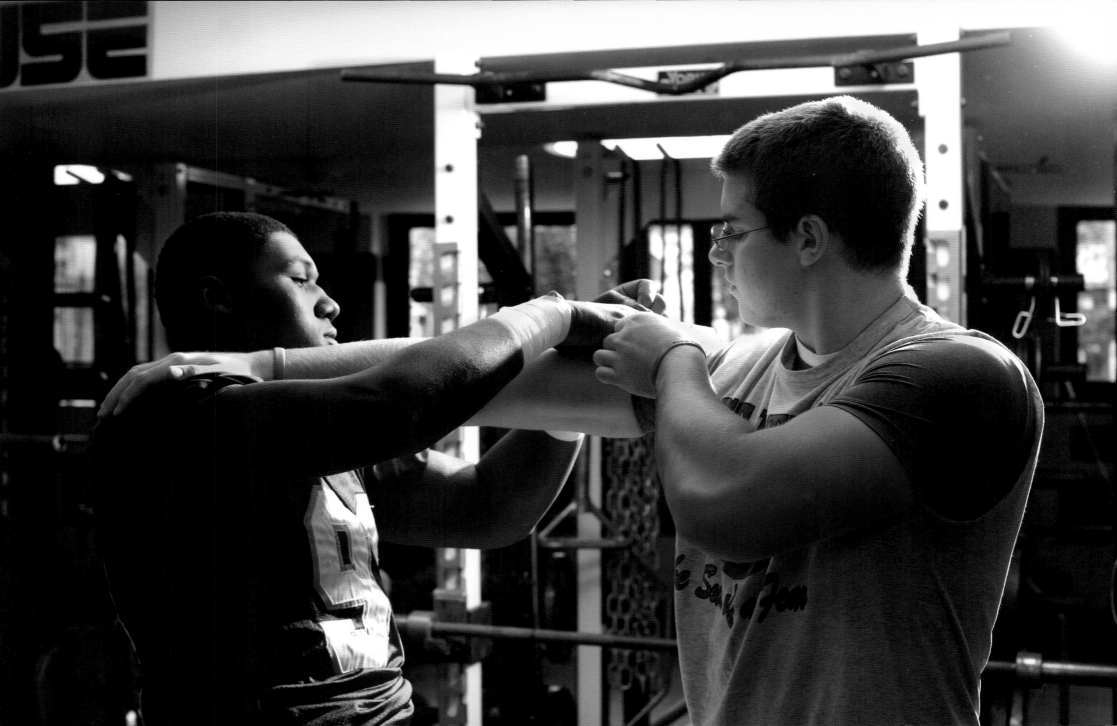

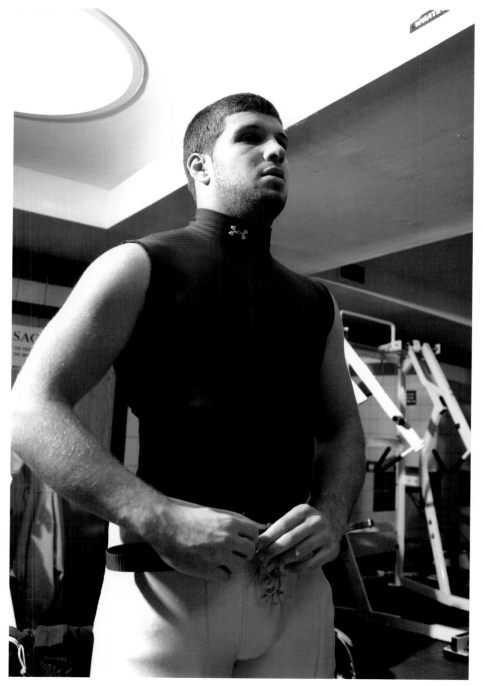
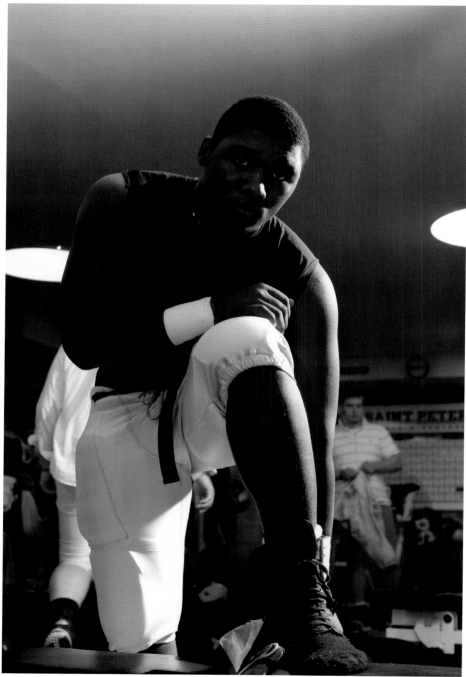

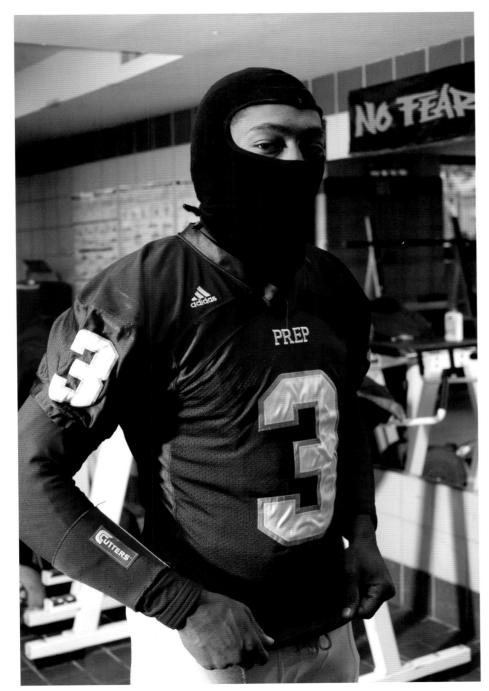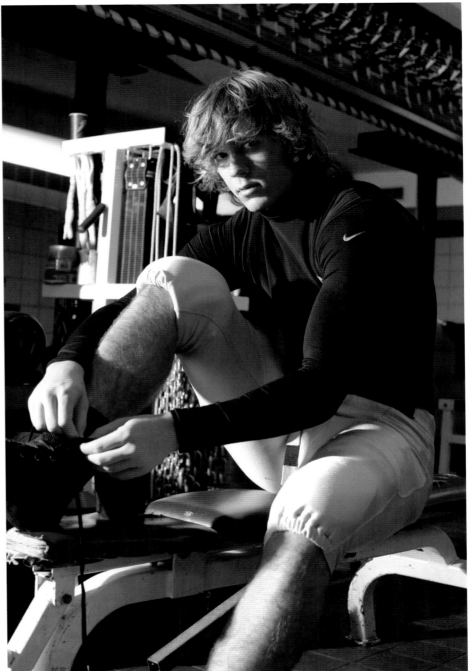

Leaders aren't made by being given titles.

They are made by actions of respect.

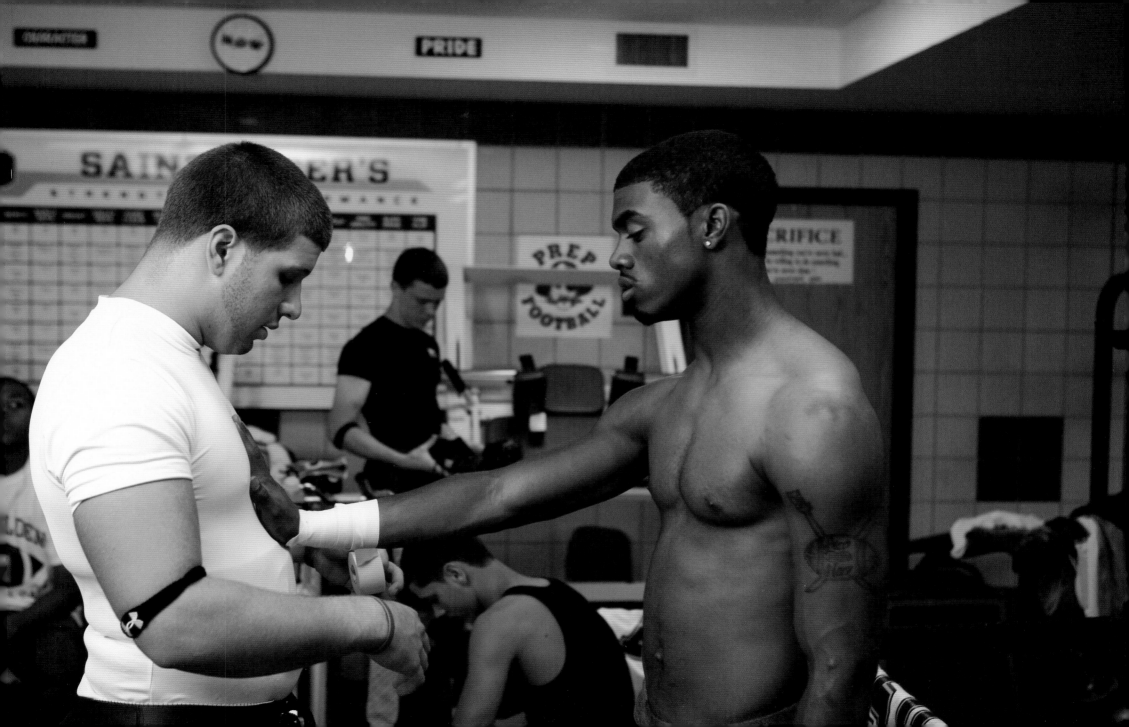

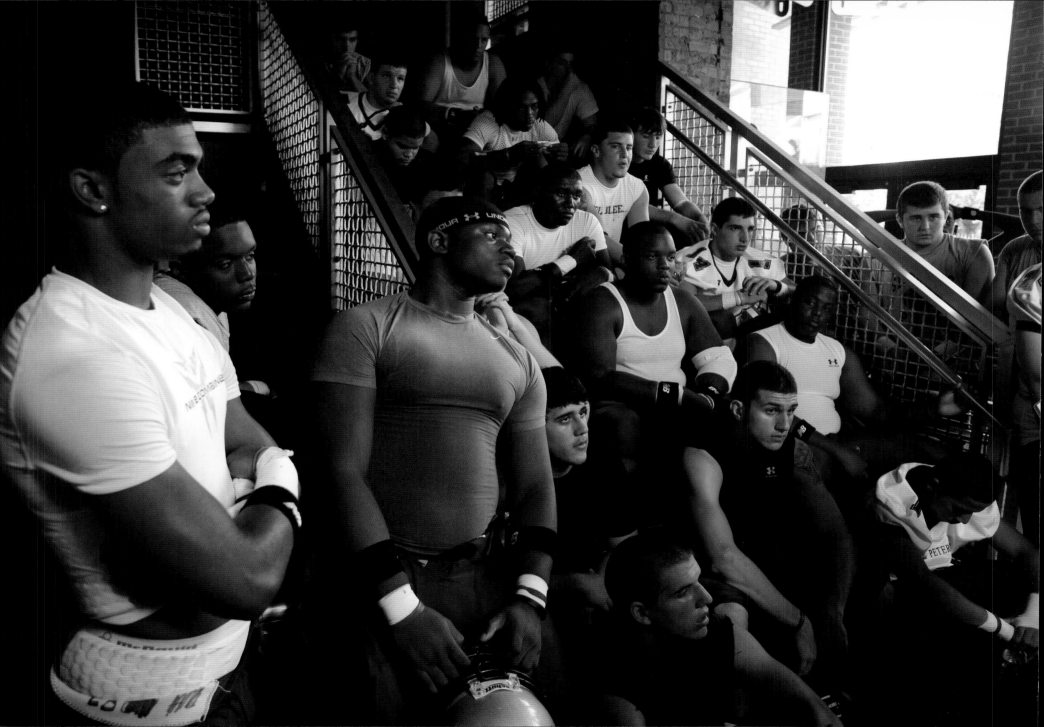

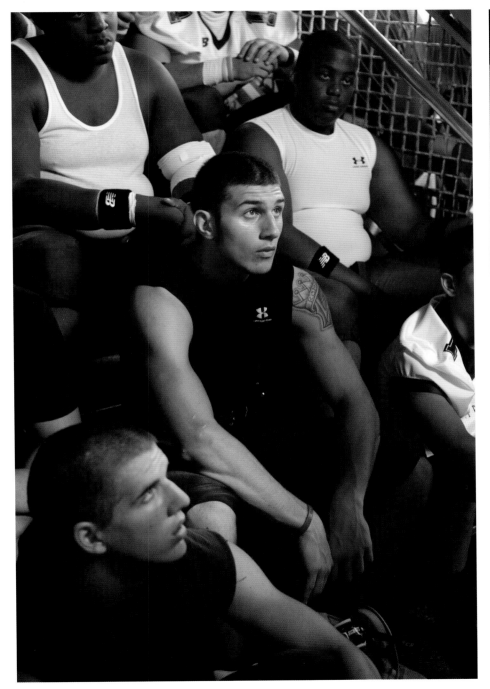
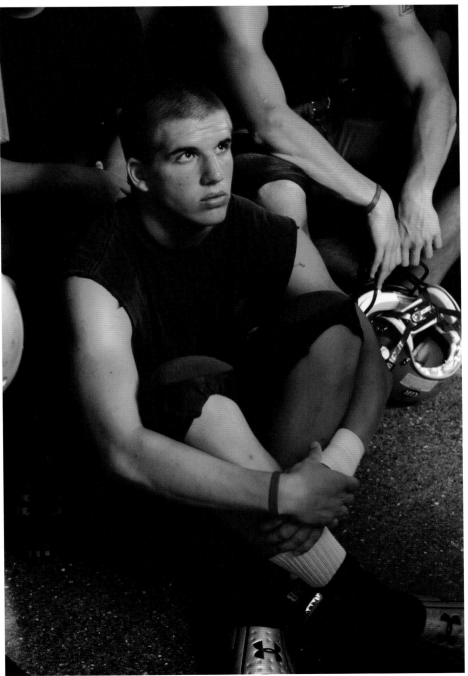

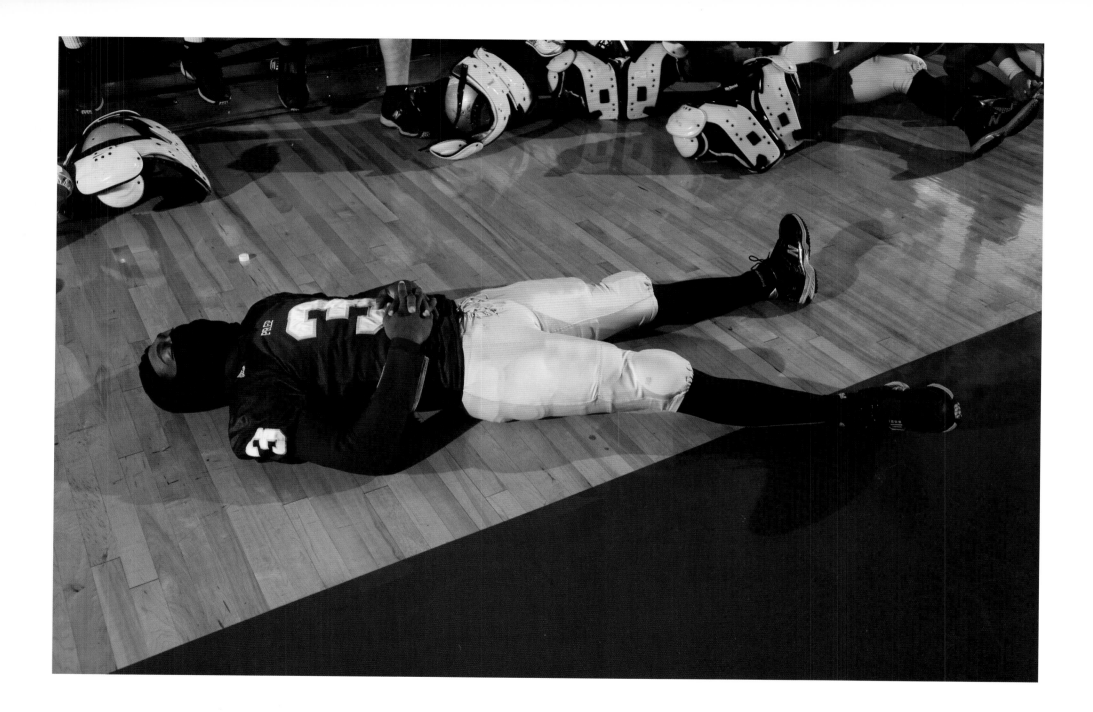

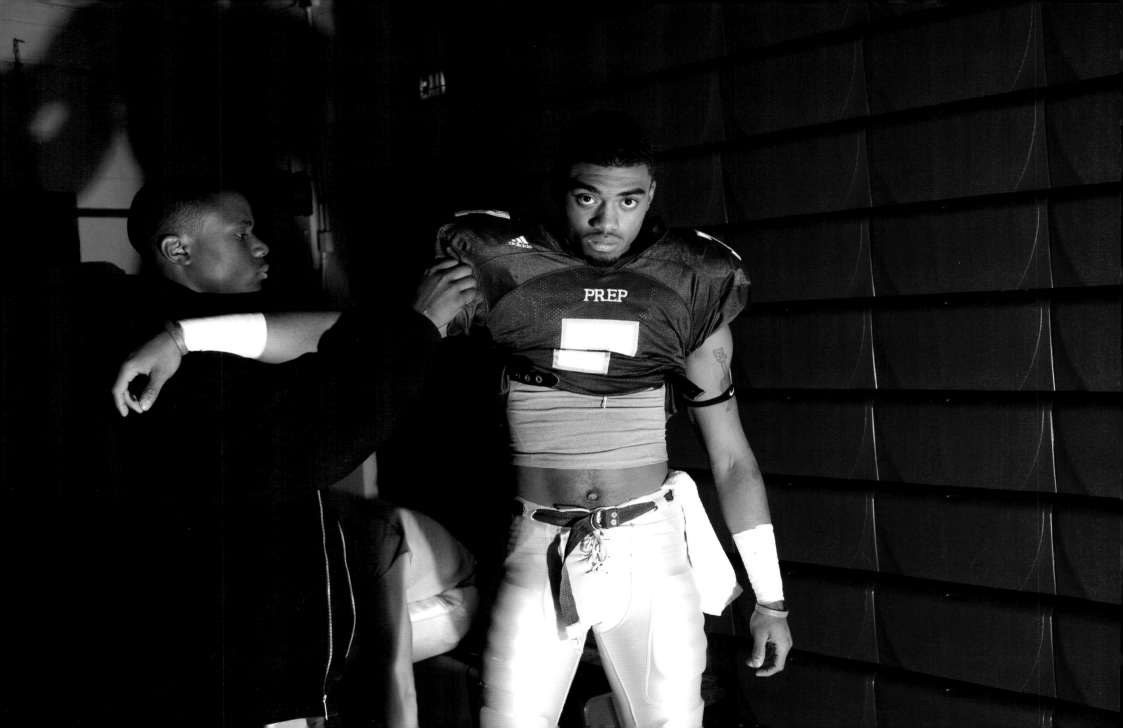

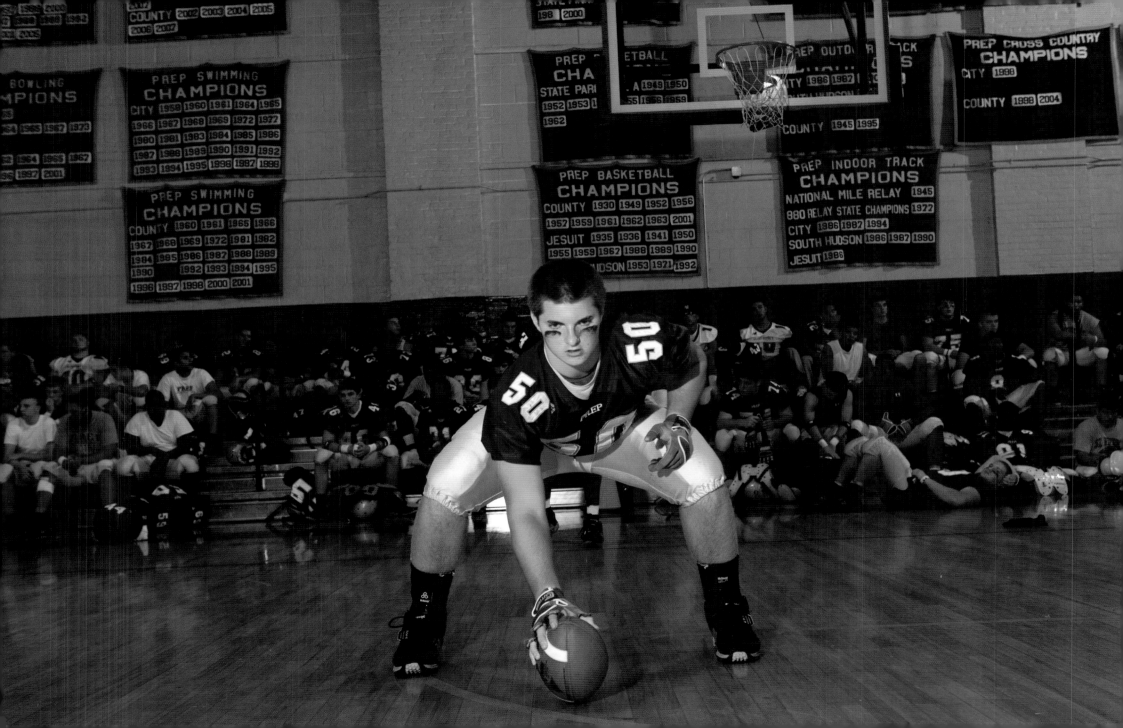

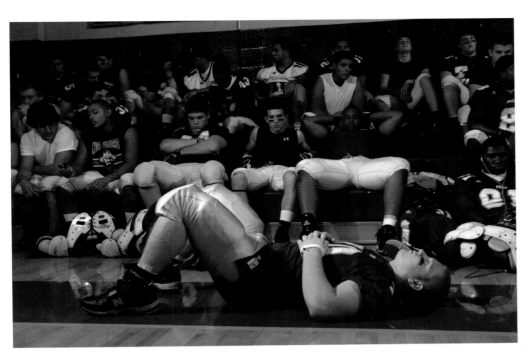

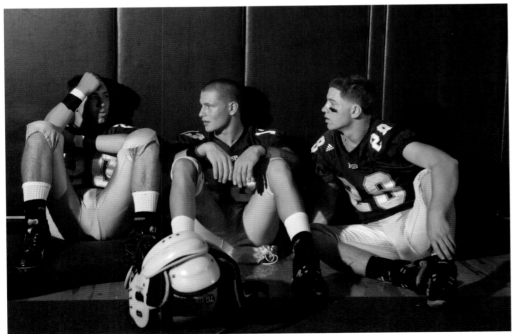

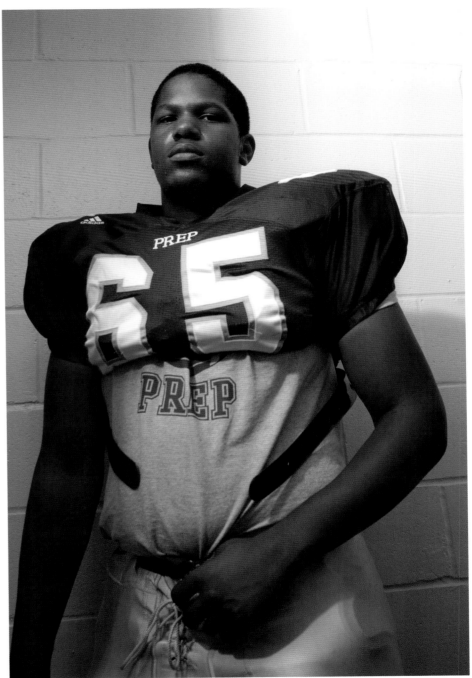

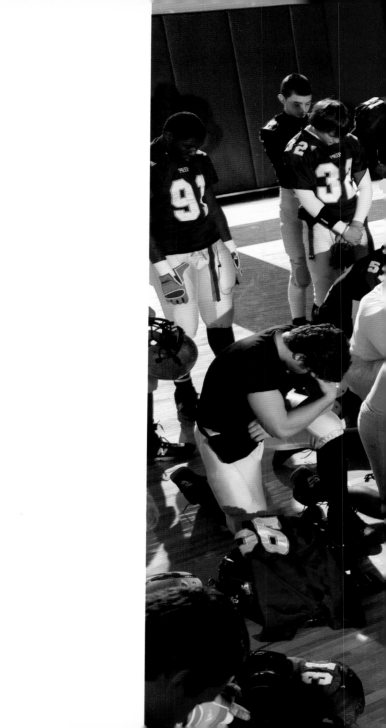

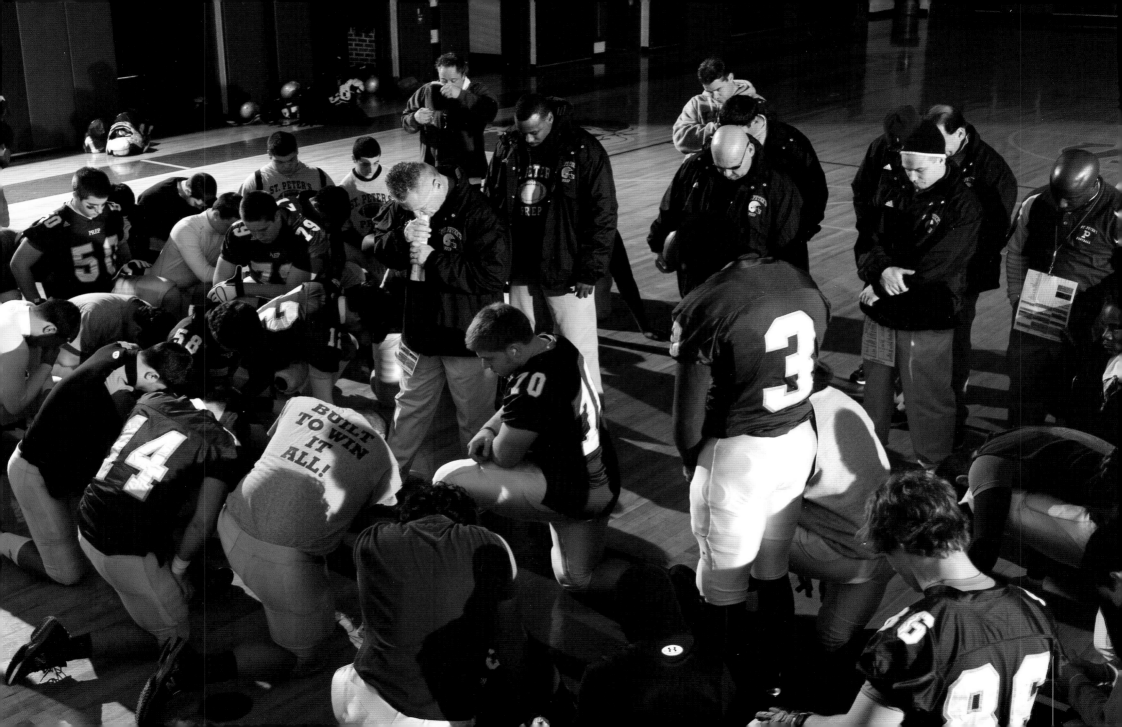

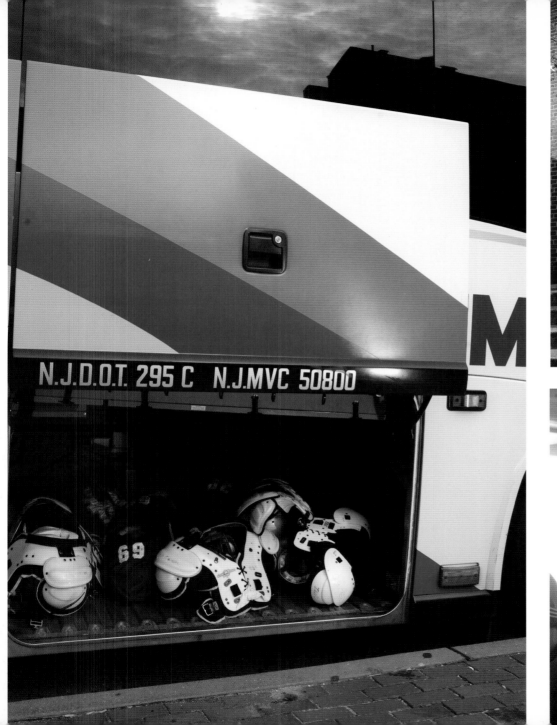
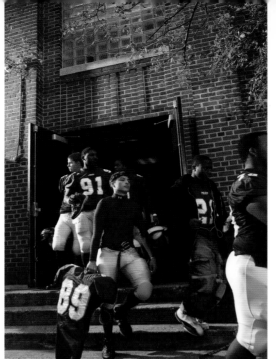
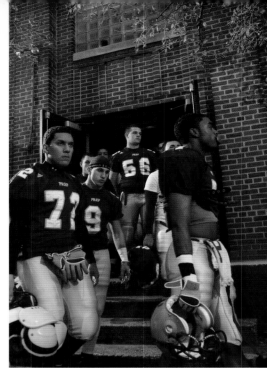
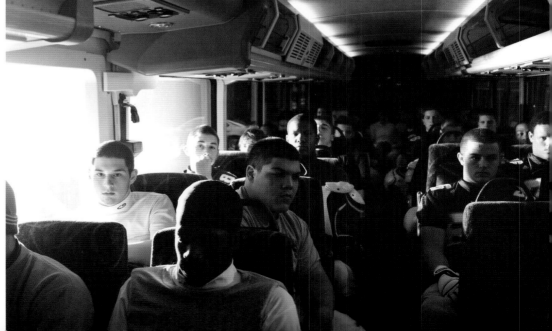

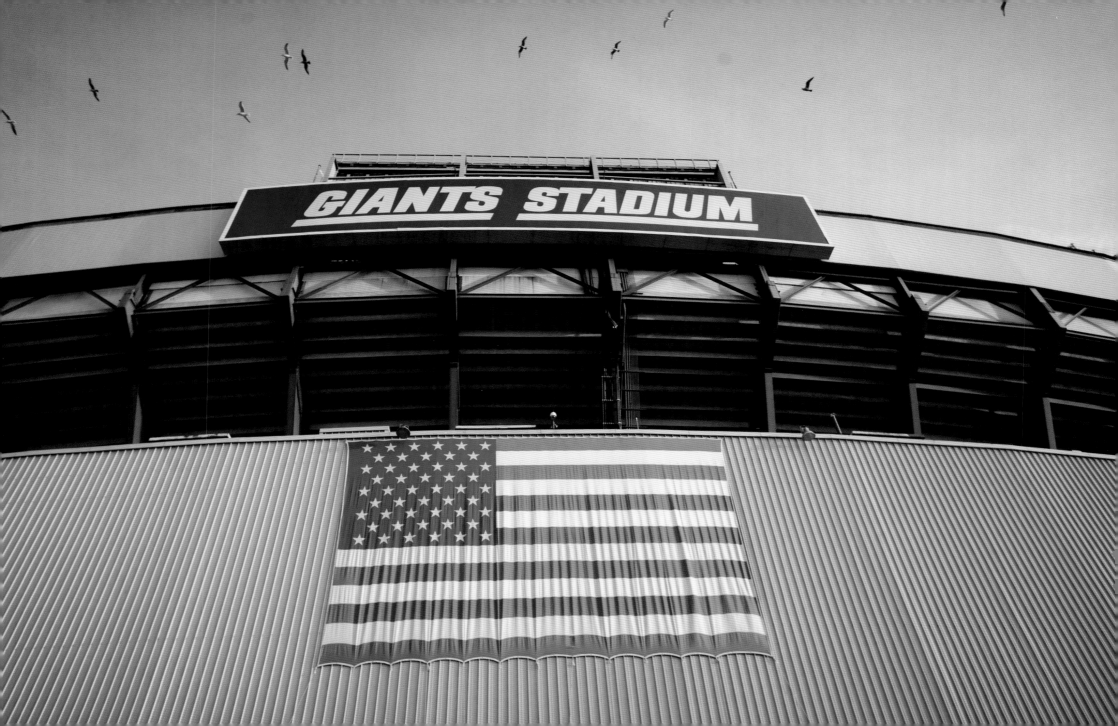

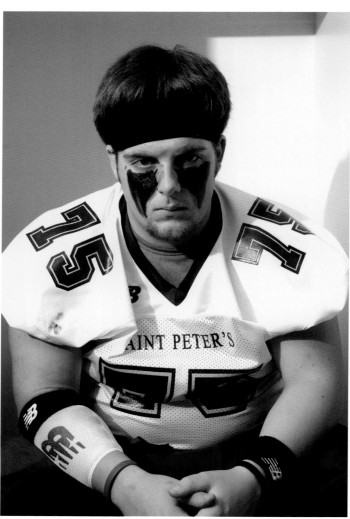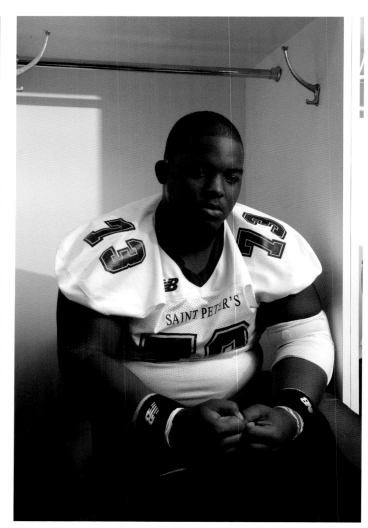

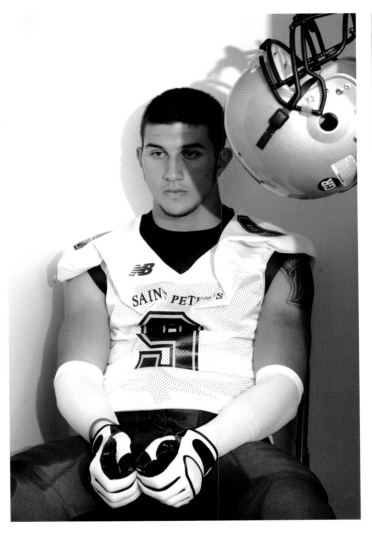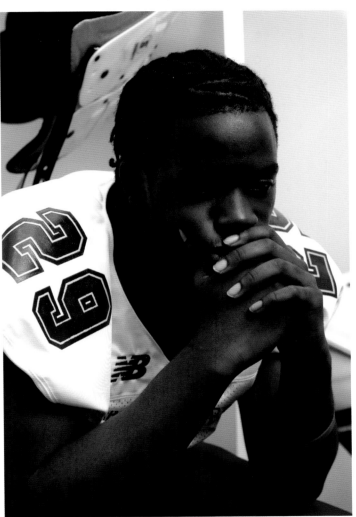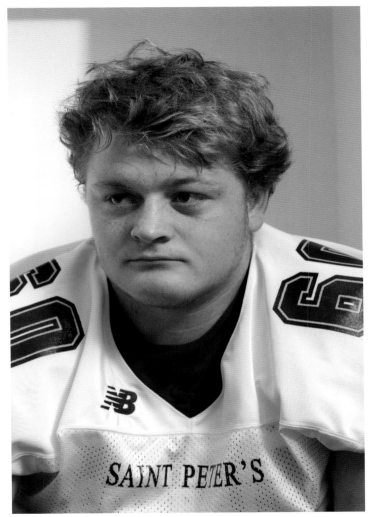

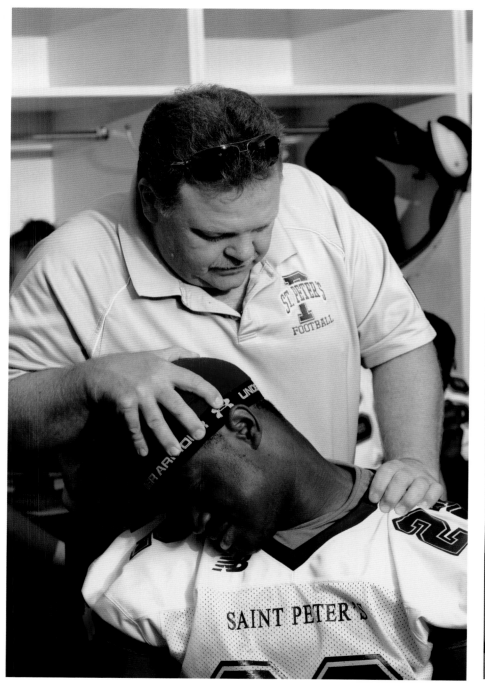
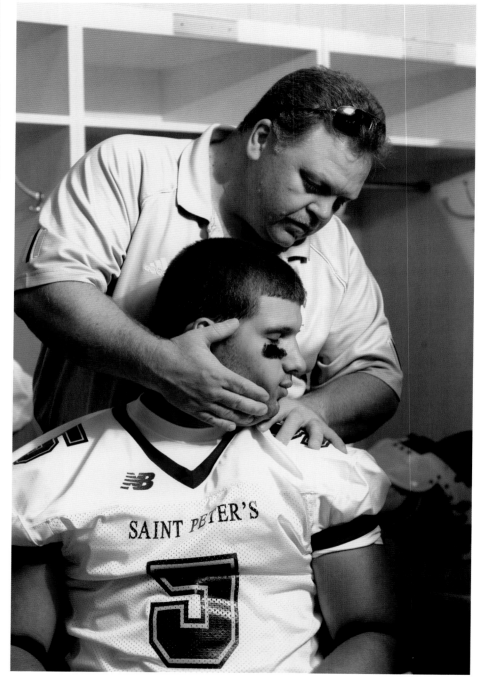

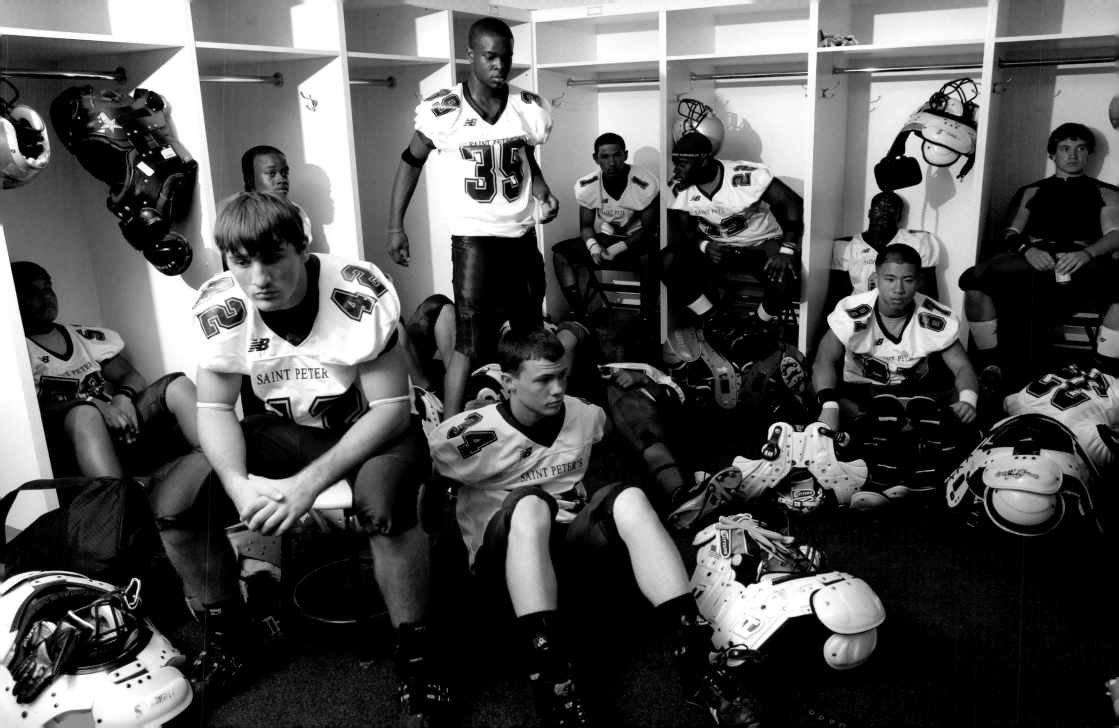

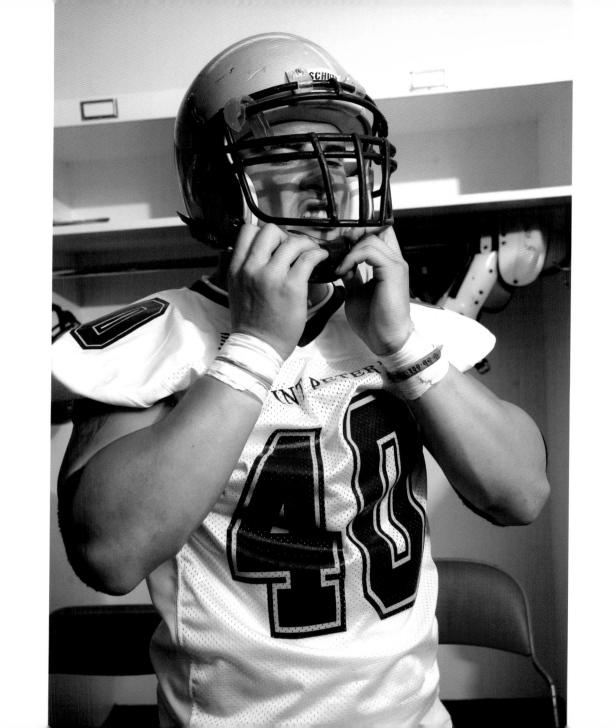

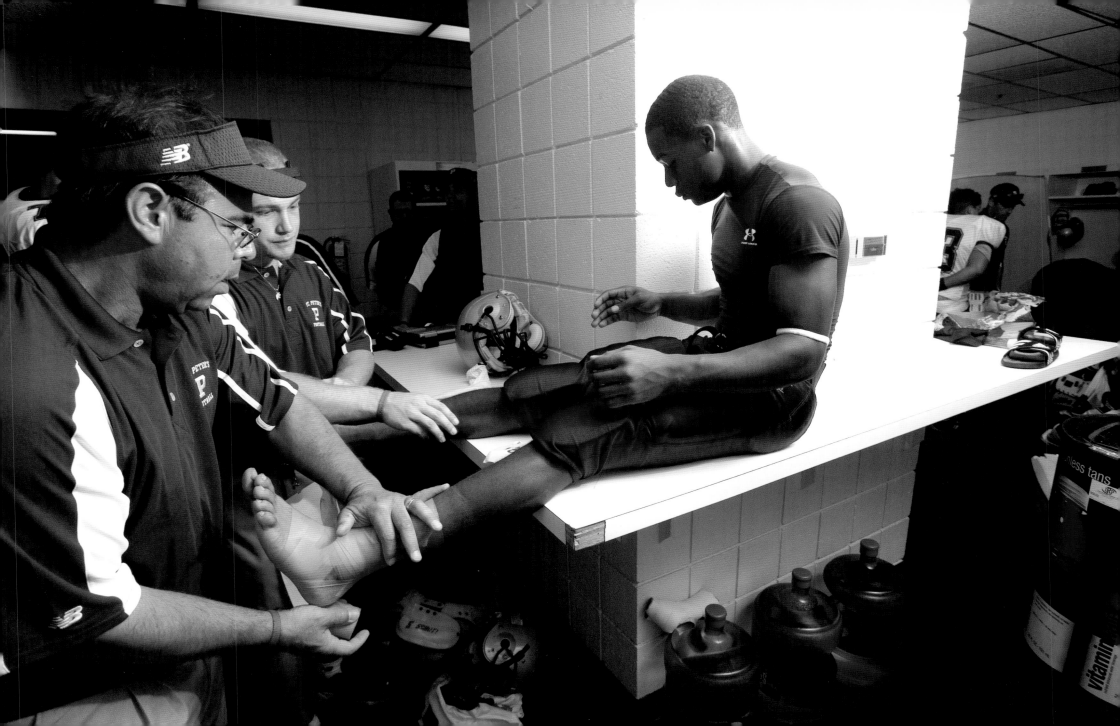

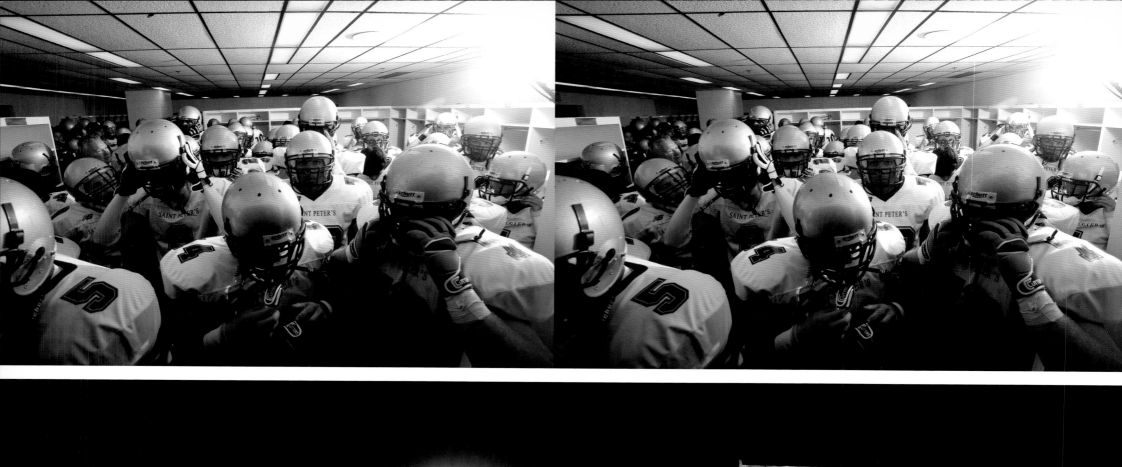
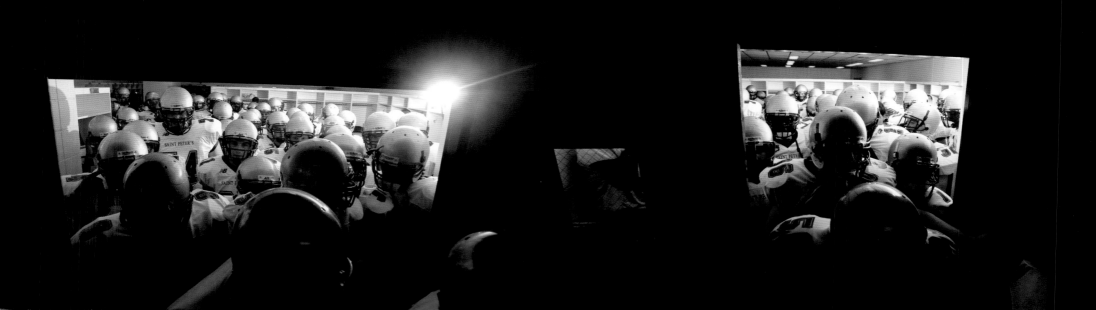

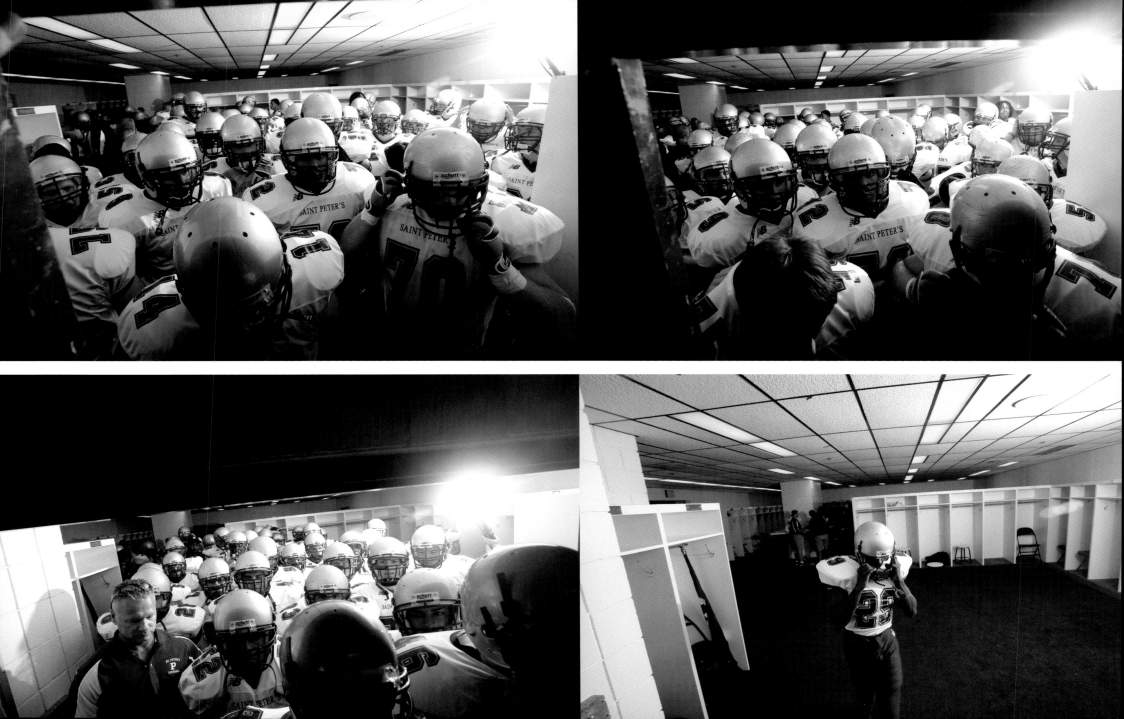

DON'T BLINK
DON'T EVER BLINK

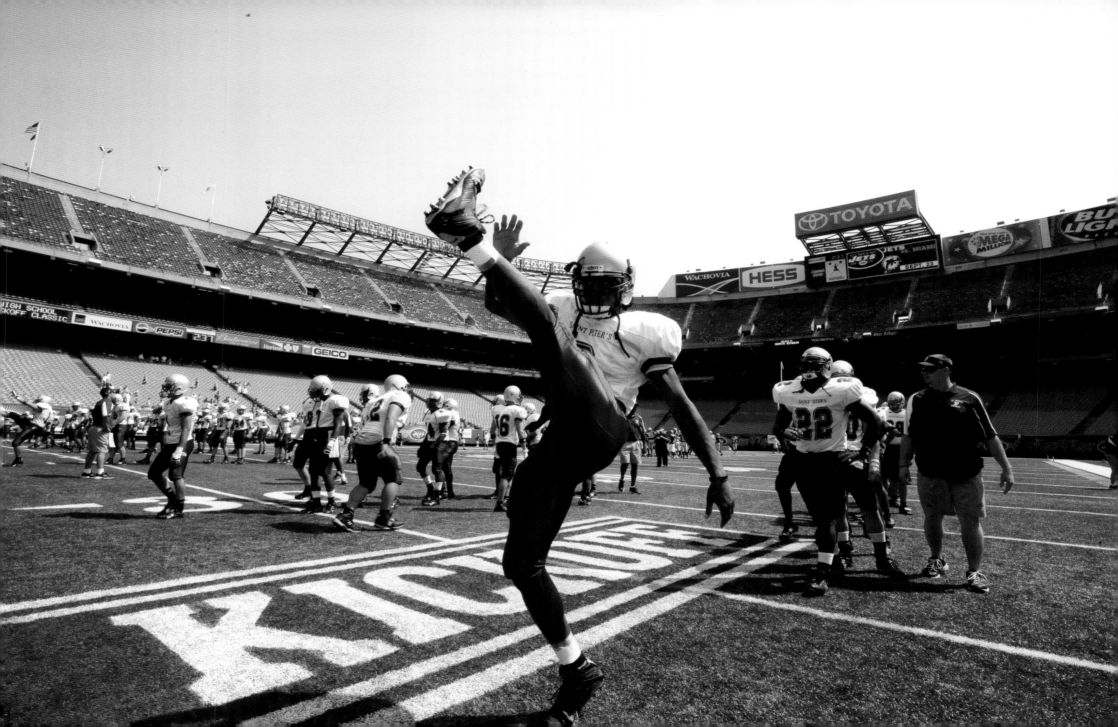

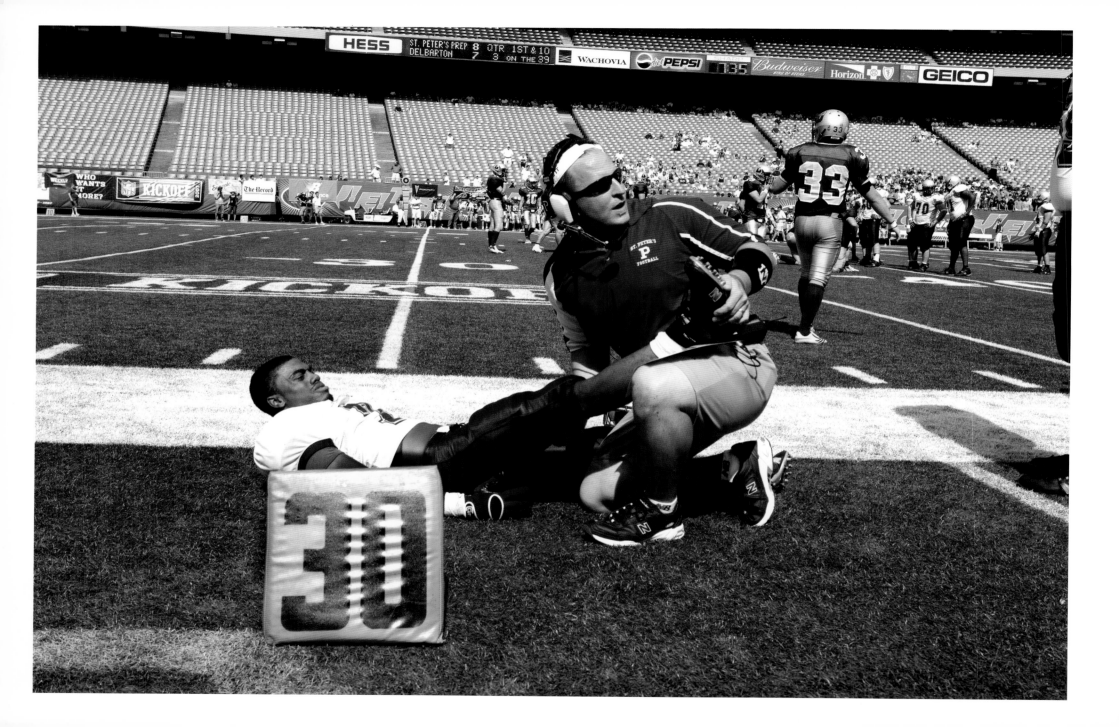

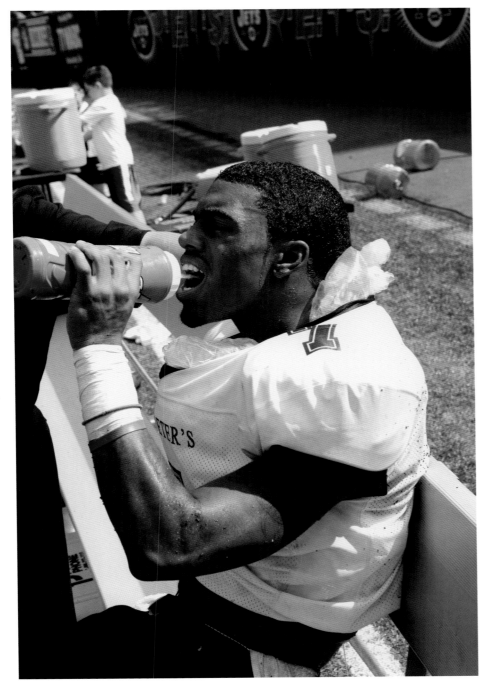
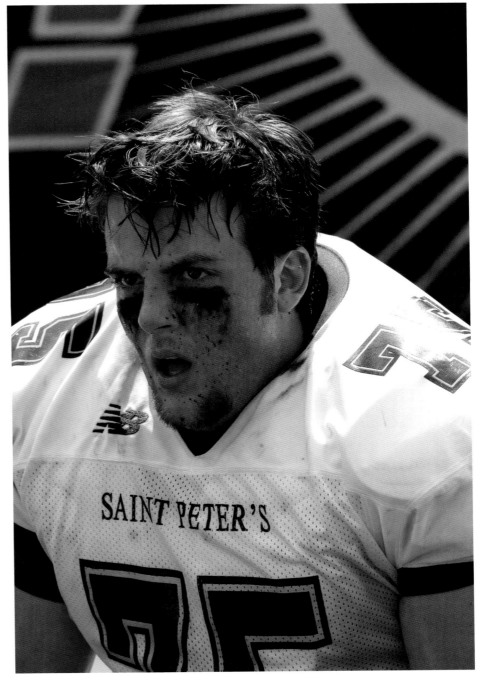

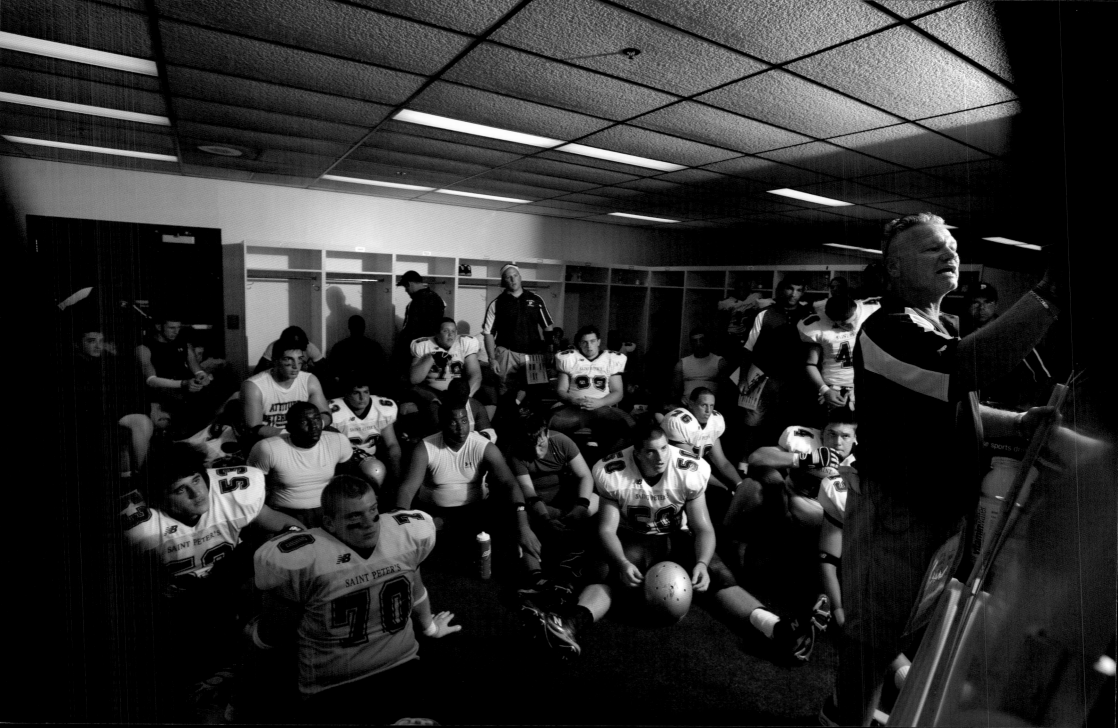

visualize...believe...achieve

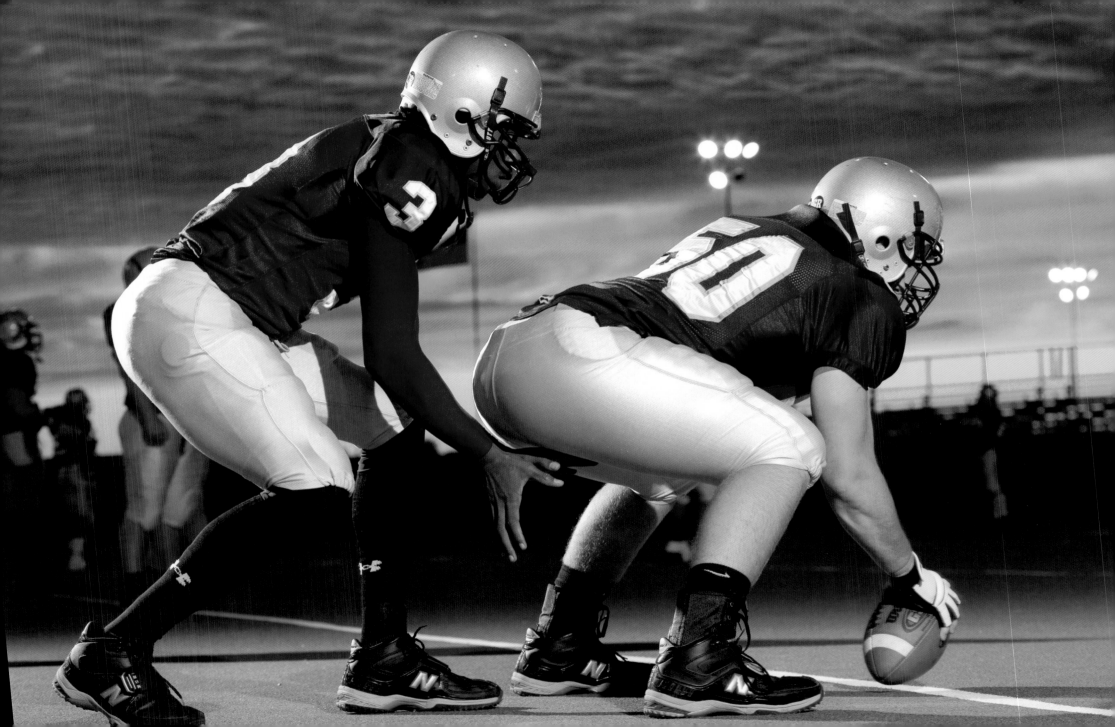

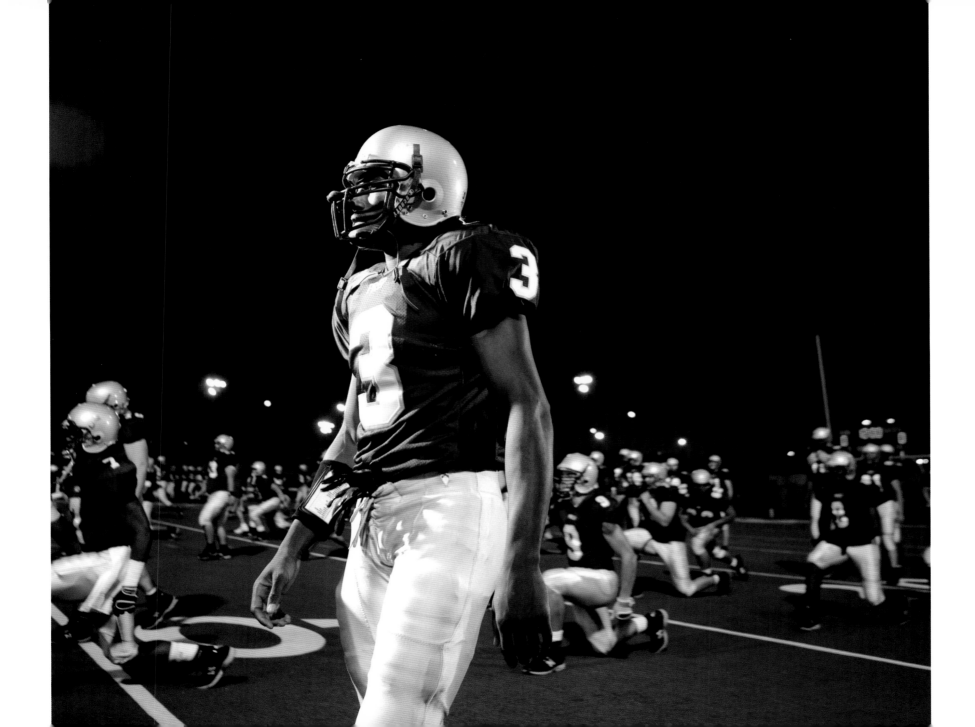

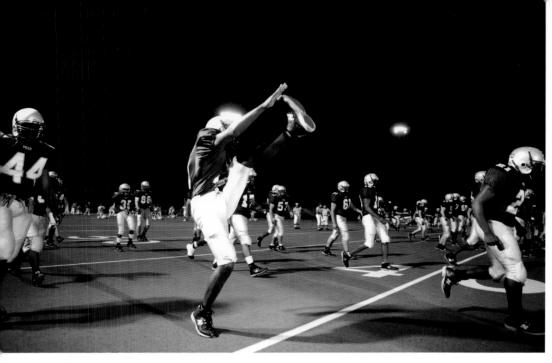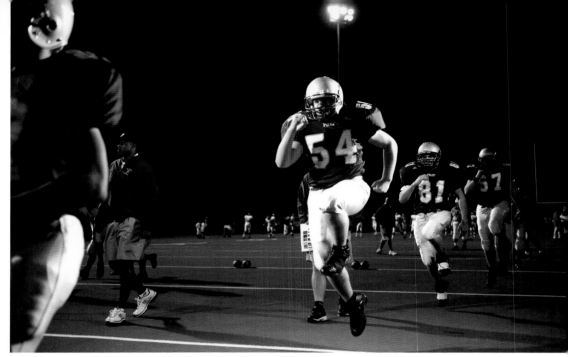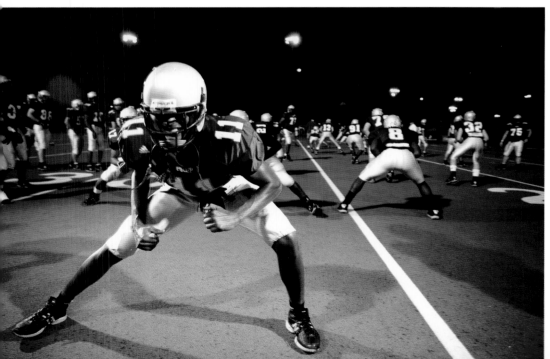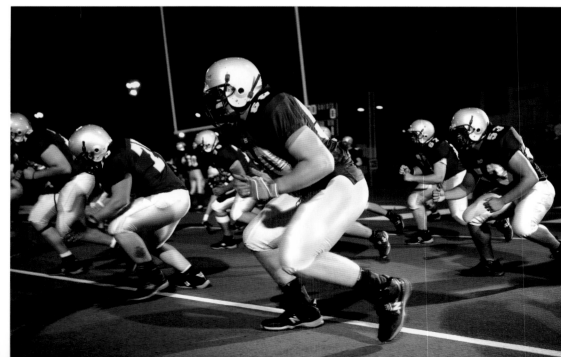

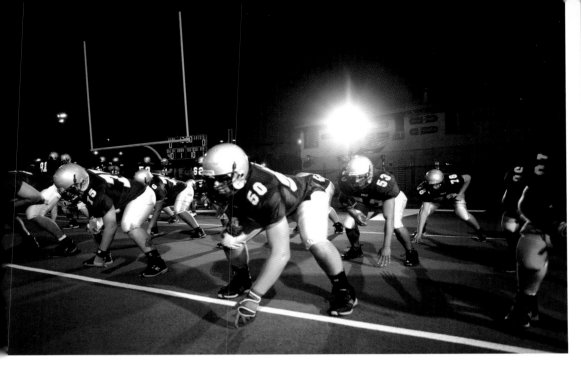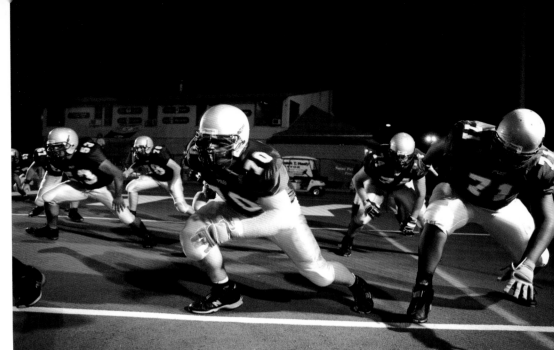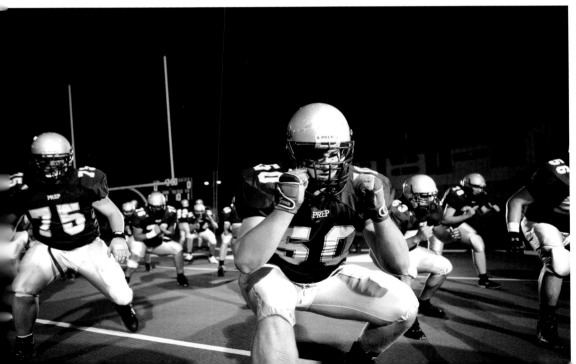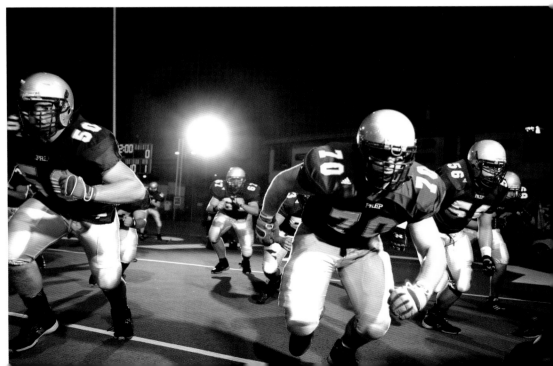

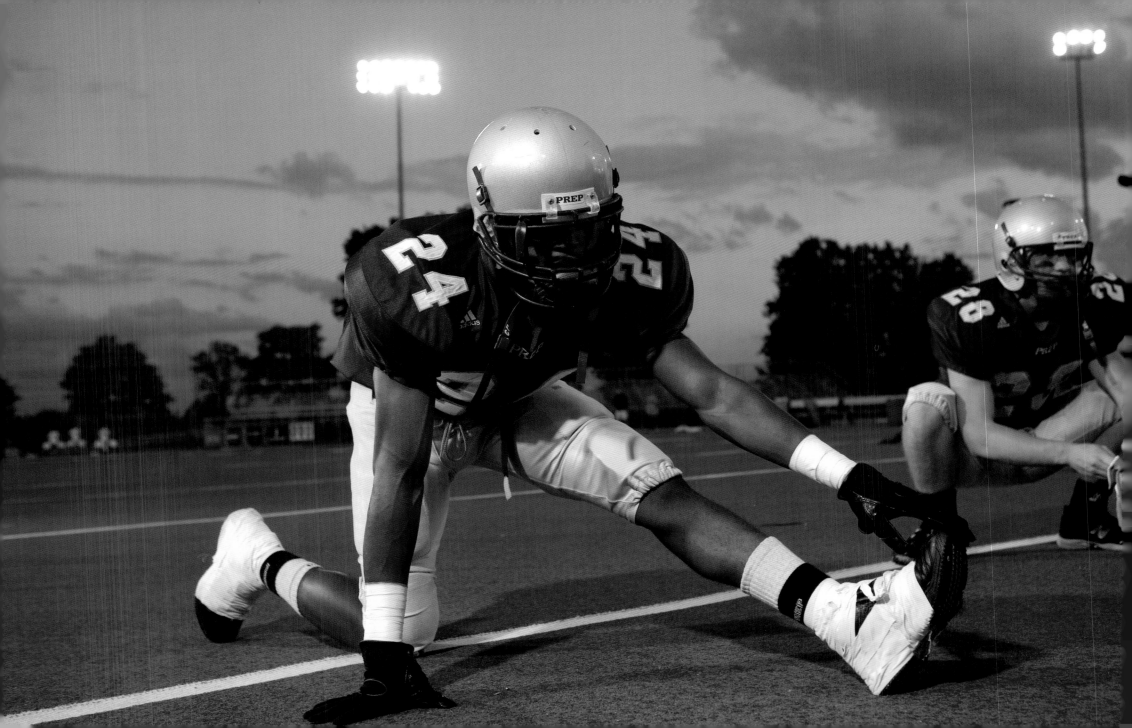

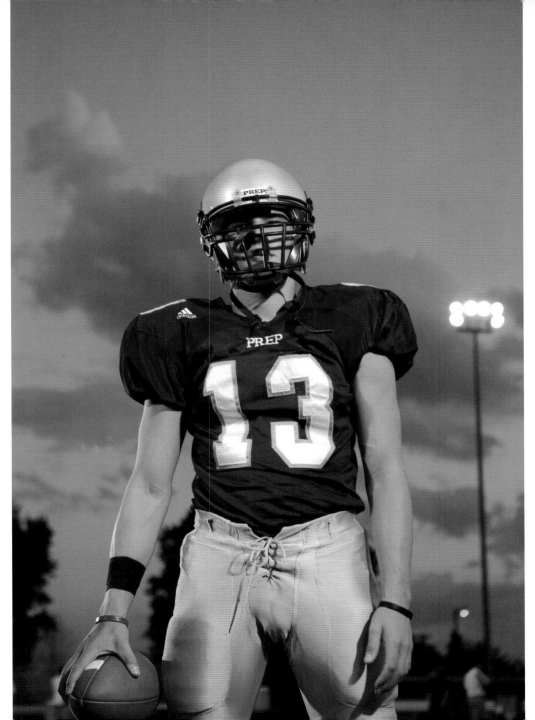
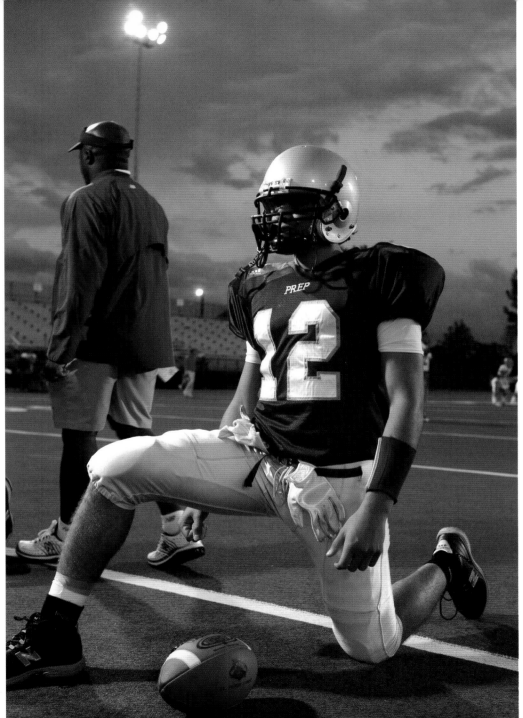

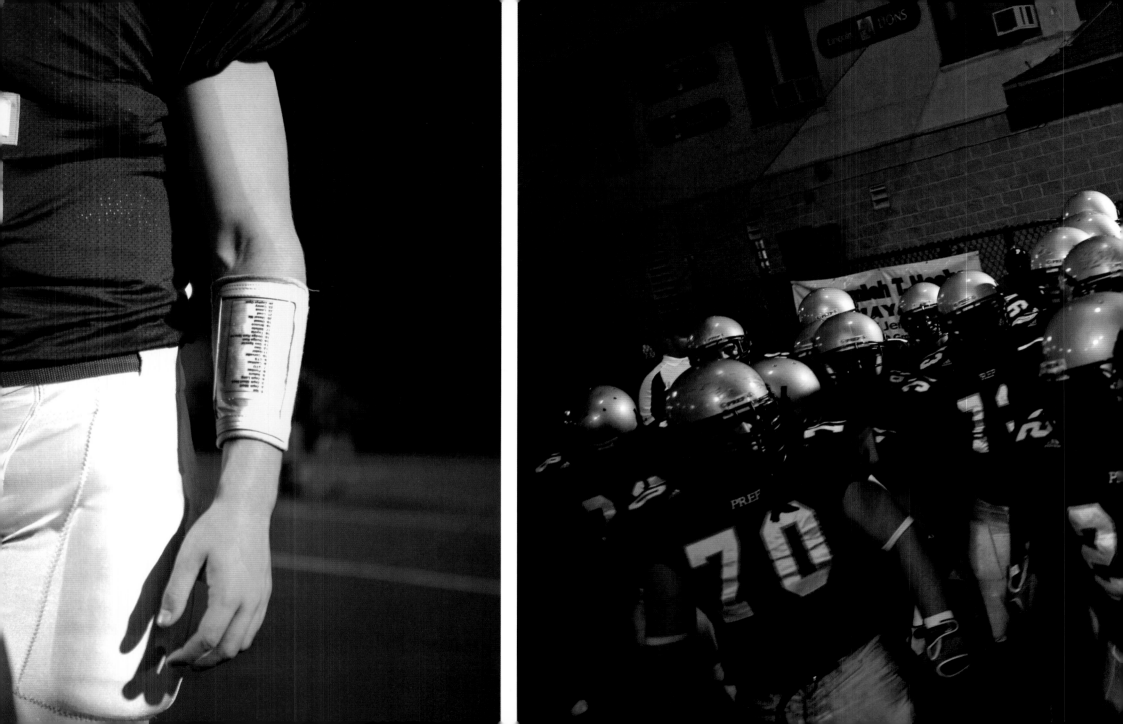

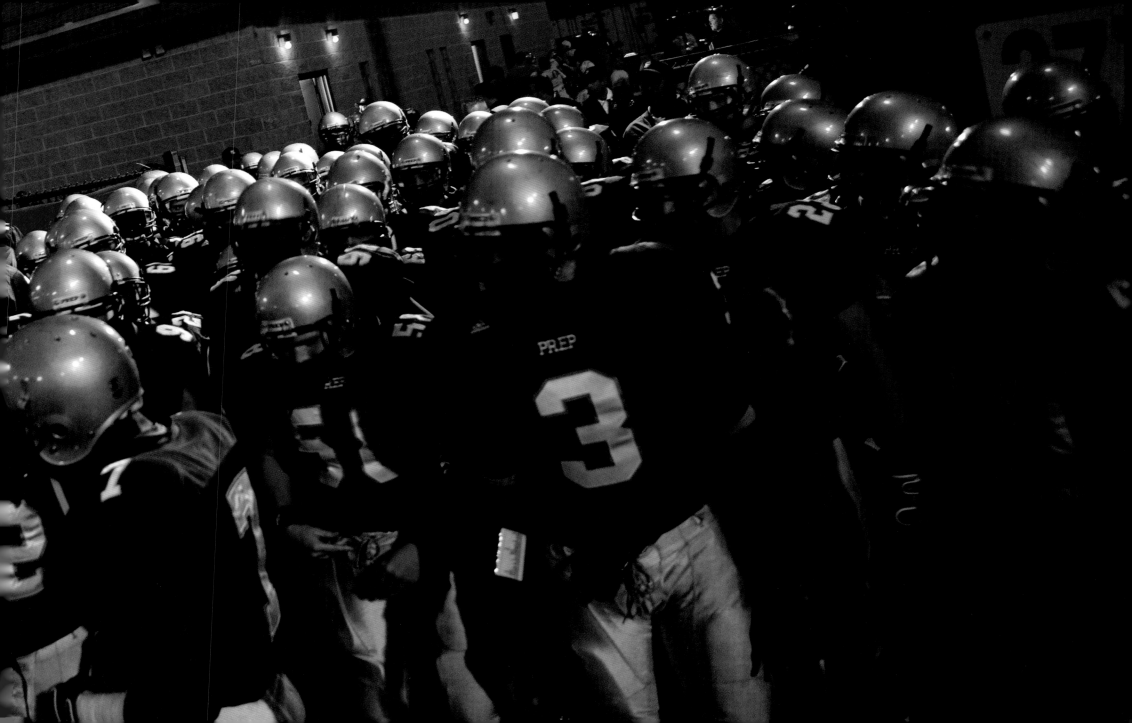

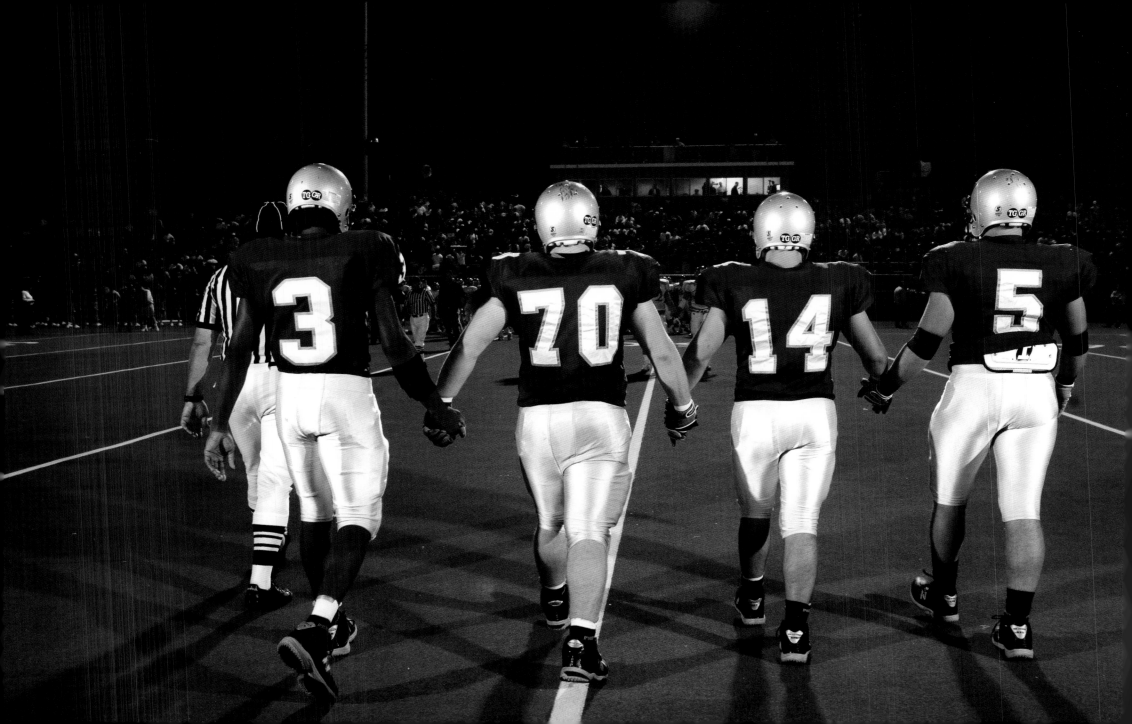

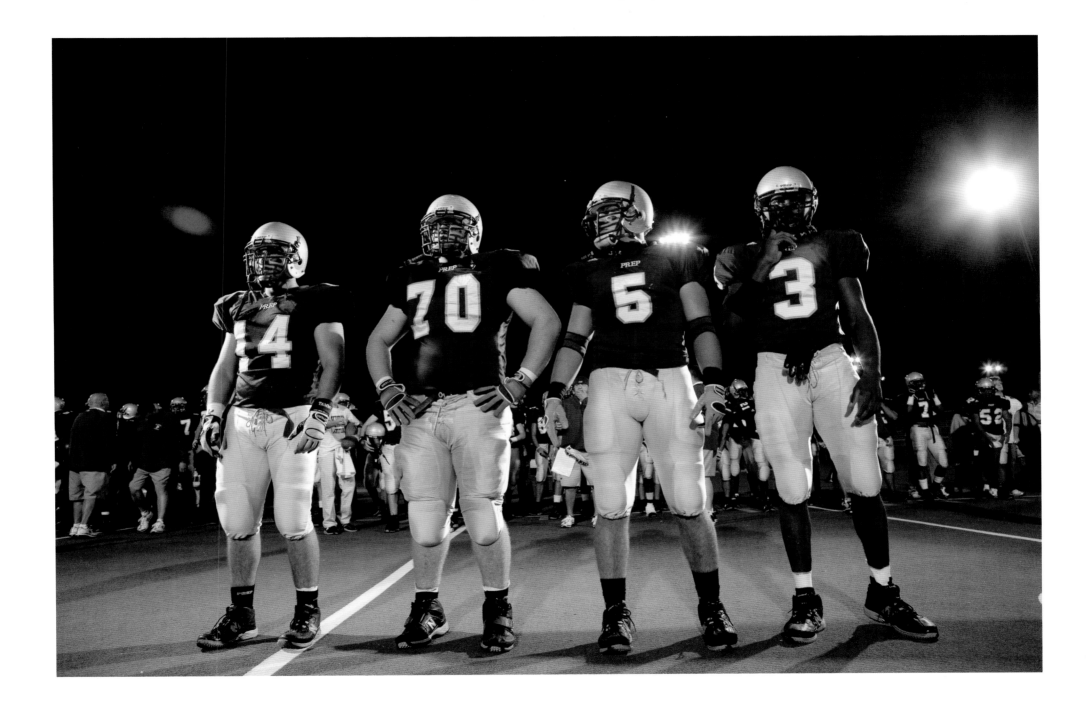

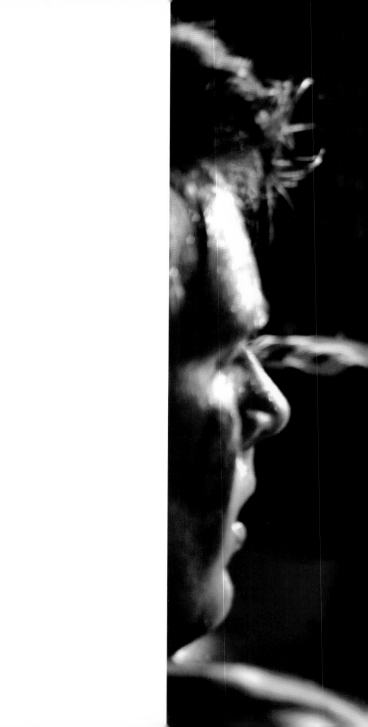

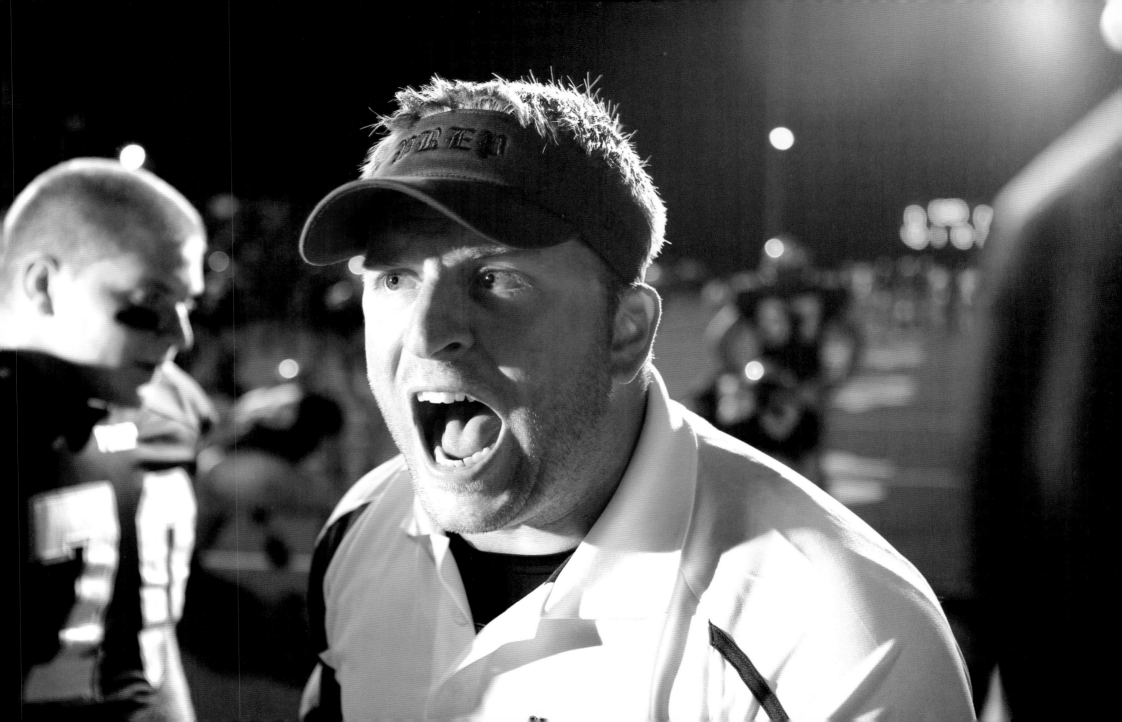

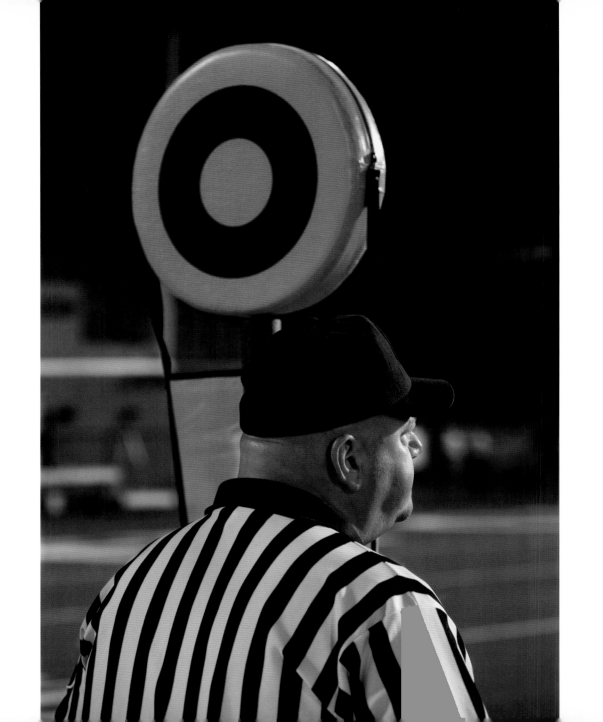

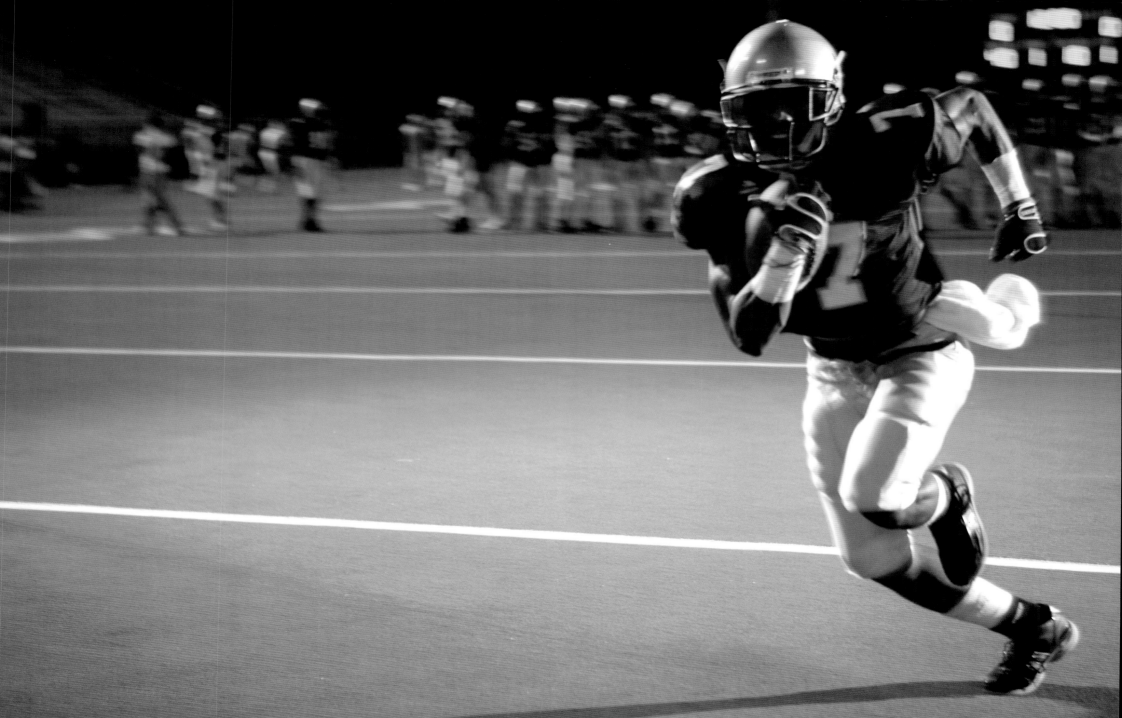

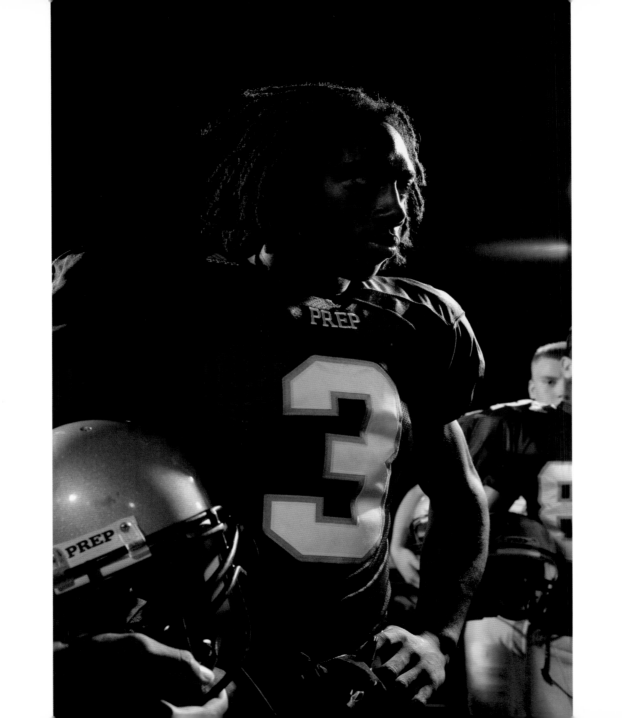

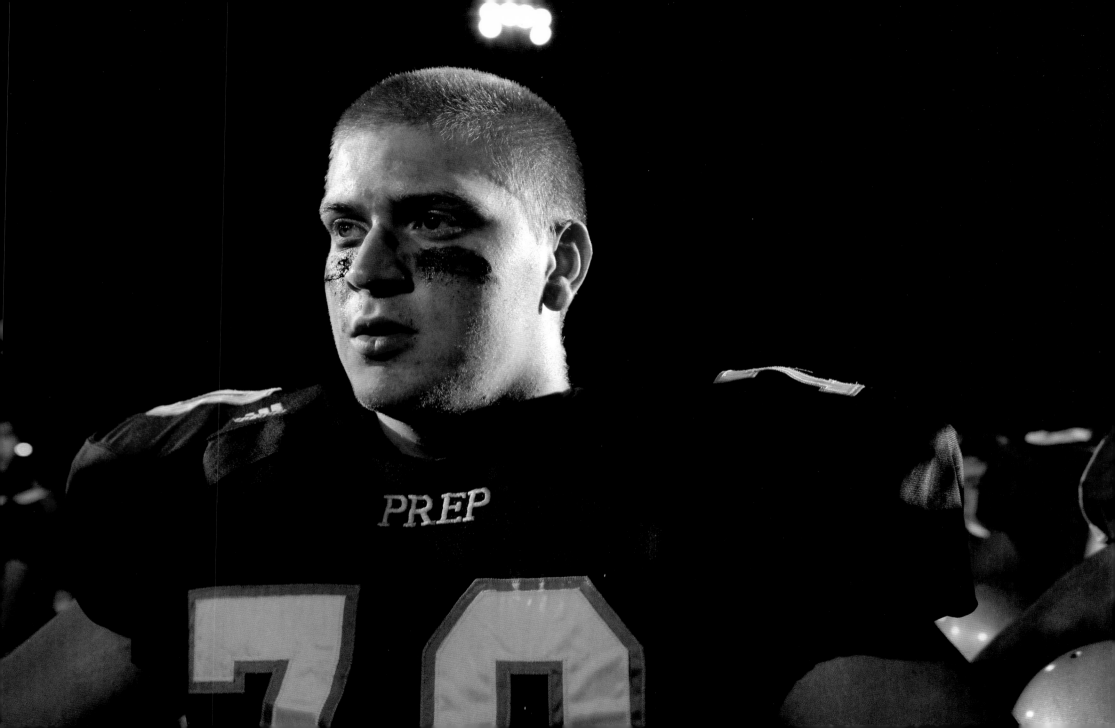

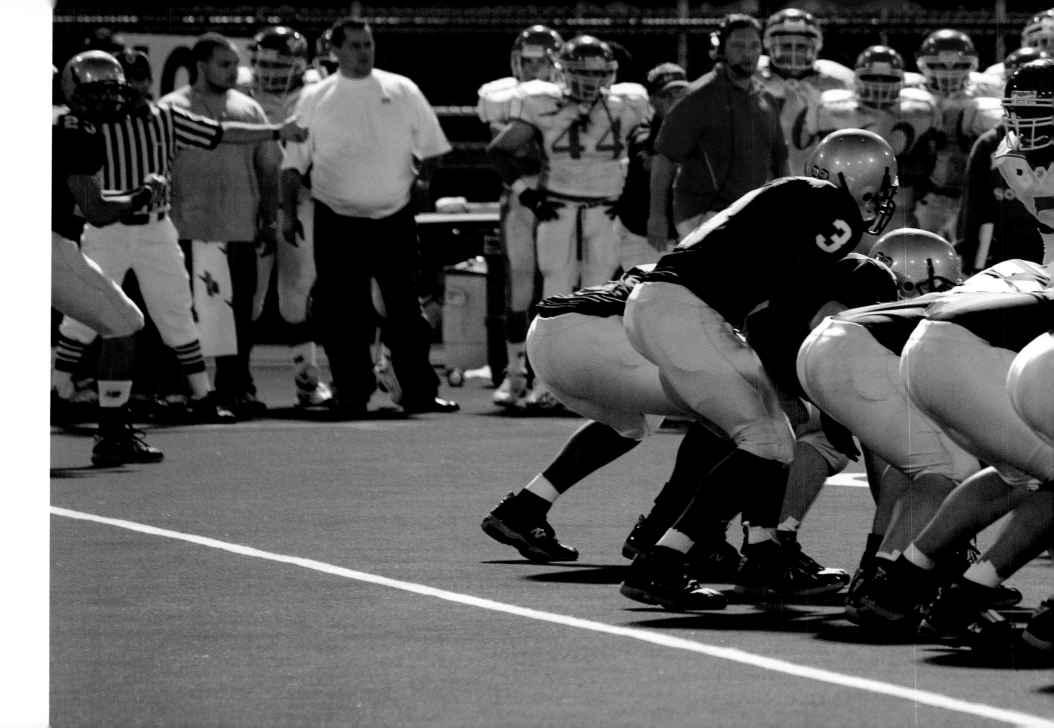

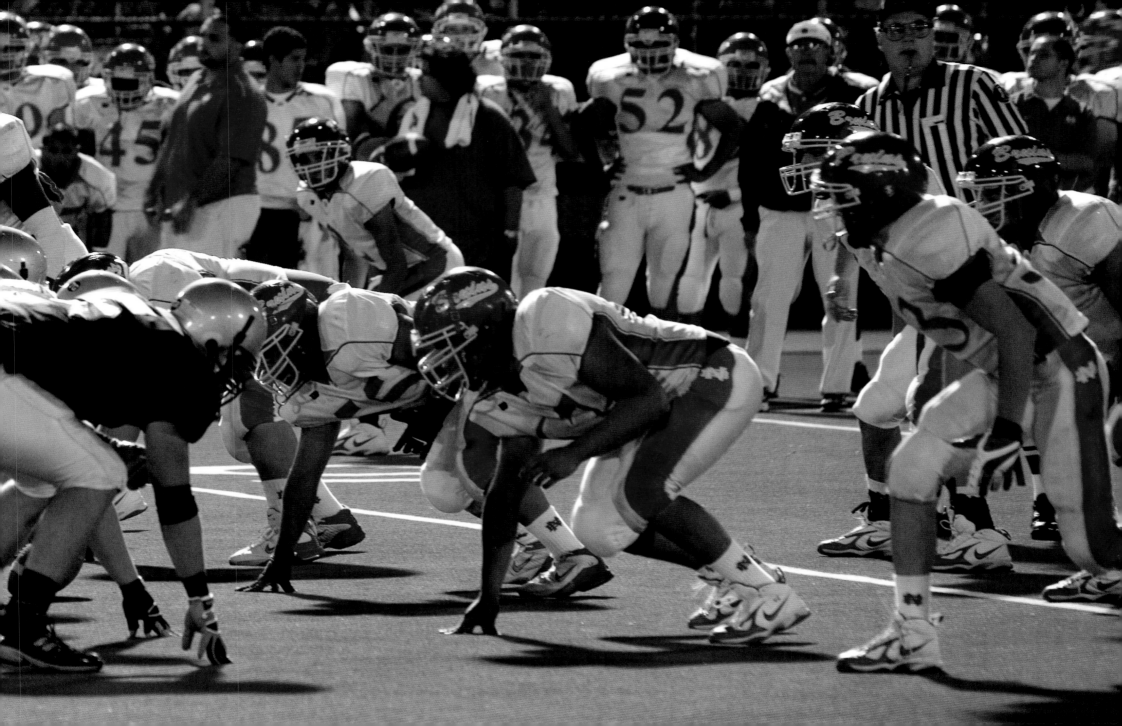

PASSION DRIVES THE SOUL

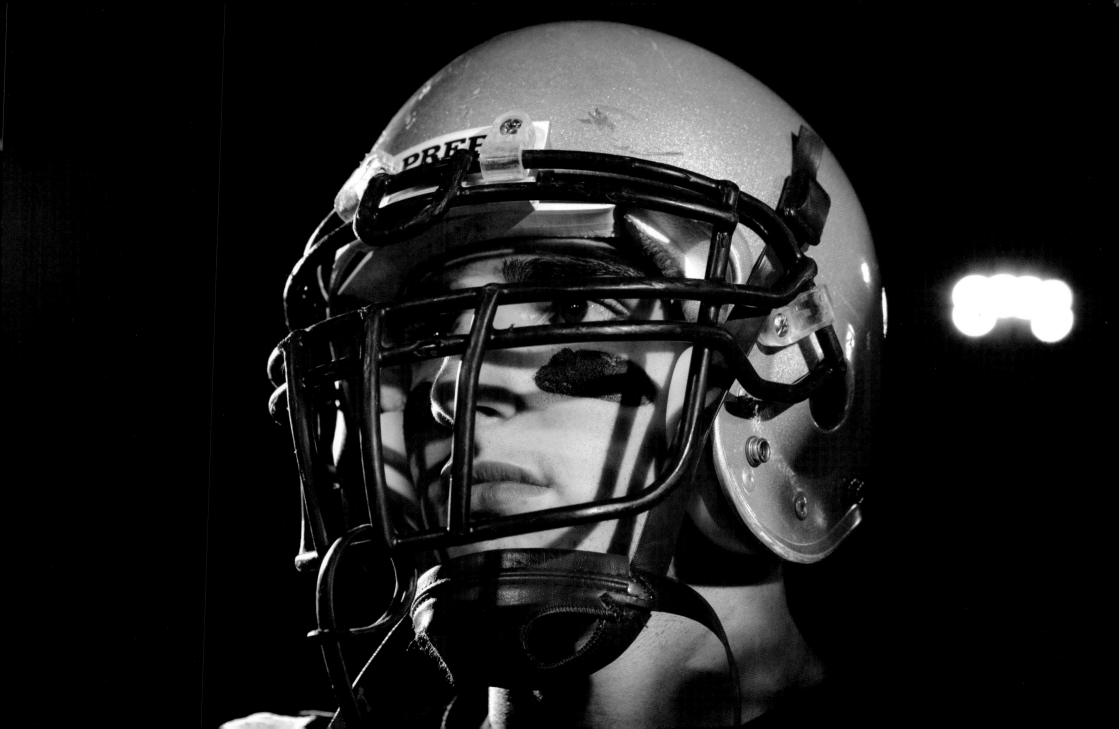

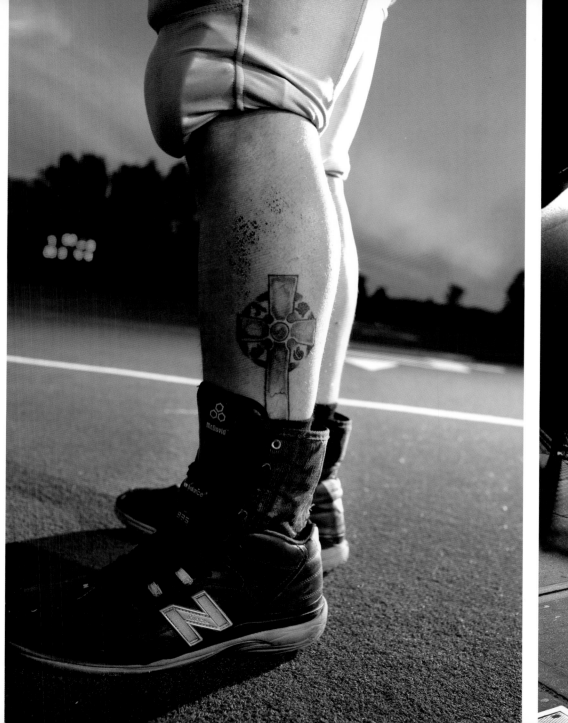
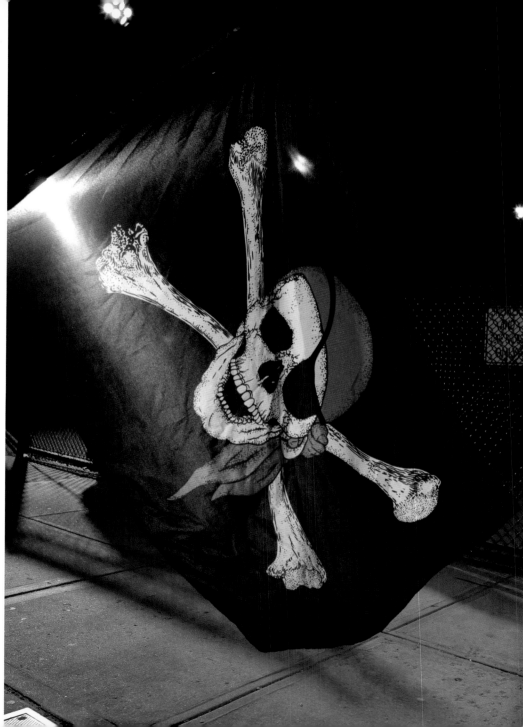

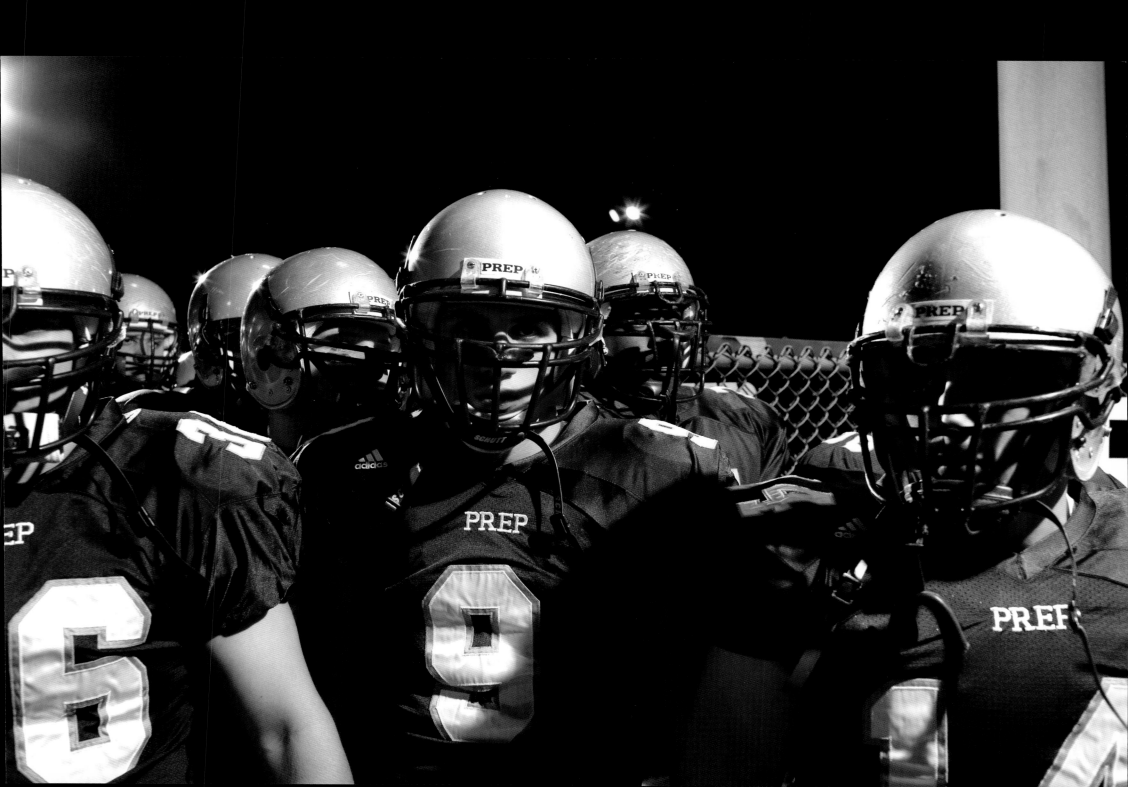

HARD WORK BEATS TALENT WHEN TALENT DOESN'T WORK HARD

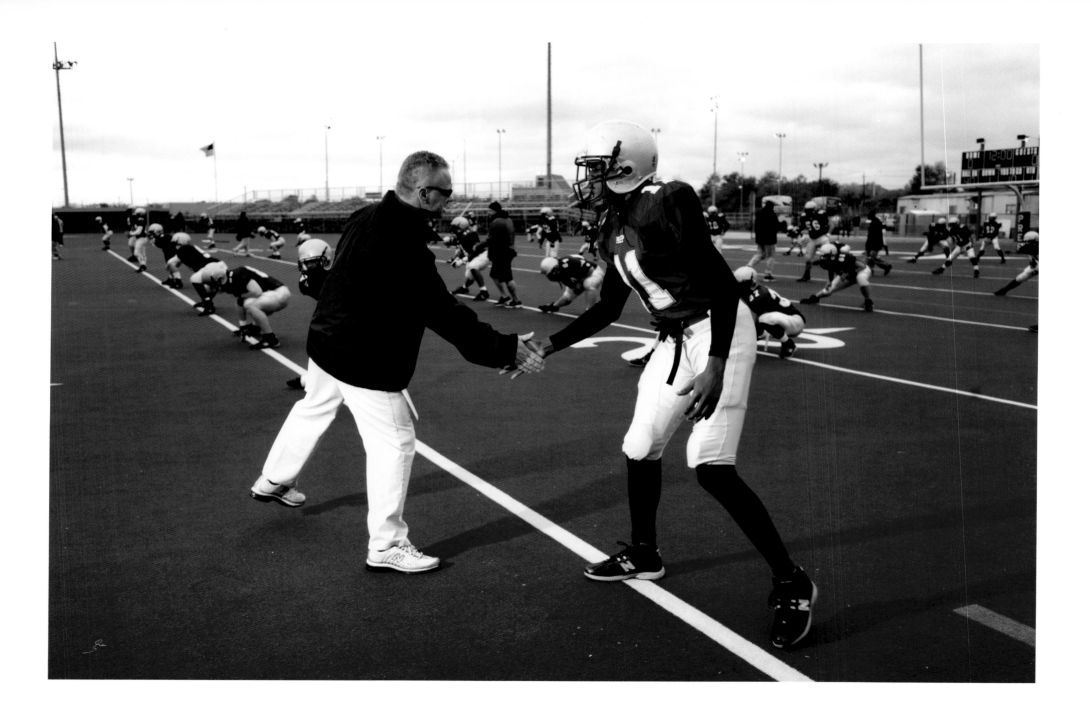

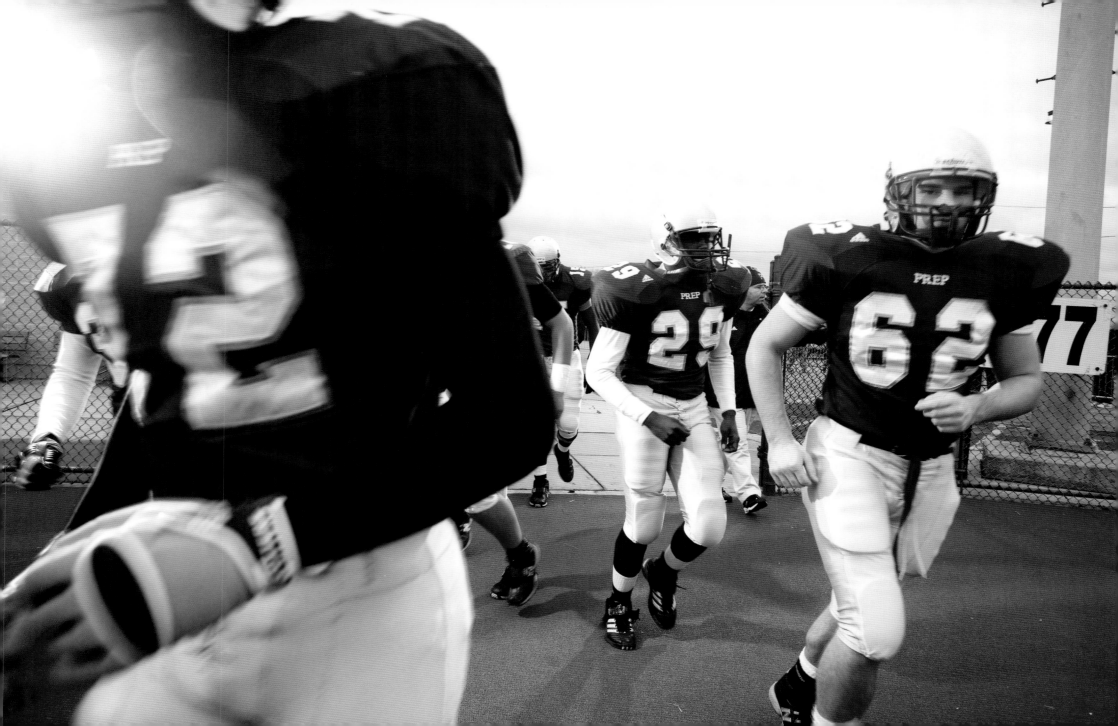

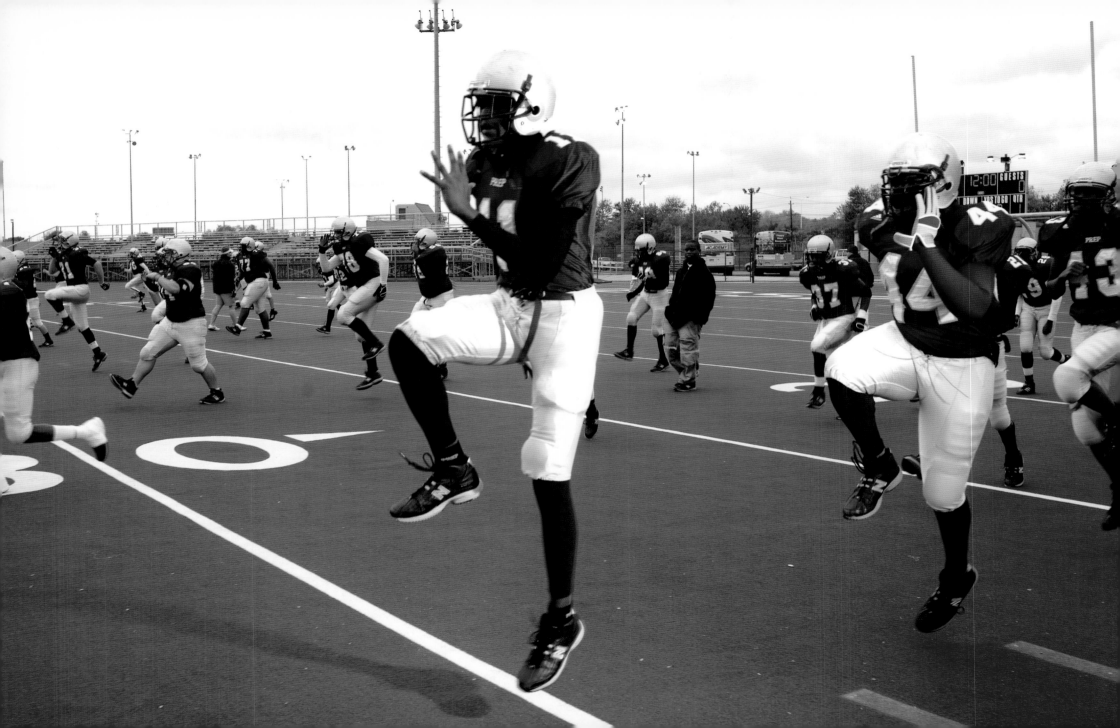

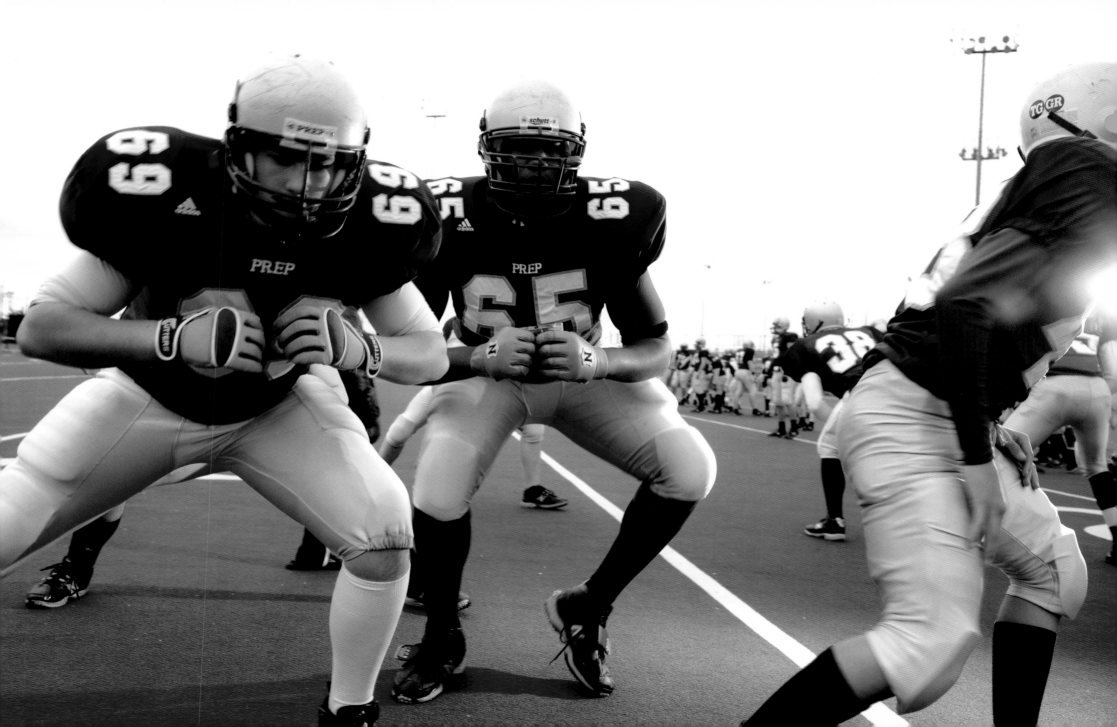

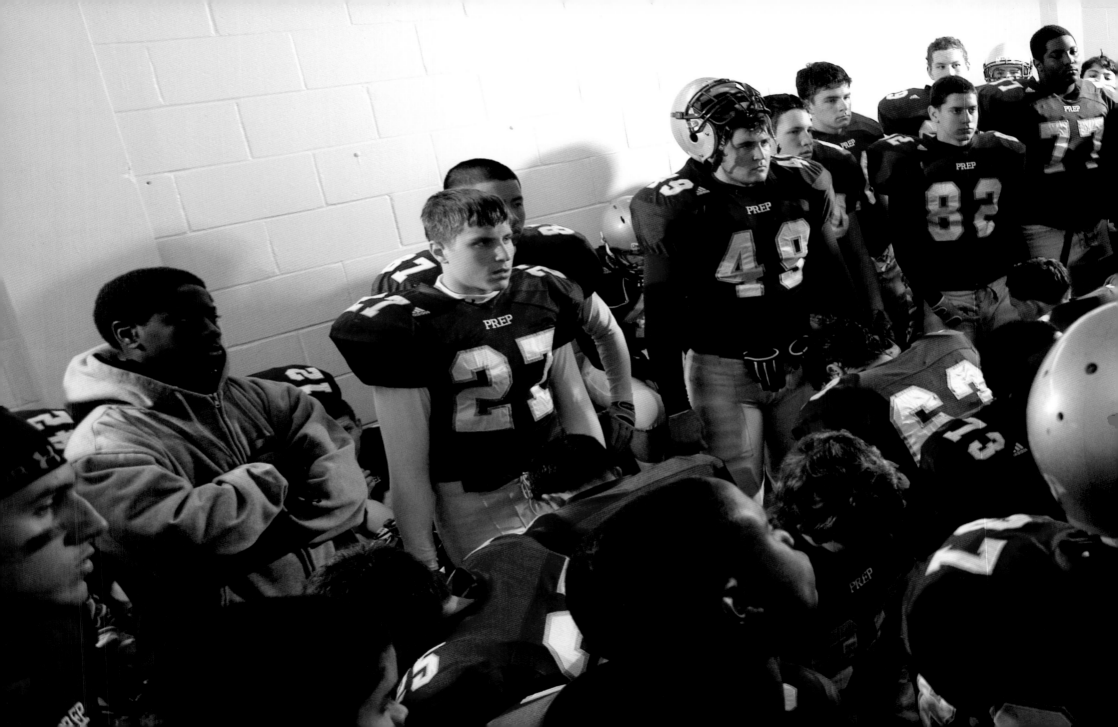

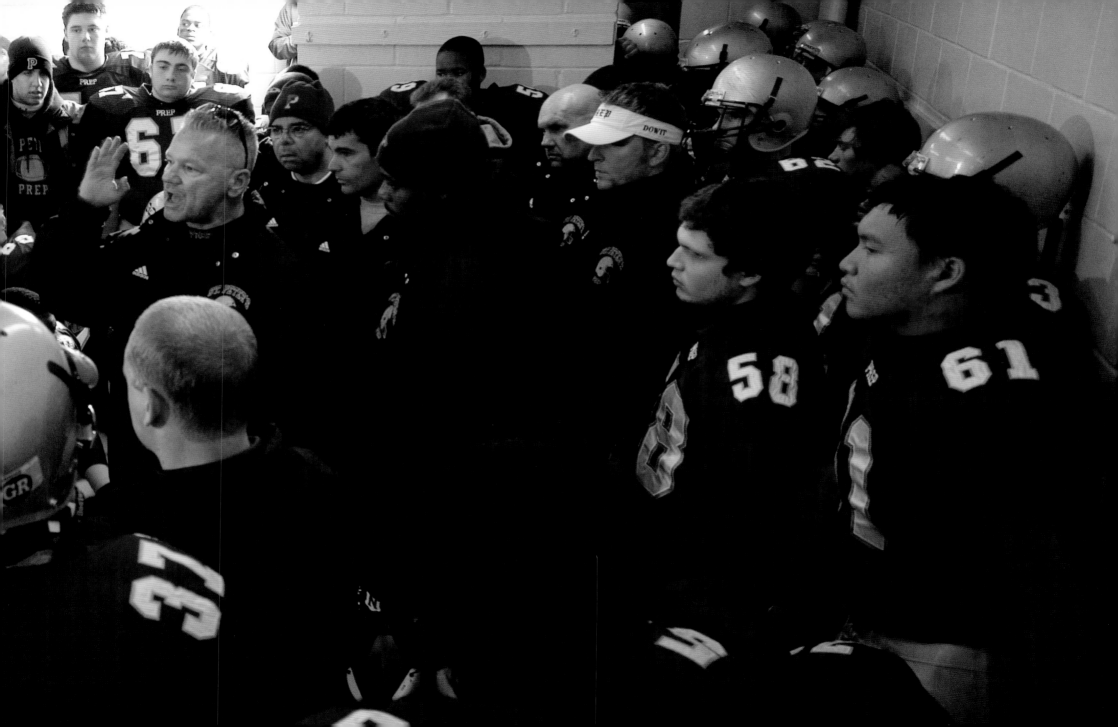

IT IS NOT GOOD ENOUGH TO BE BET

IT IS NOT GOOD ENOUGH TO

TER, YOU HAVE TO PLAY BETTER.

WANT IT, YOU HAVE TO TAKE IT!

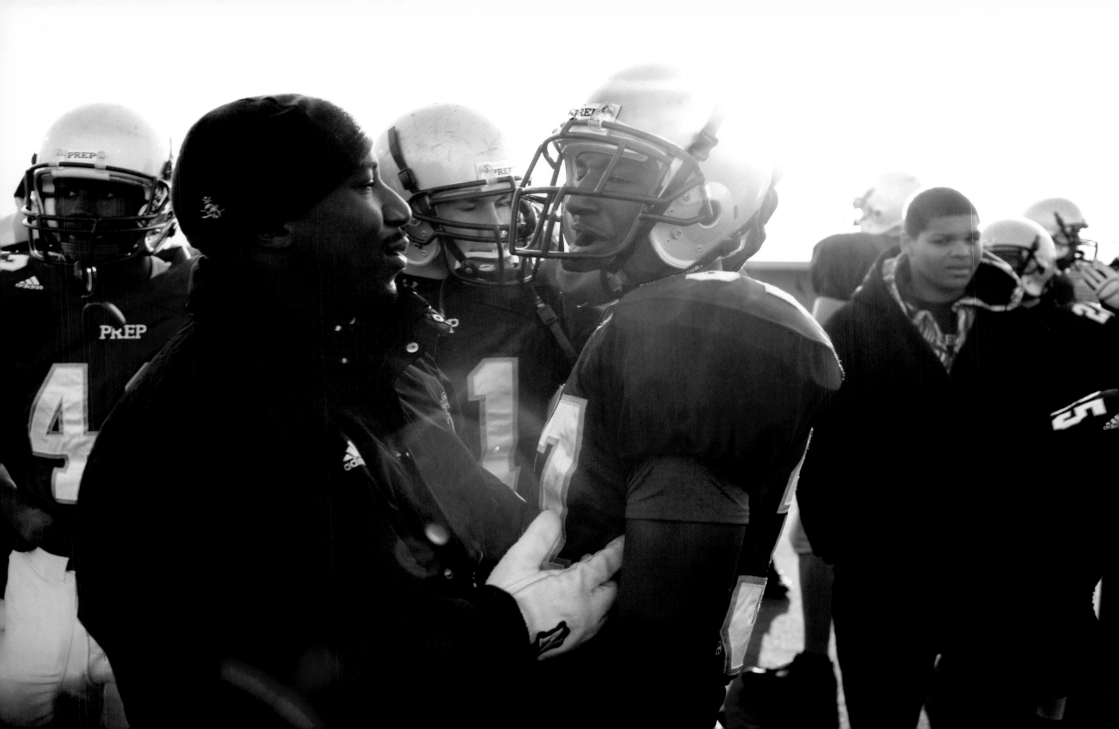

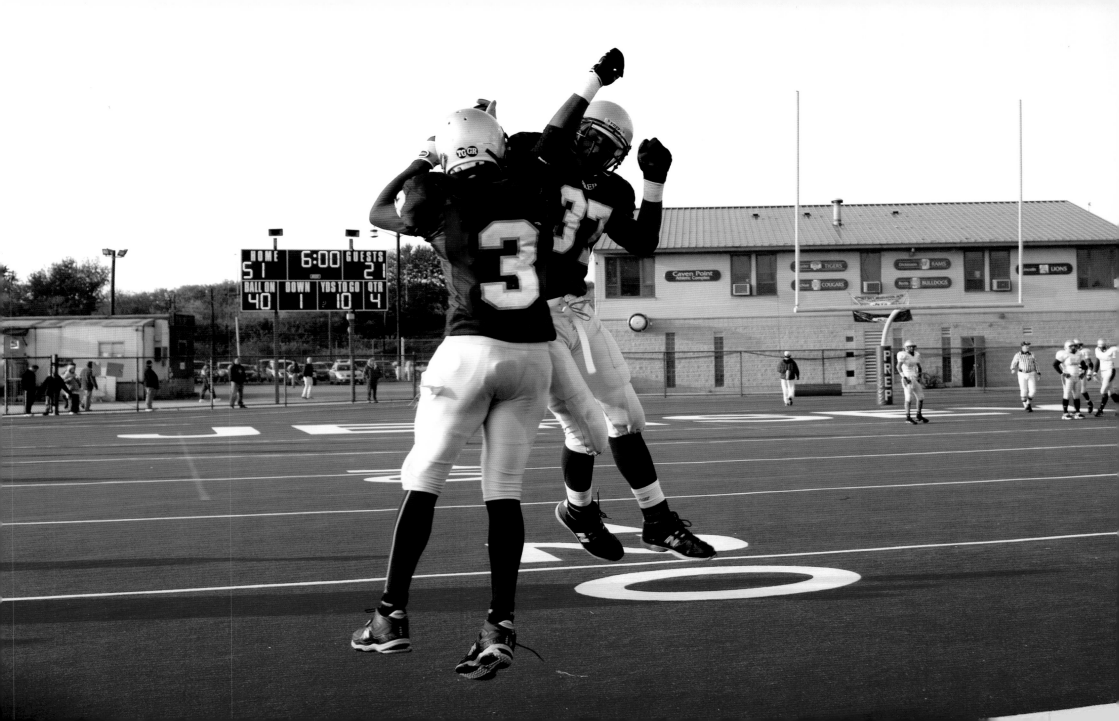

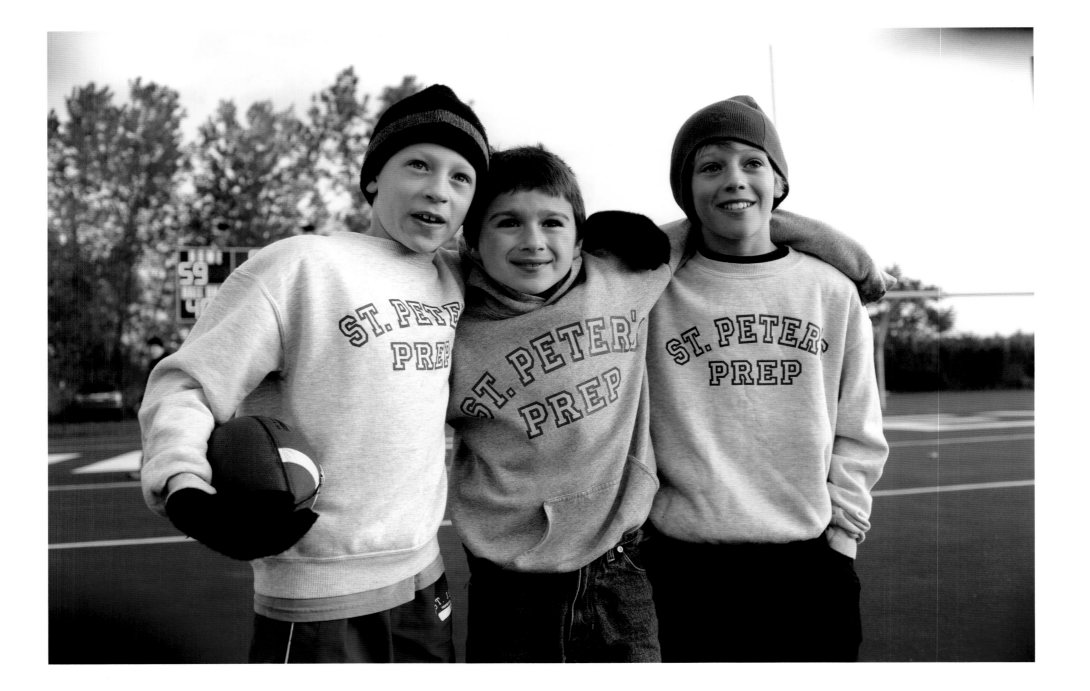

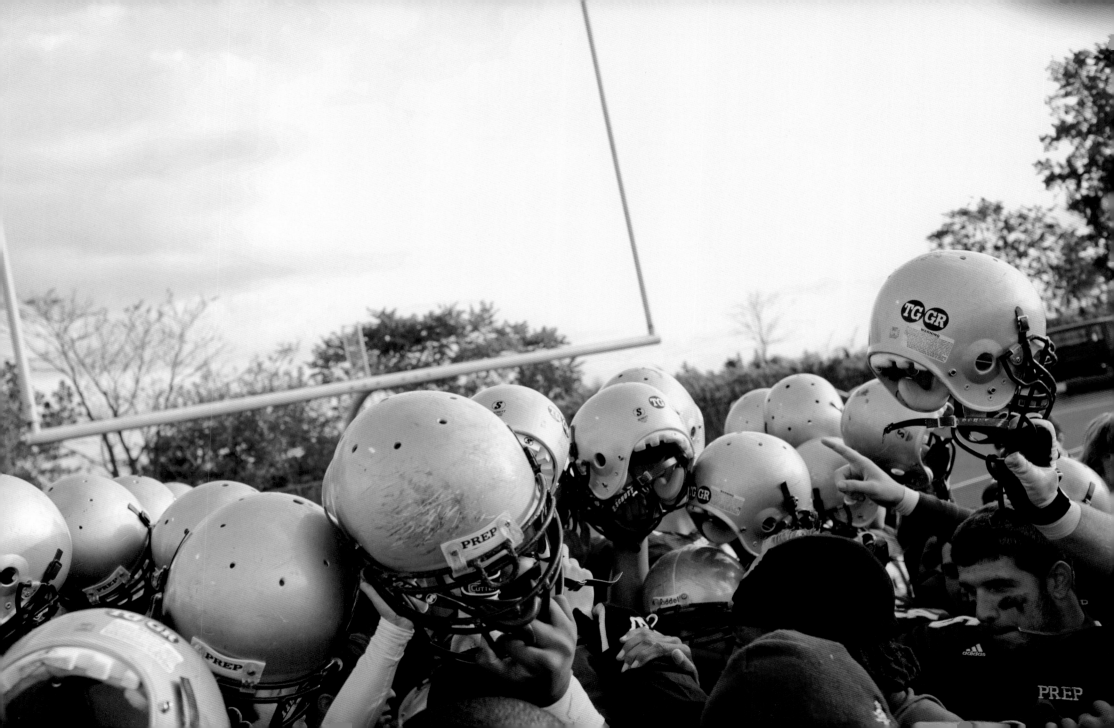

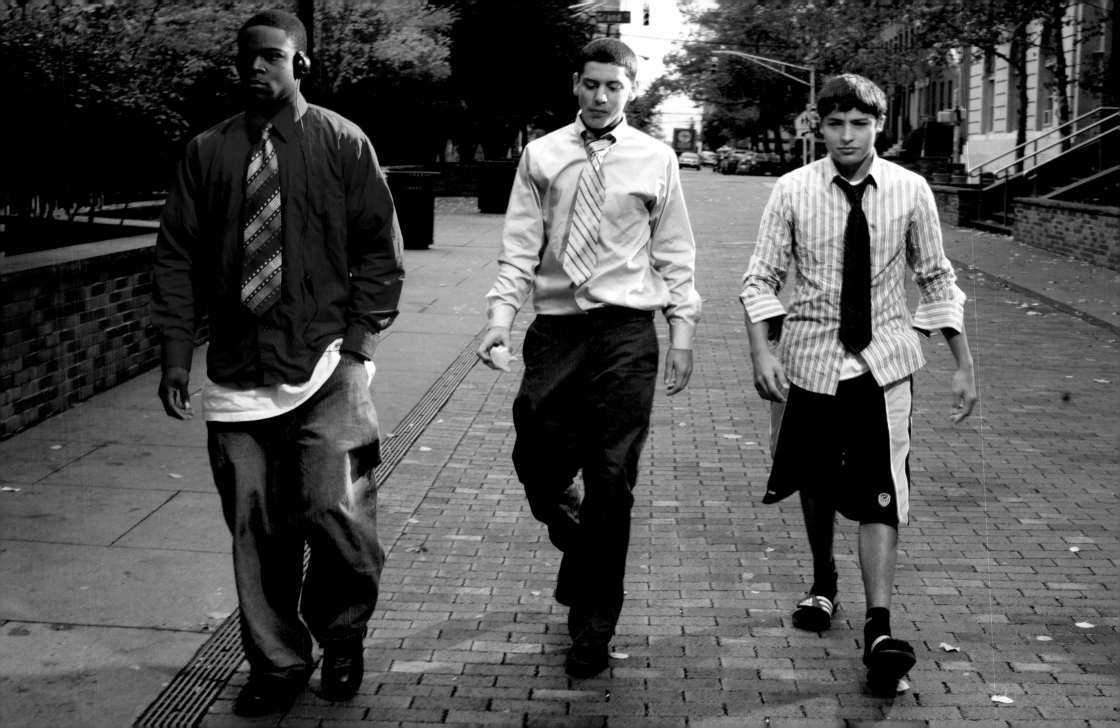

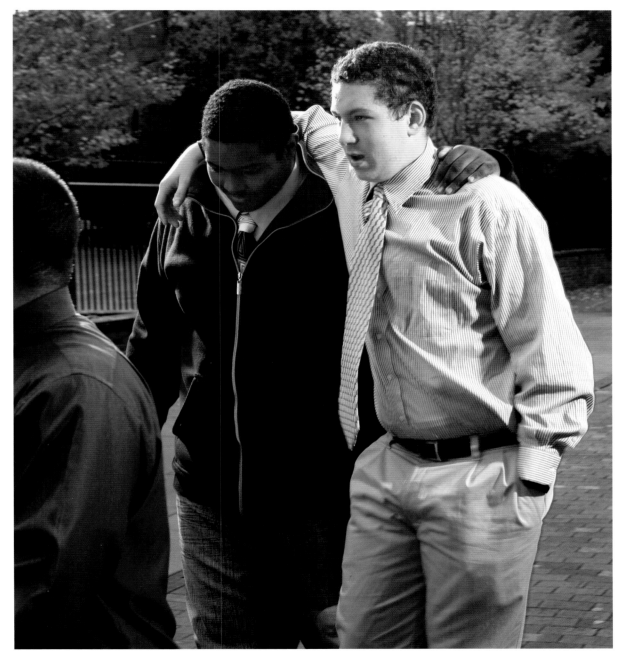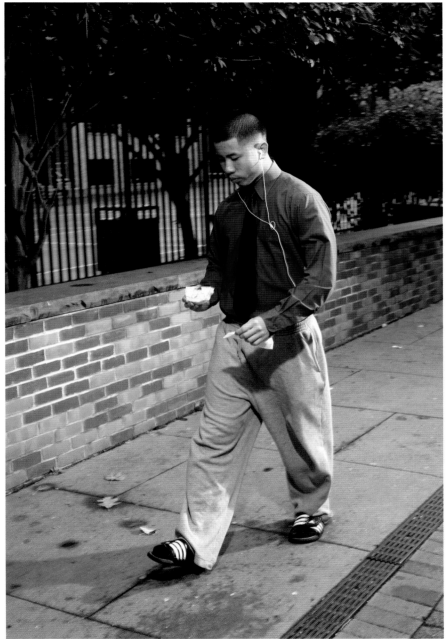

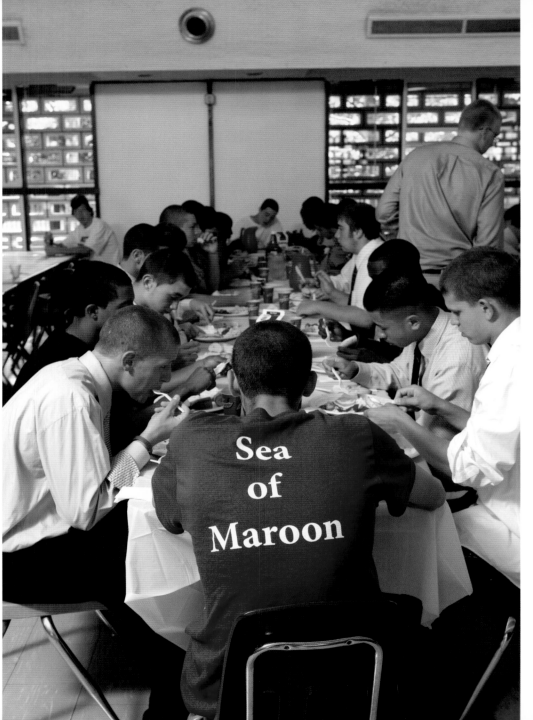
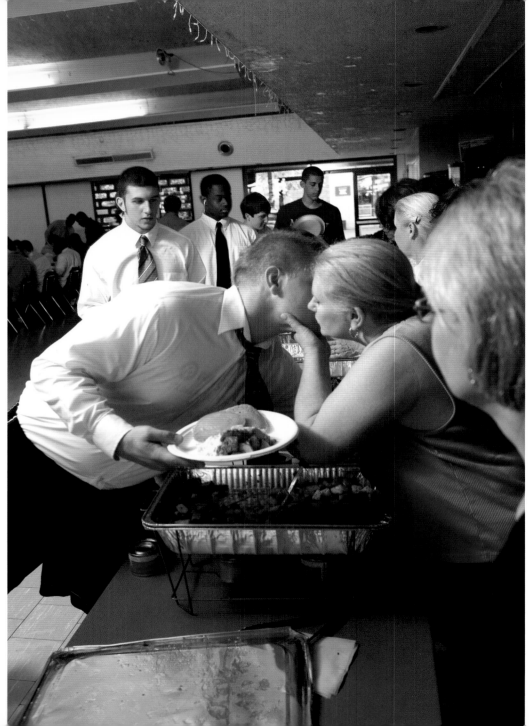

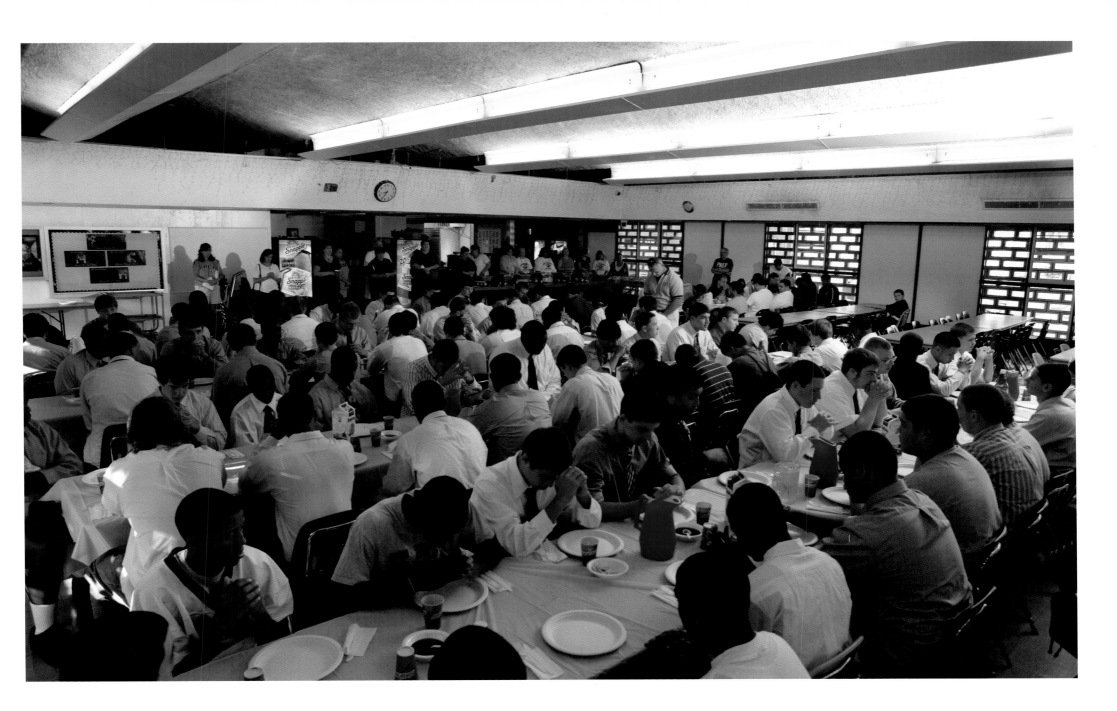

Winning isn't everything. PREPARING to win is.

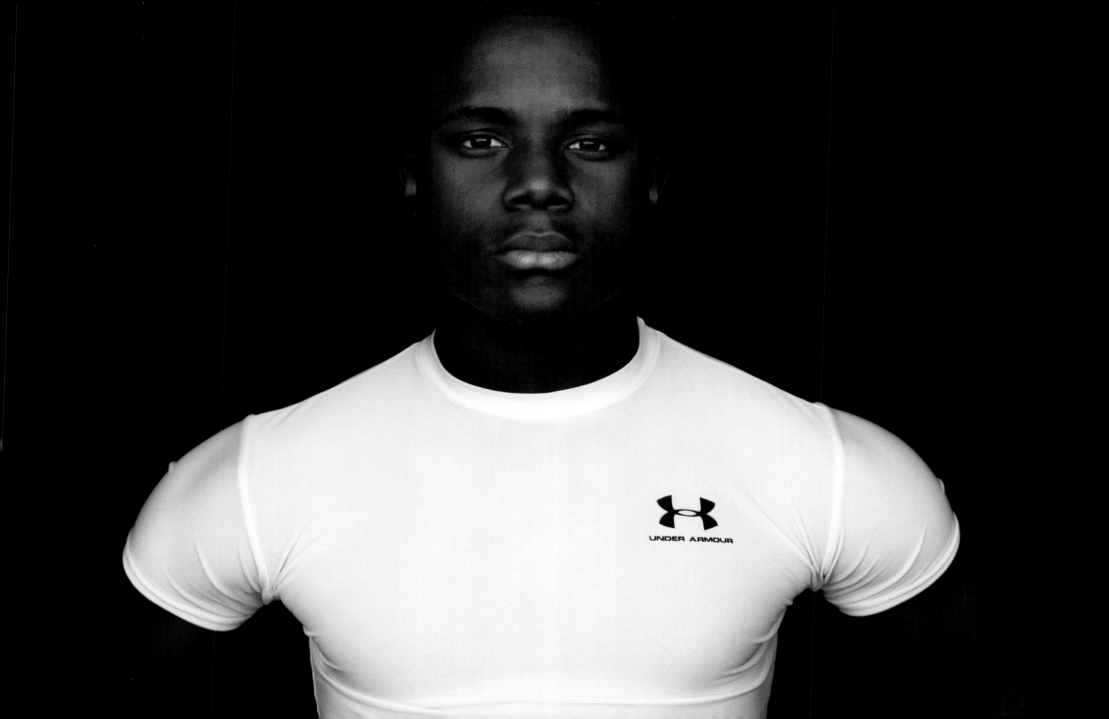

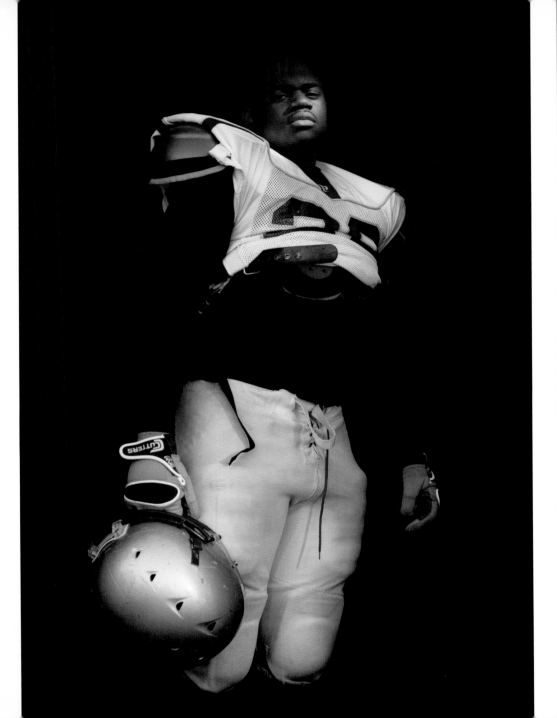
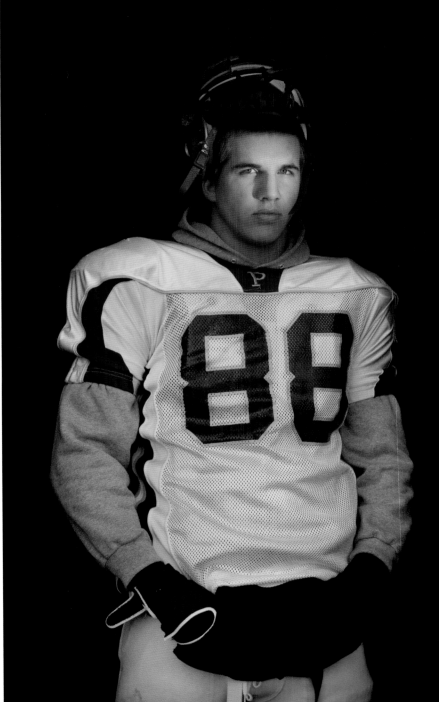

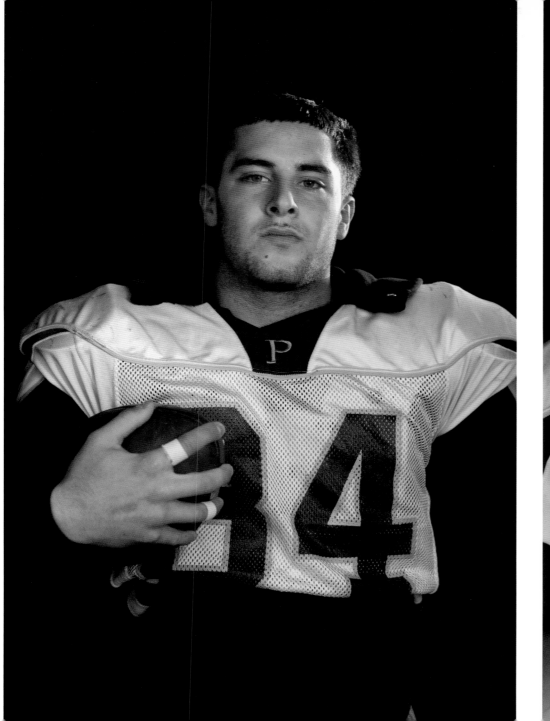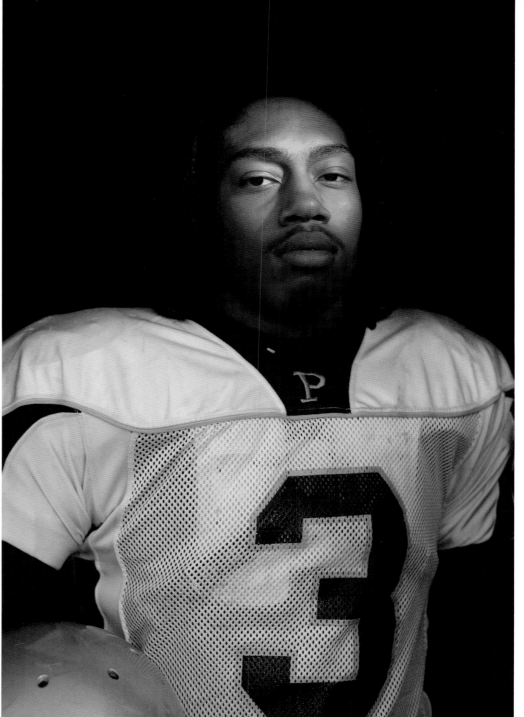

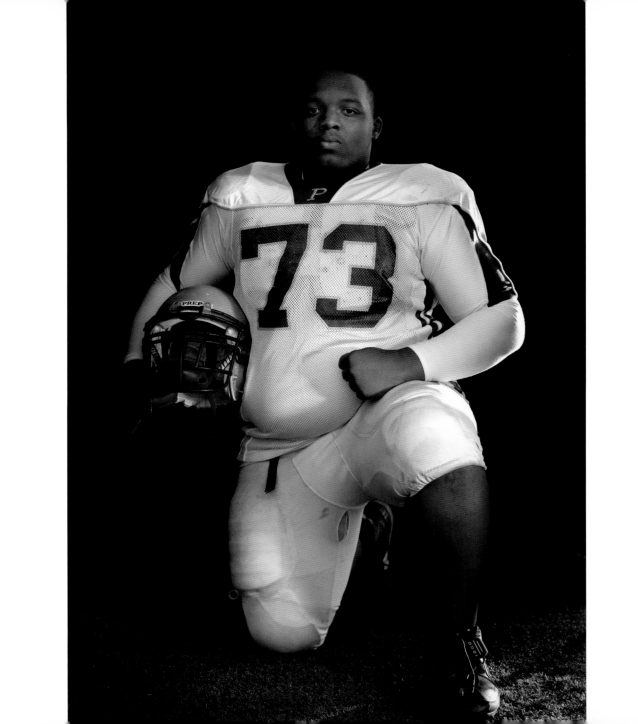

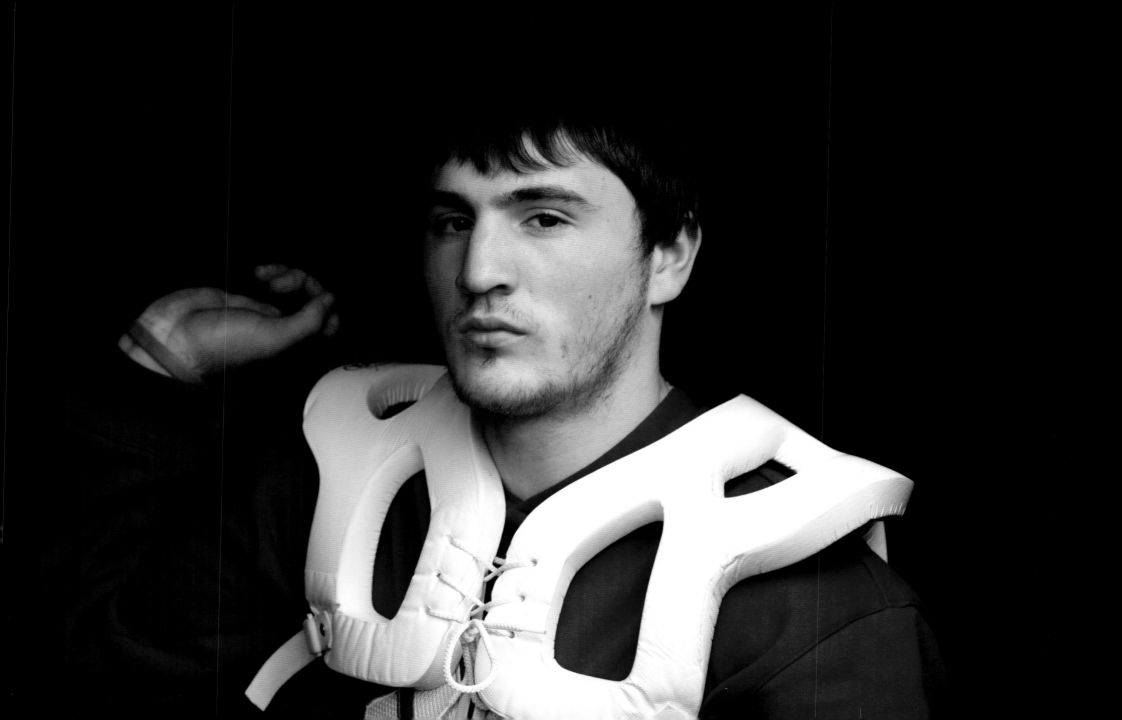

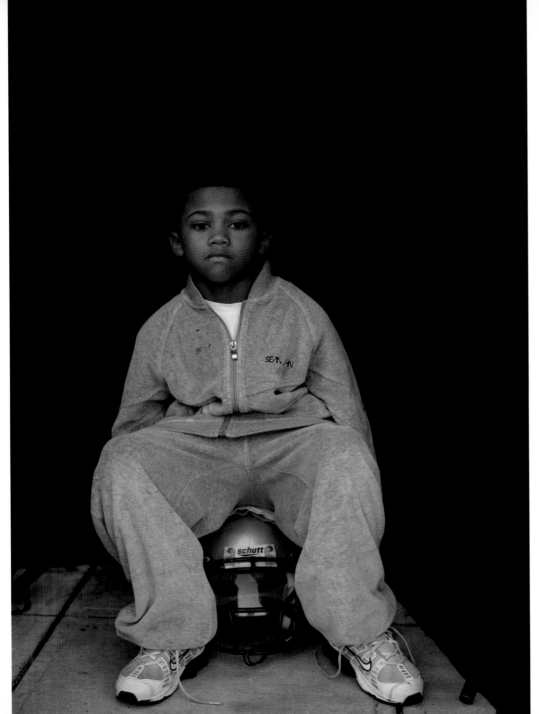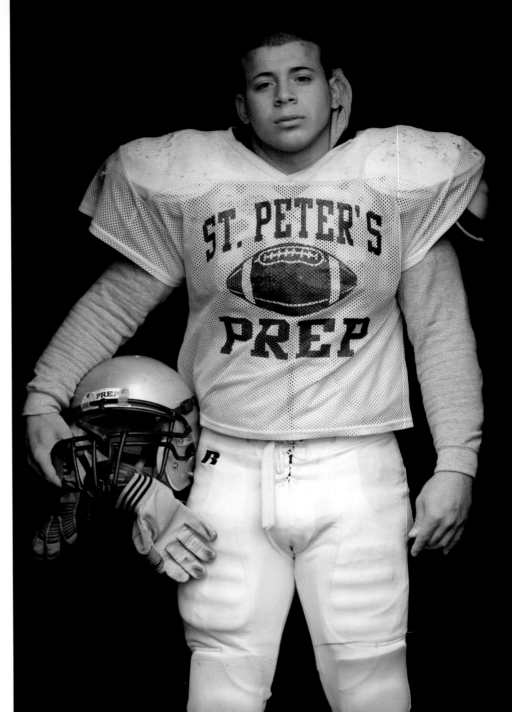

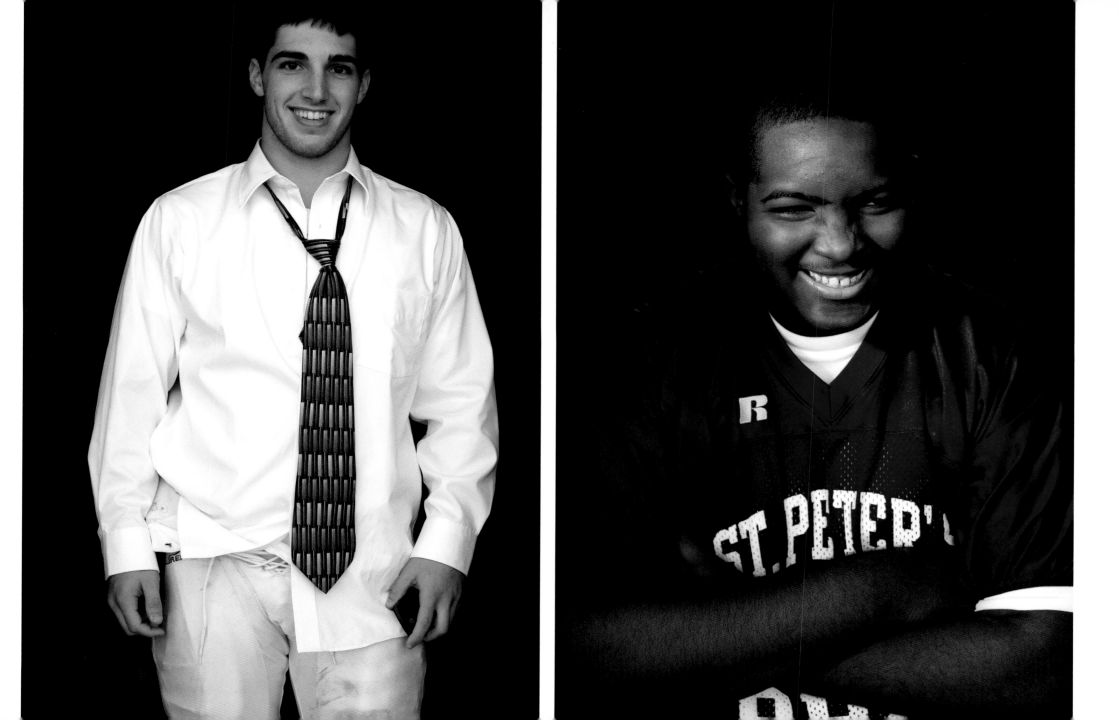

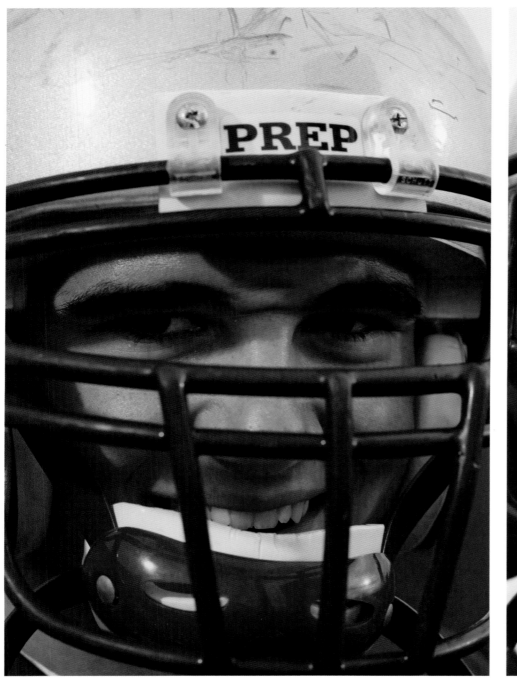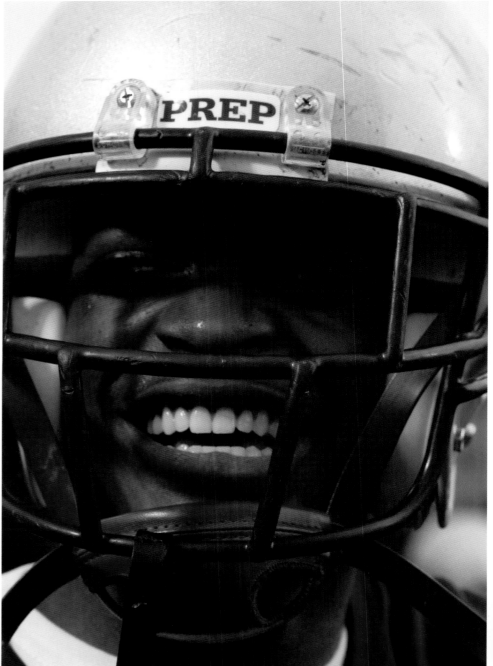

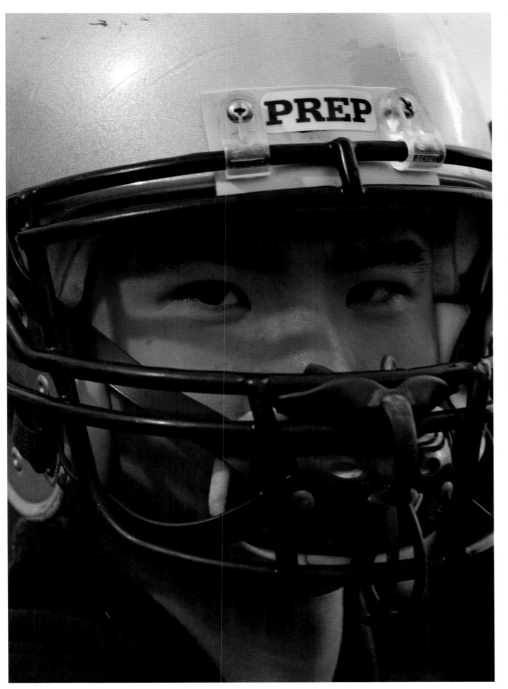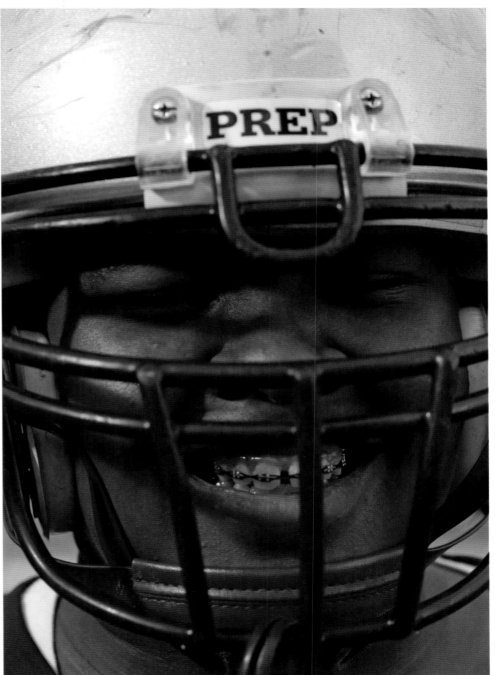

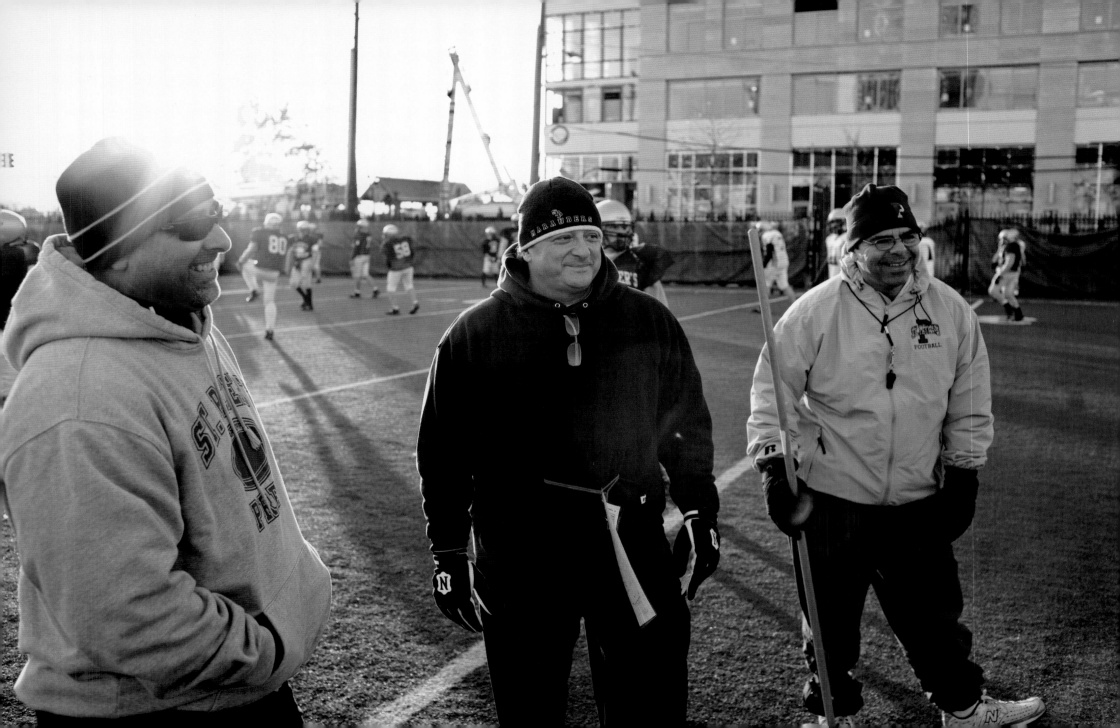

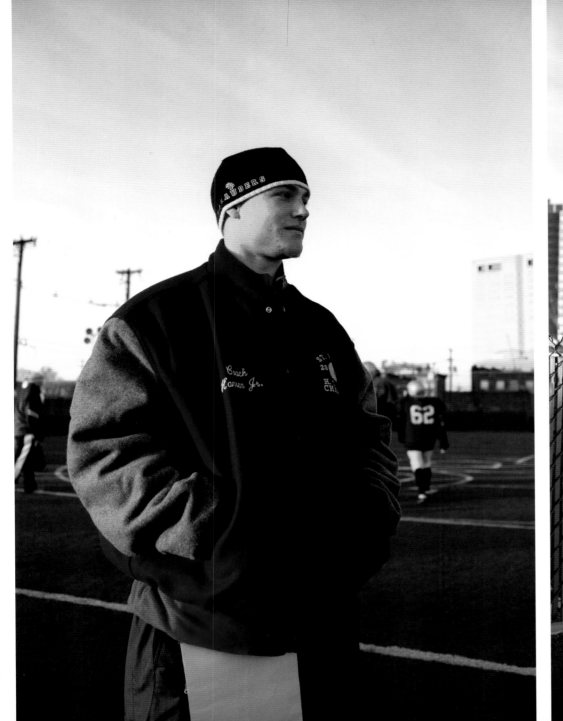
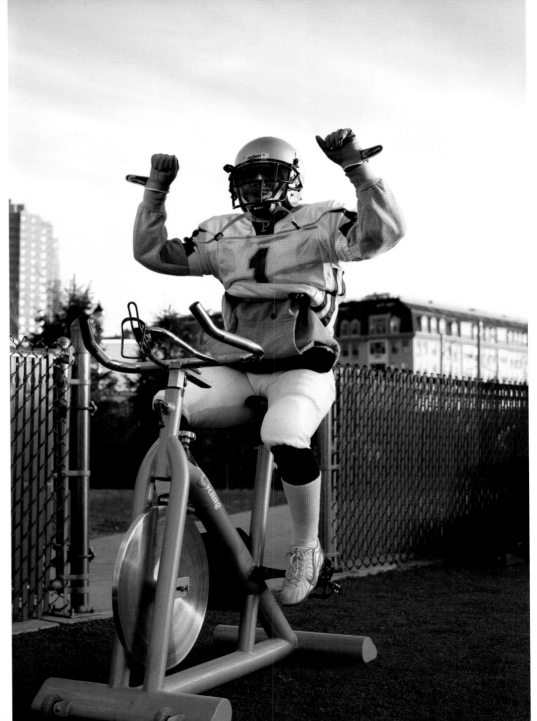

What It Means To Be A Marauder

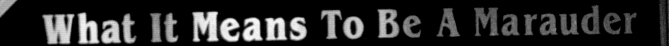

We believe in the value of hard work, of knowing that our reward is who we are and what we are part of...

We carry with us a conviction; one that is reinforced by 125 years of glory, of men striving to represent our honor. We carry this conviction with a respect and understanding of our history and appreciation for the power of tradition...

We are committed to the presence of those who've come before us and to the spirit of those who will follow. Our actions speak for all who have graced the fields of battle...

We are of strong character & discipline, built to endure the greatest ____. Our will is steeped in the knowledge that we are not

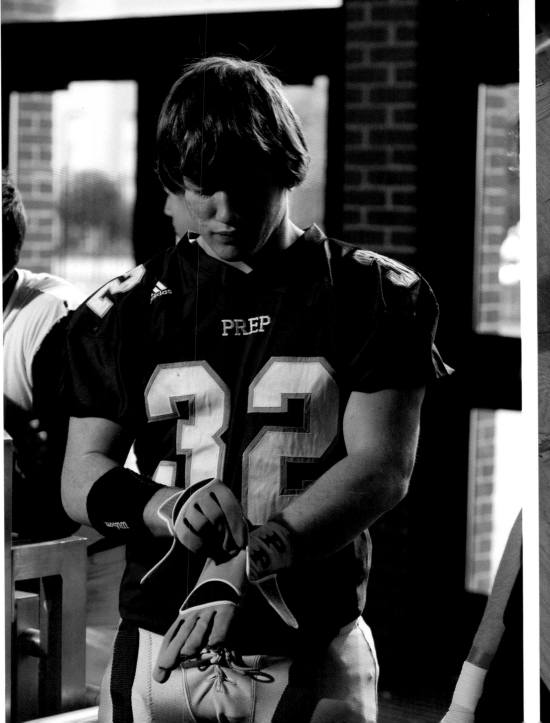
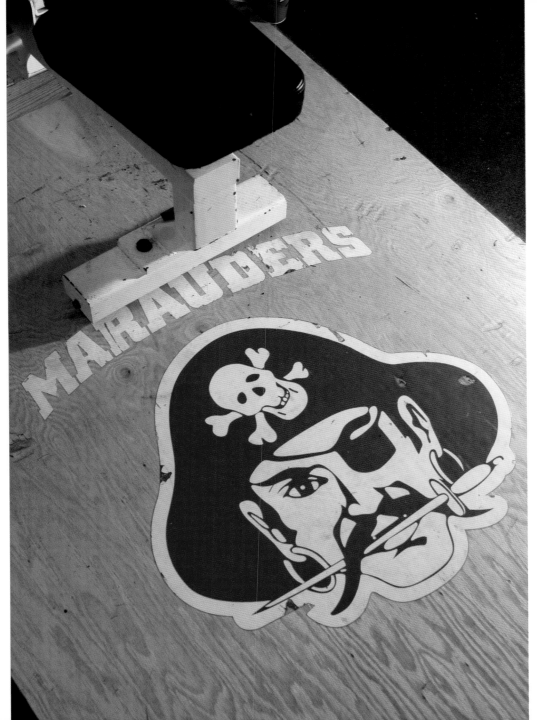

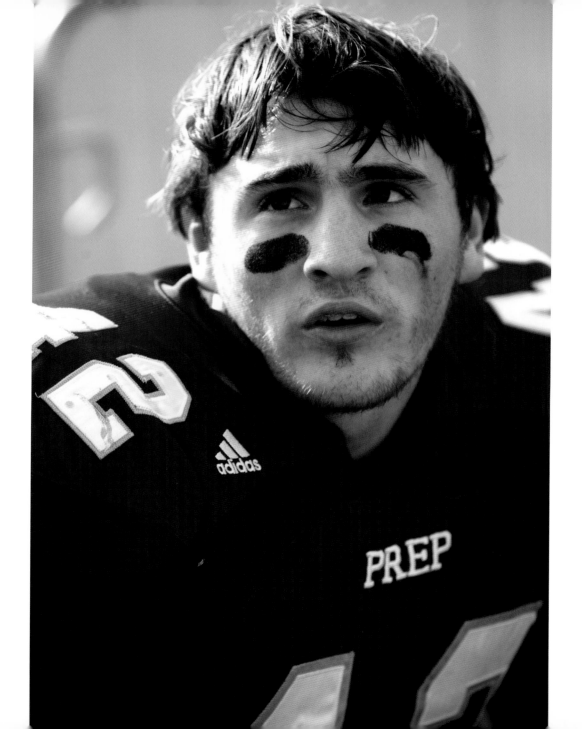

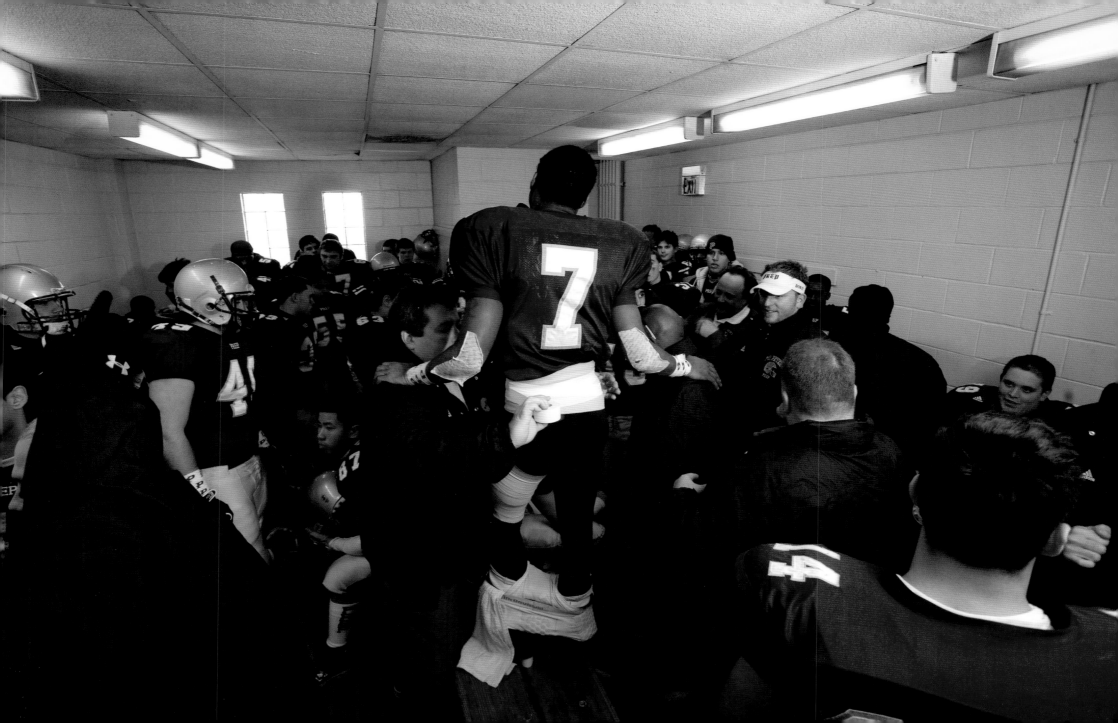

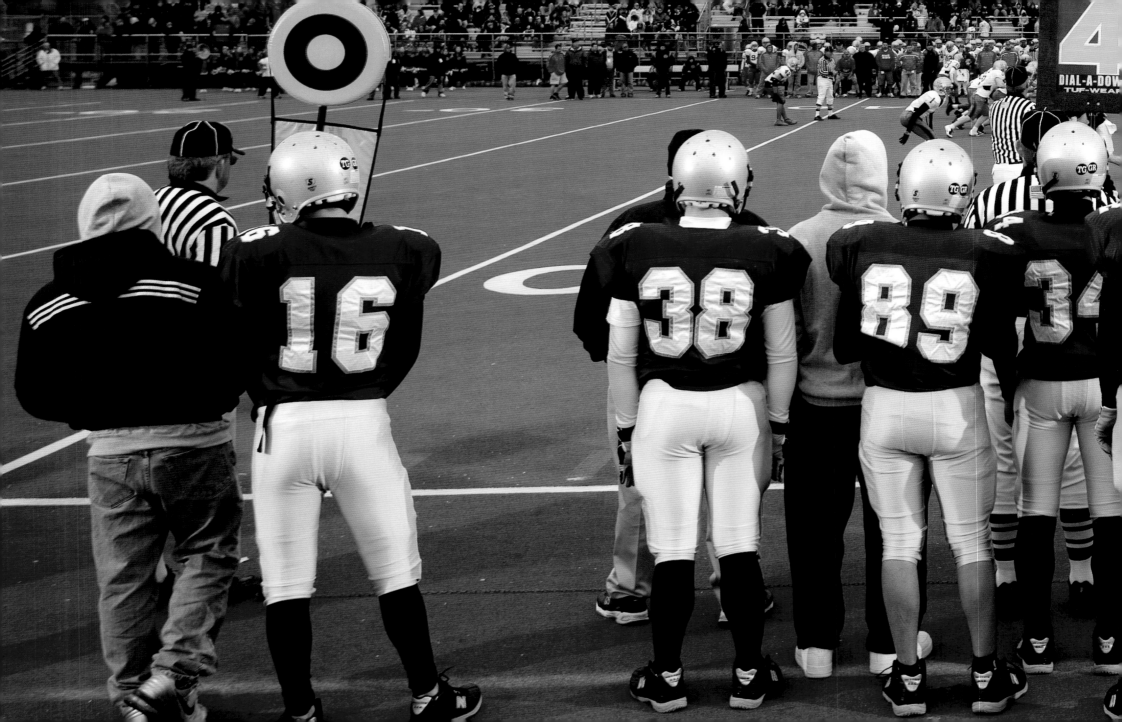

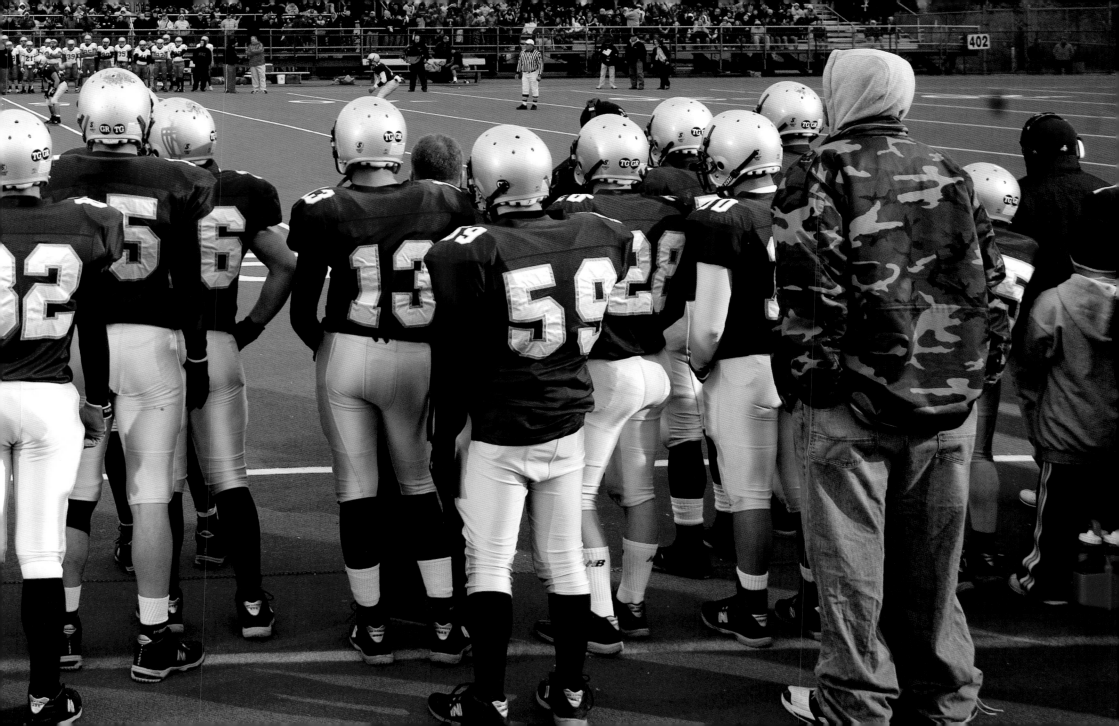

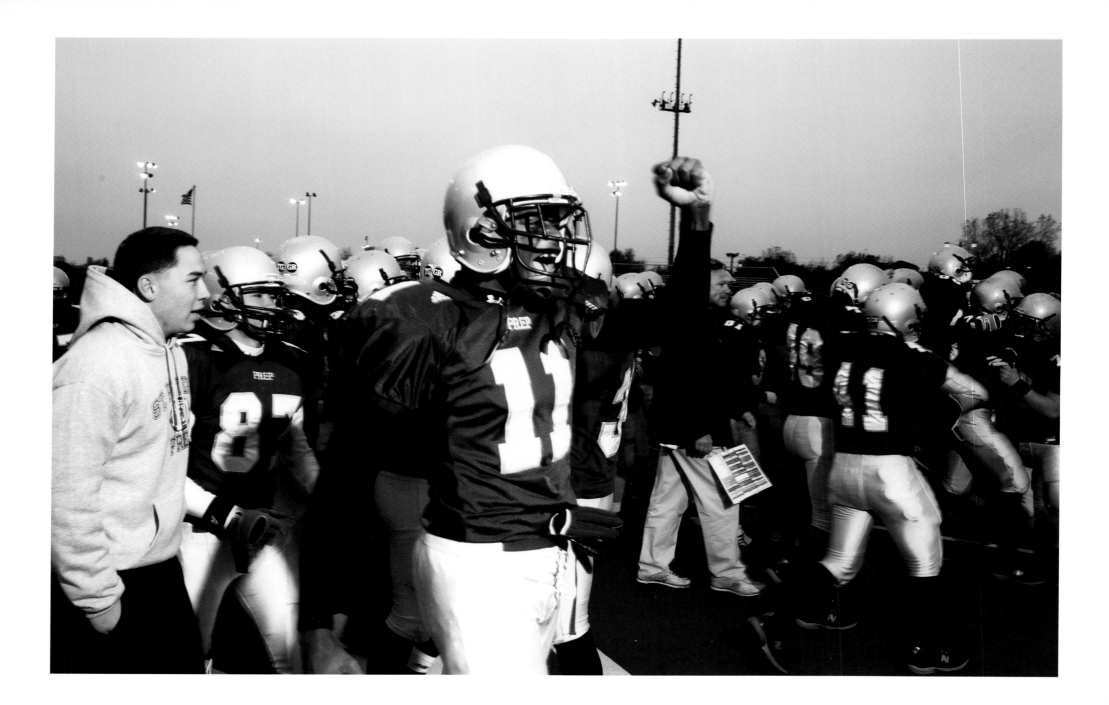

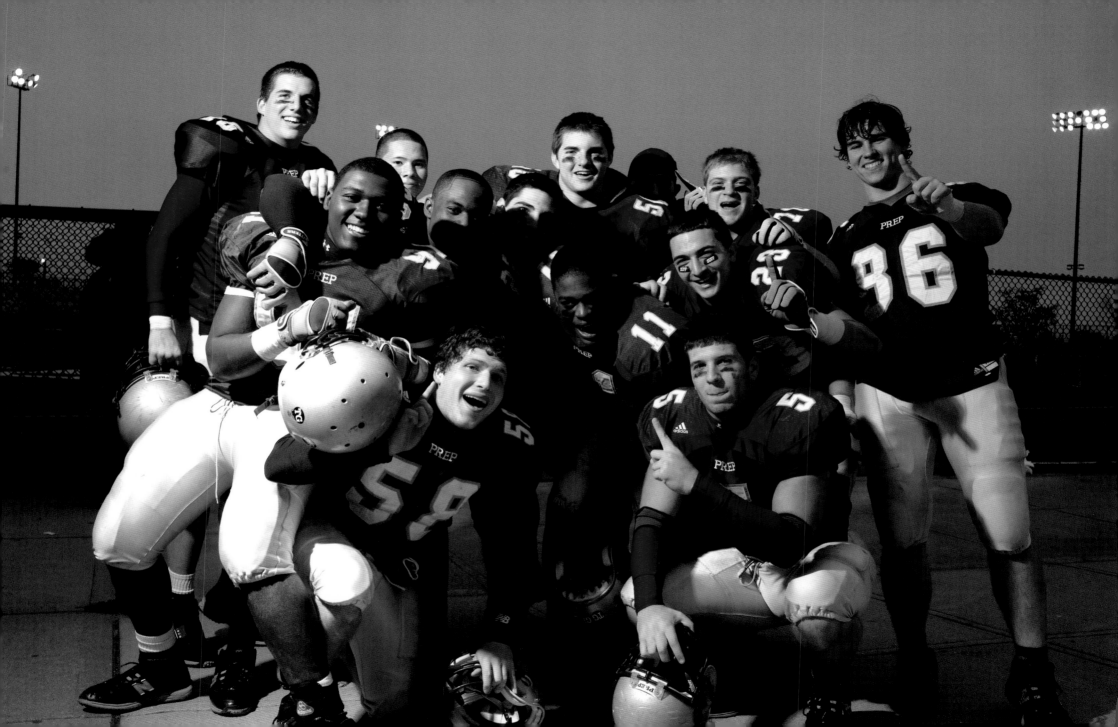

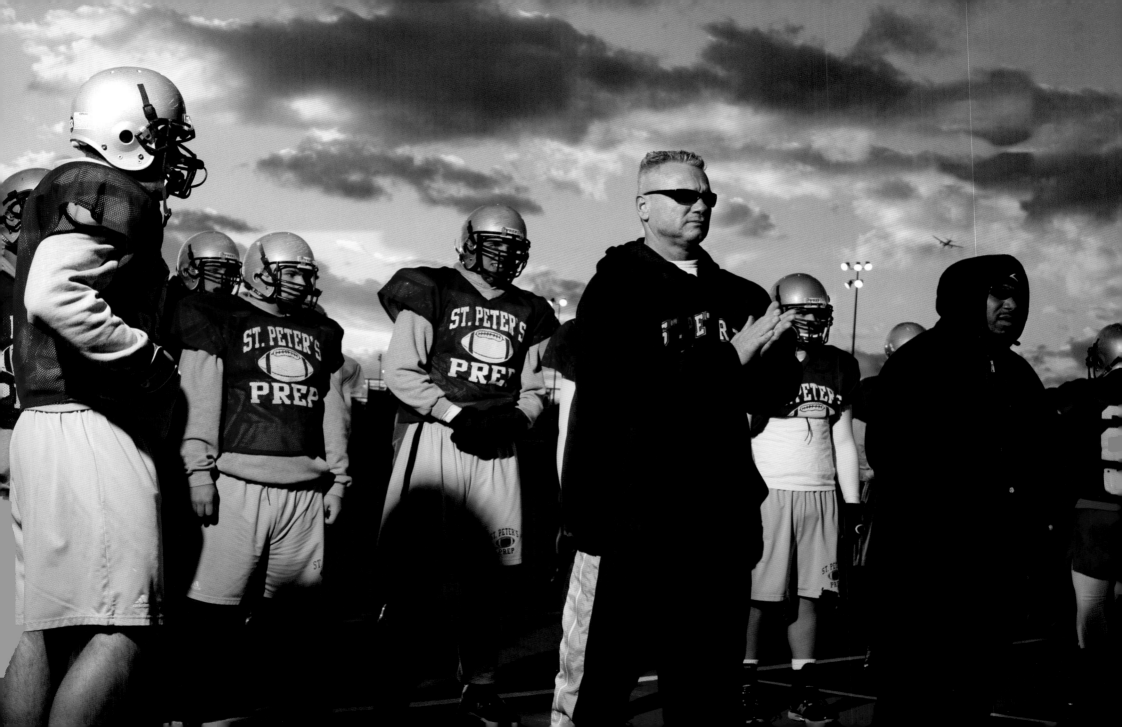

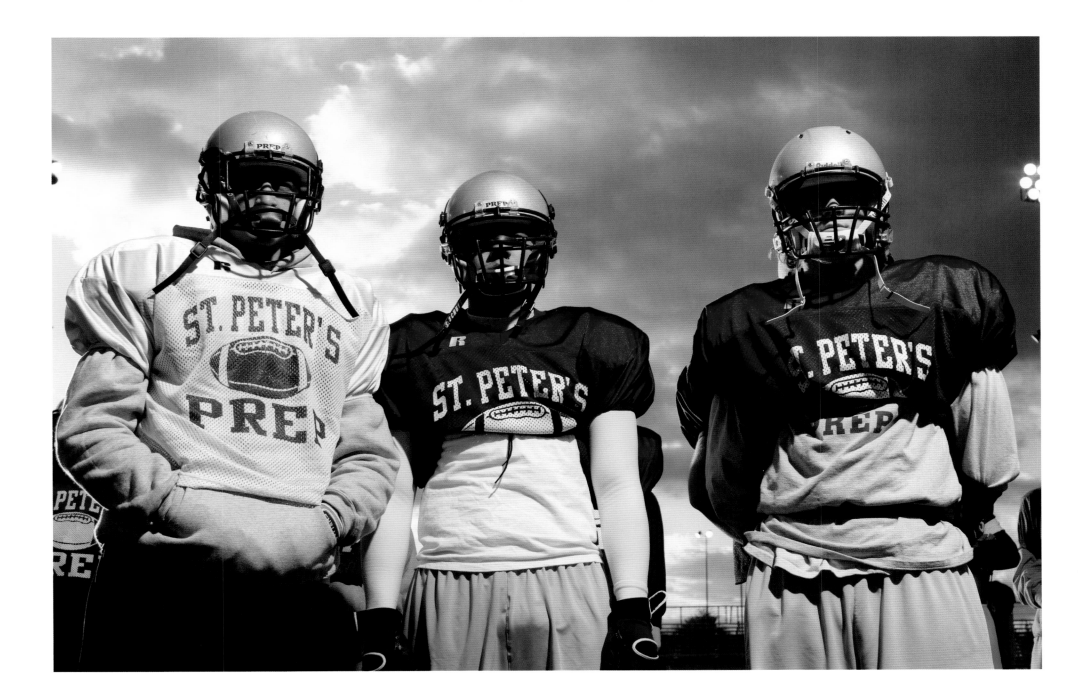

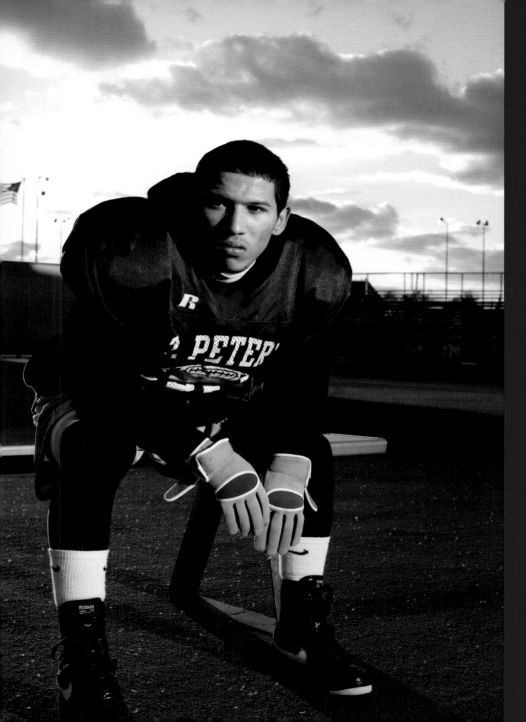

COMMIT YOURSELF TO SOMETHING, TO A CAUSE THAT IS

IGHT AND THAT WILL DEVELOP A FIRE IN YOU TO SUCCEED

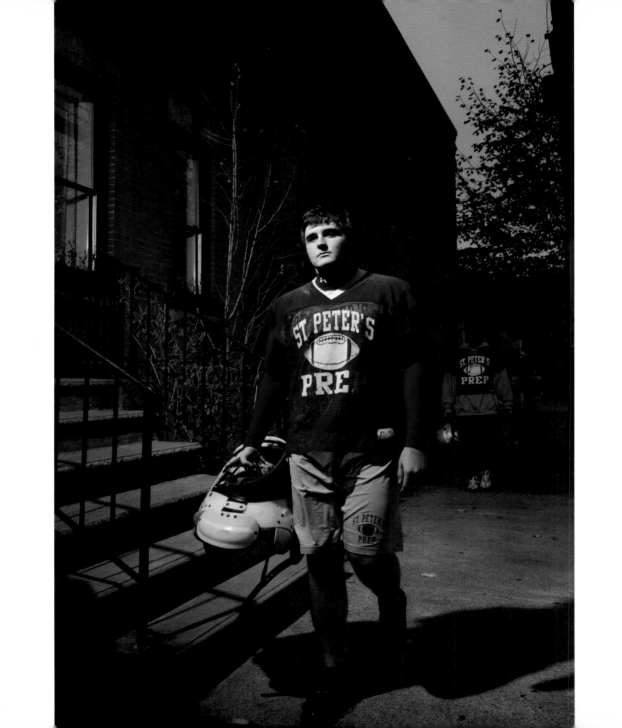

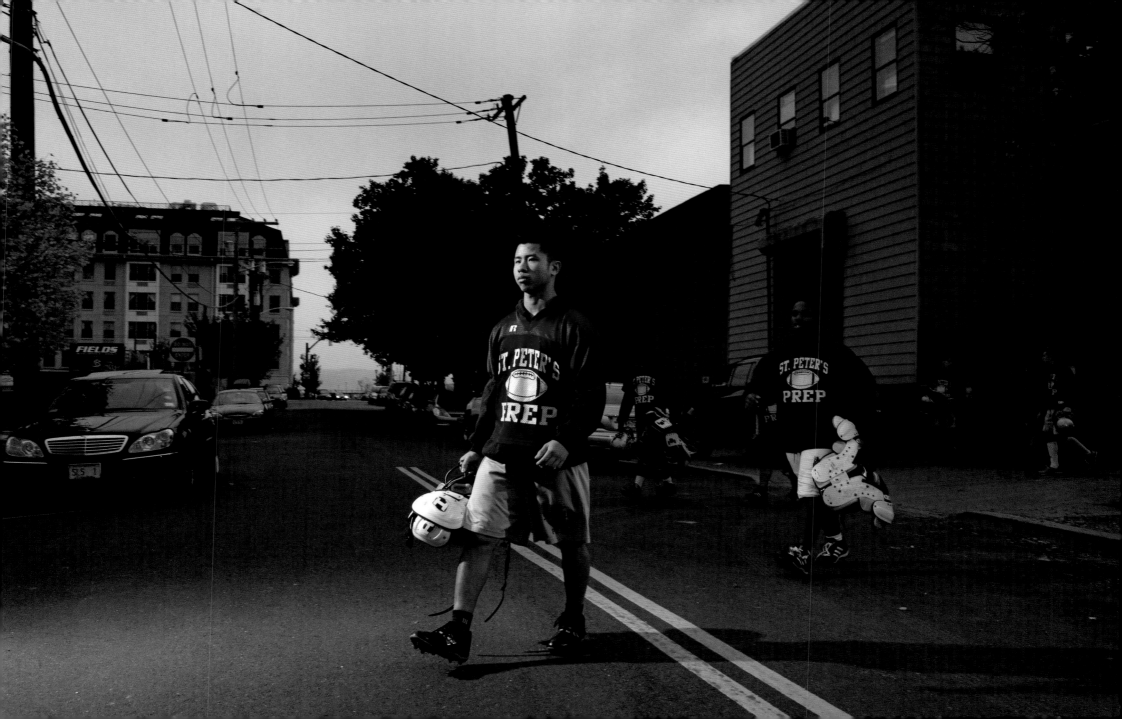

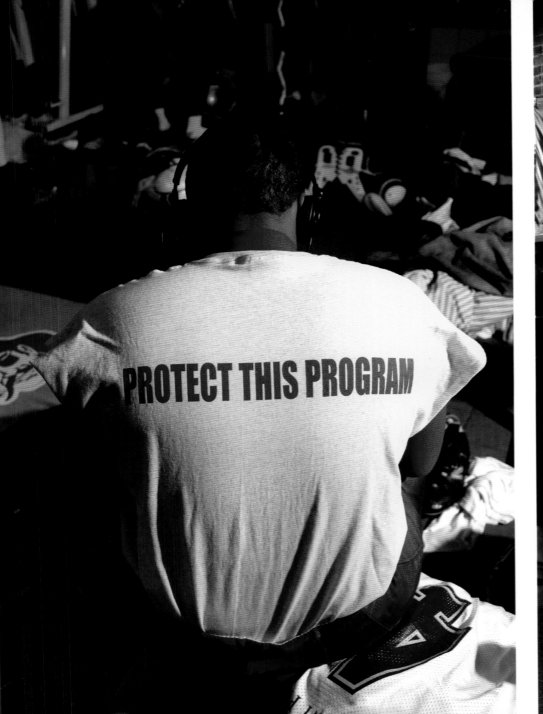
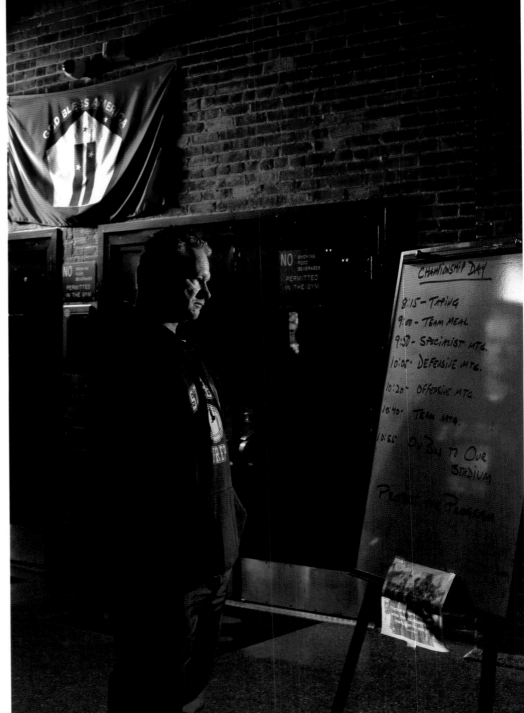

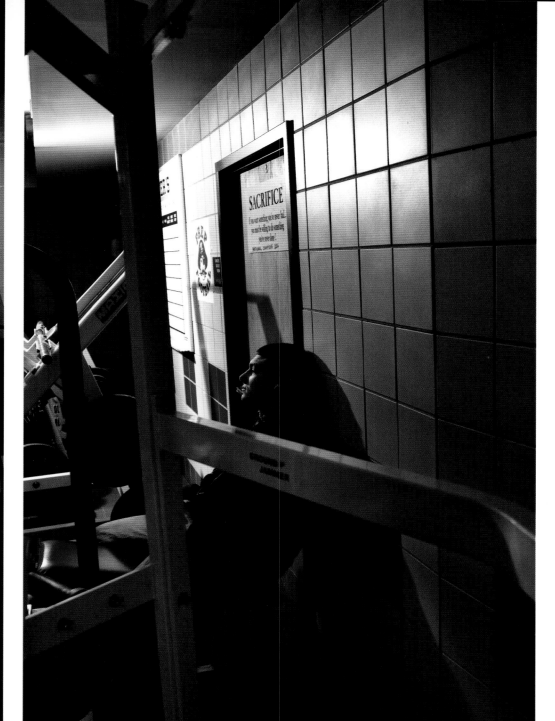

PREP FOOTBALL
CHAMPIONS
STATE 1933 1945 1946 1947 1948
1949 1951 1952 1953 1955 1956
1952 1958 1989 1994 2005
STATE FINALIST 1985 1986 1995
UNDEFEATED 1958 1994 2005

PREP FOOTBALL
CHAMPIONS
AMERICAN LEGION BOWL
1946

SACRIFICE

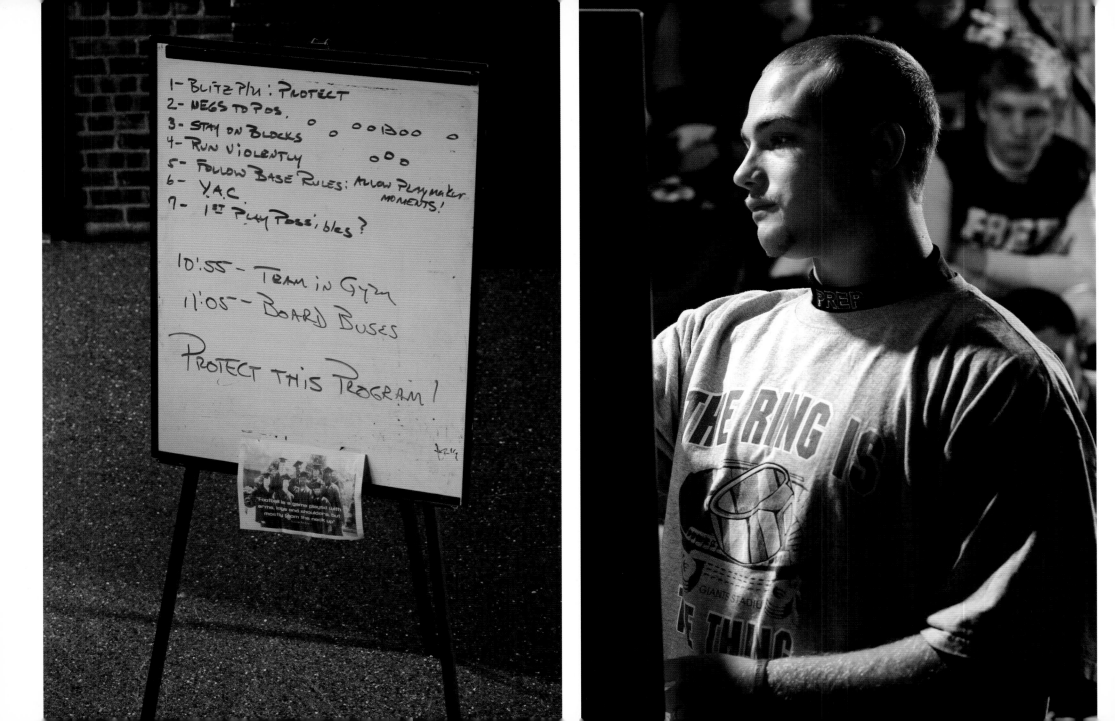

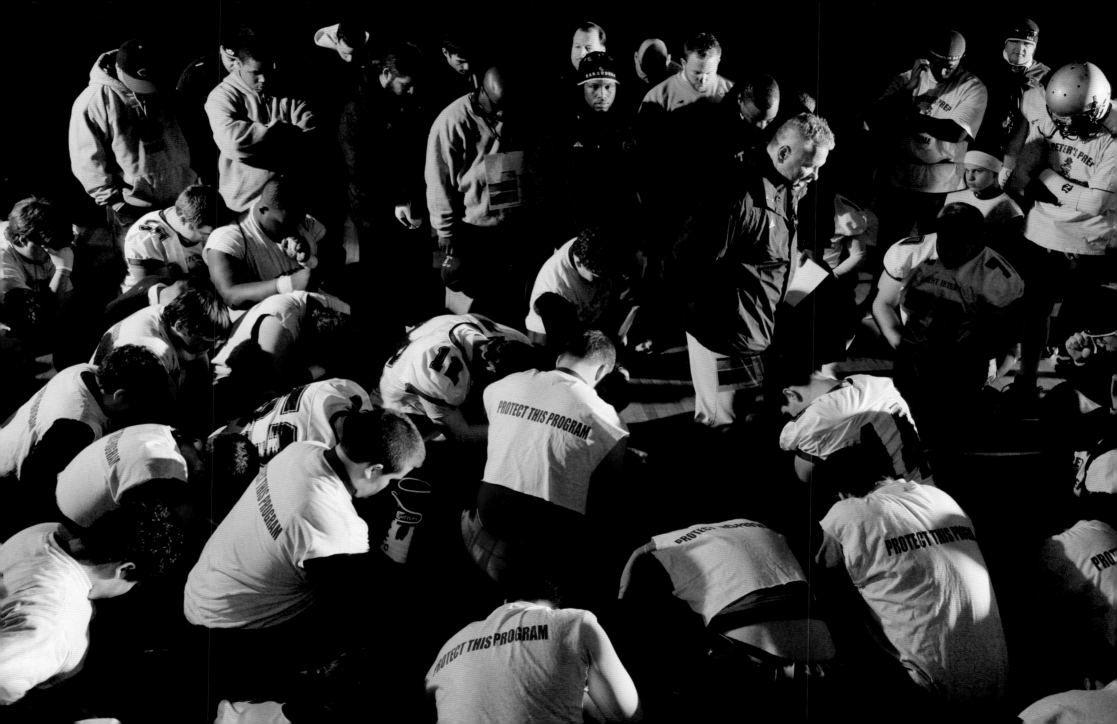

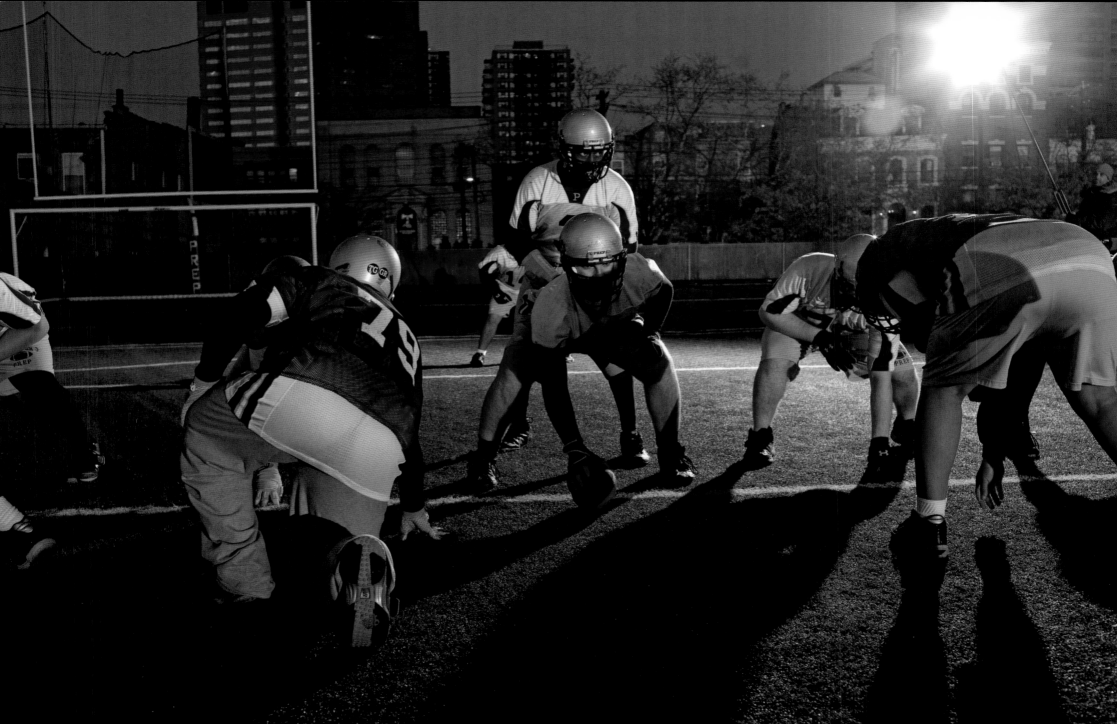

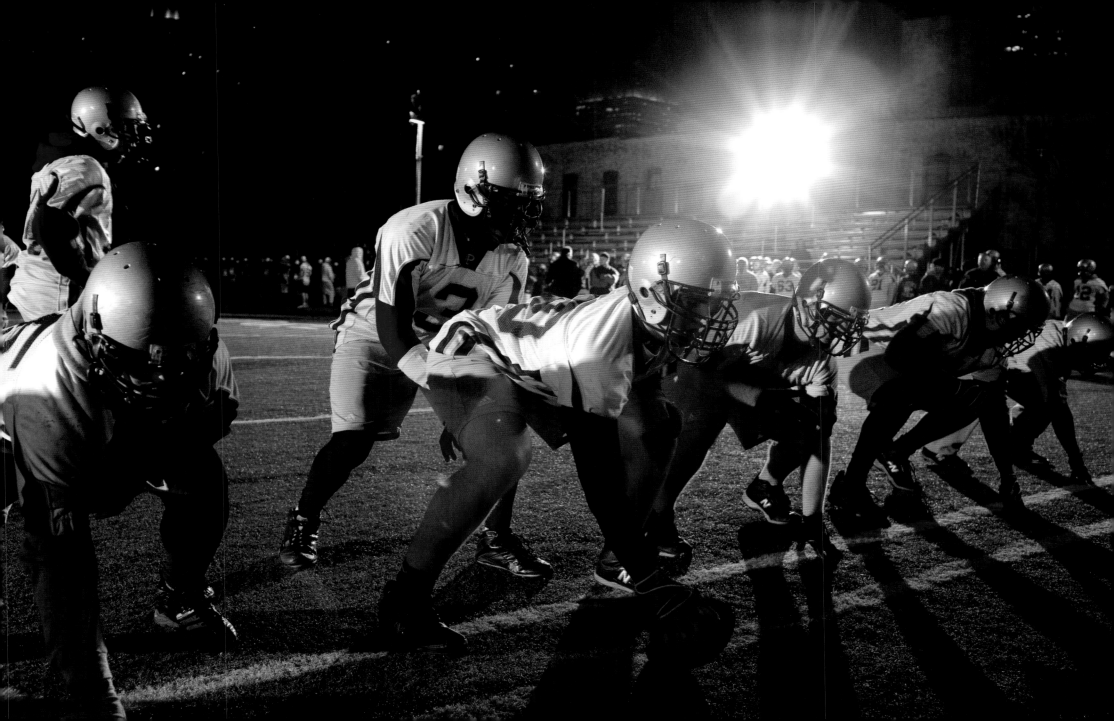

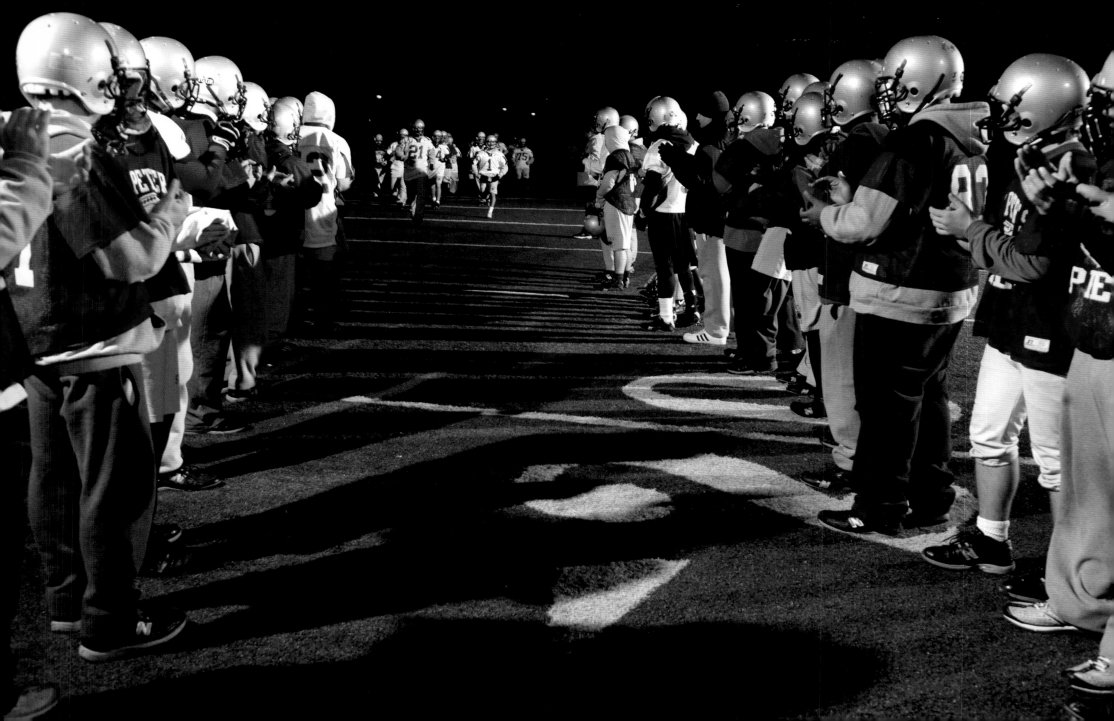

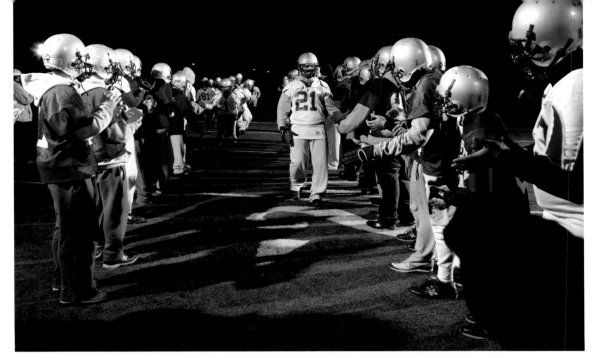
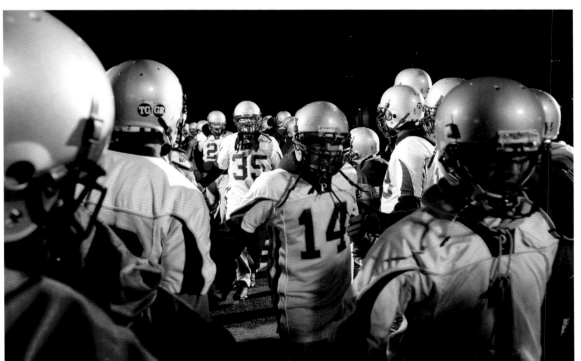

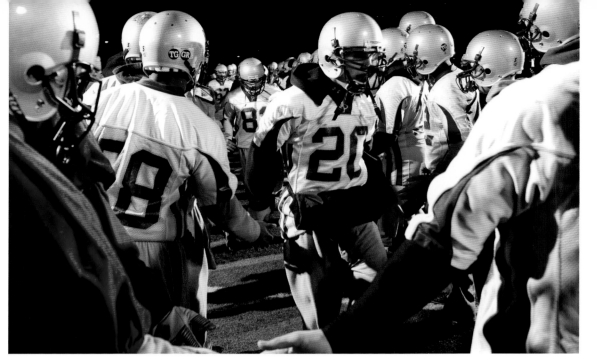

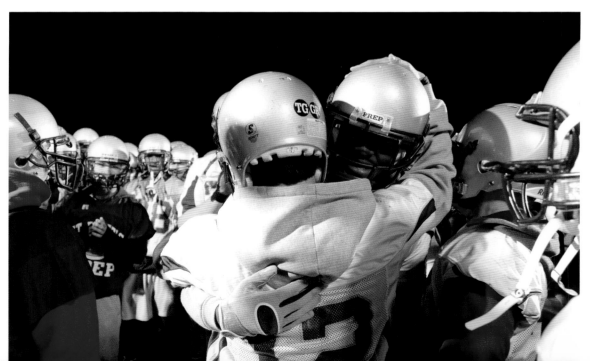

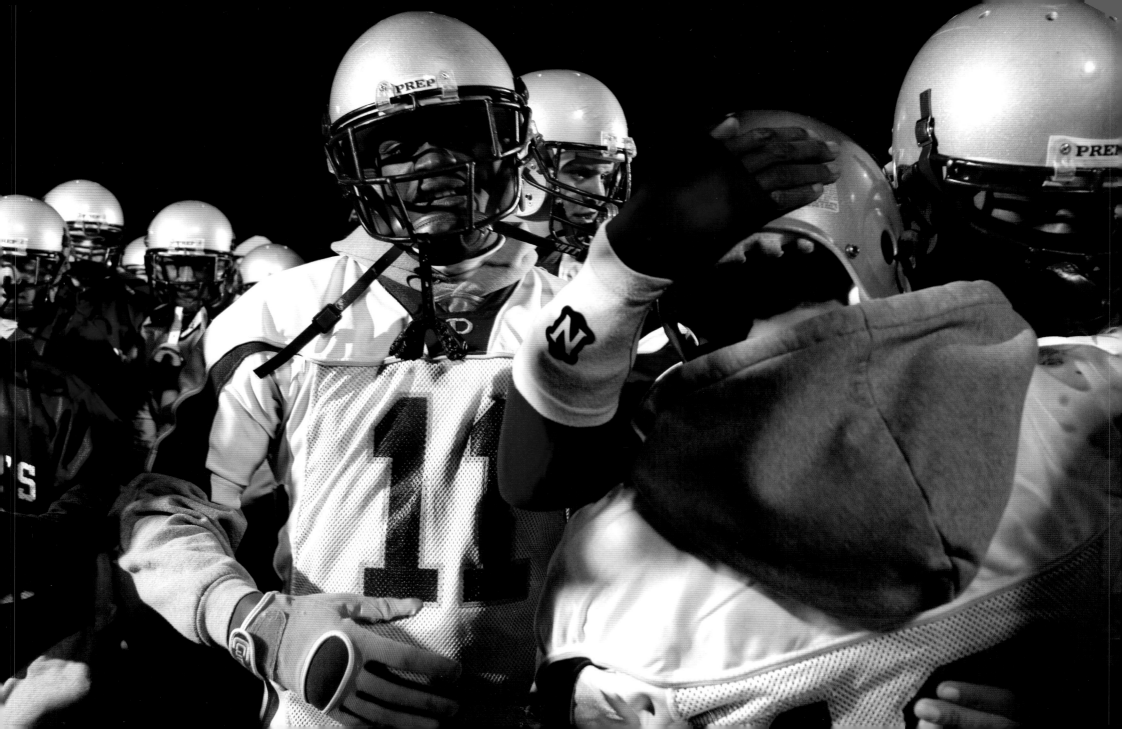

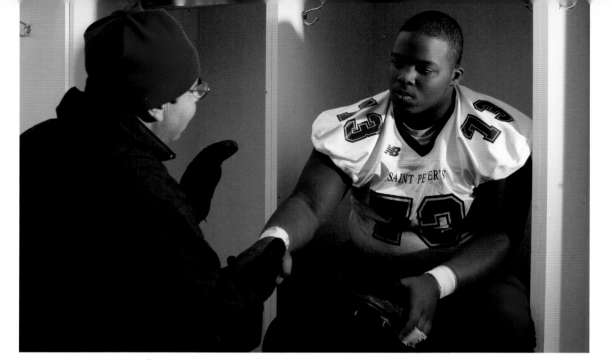
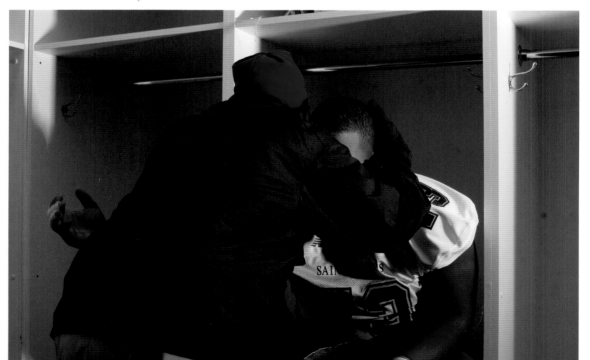

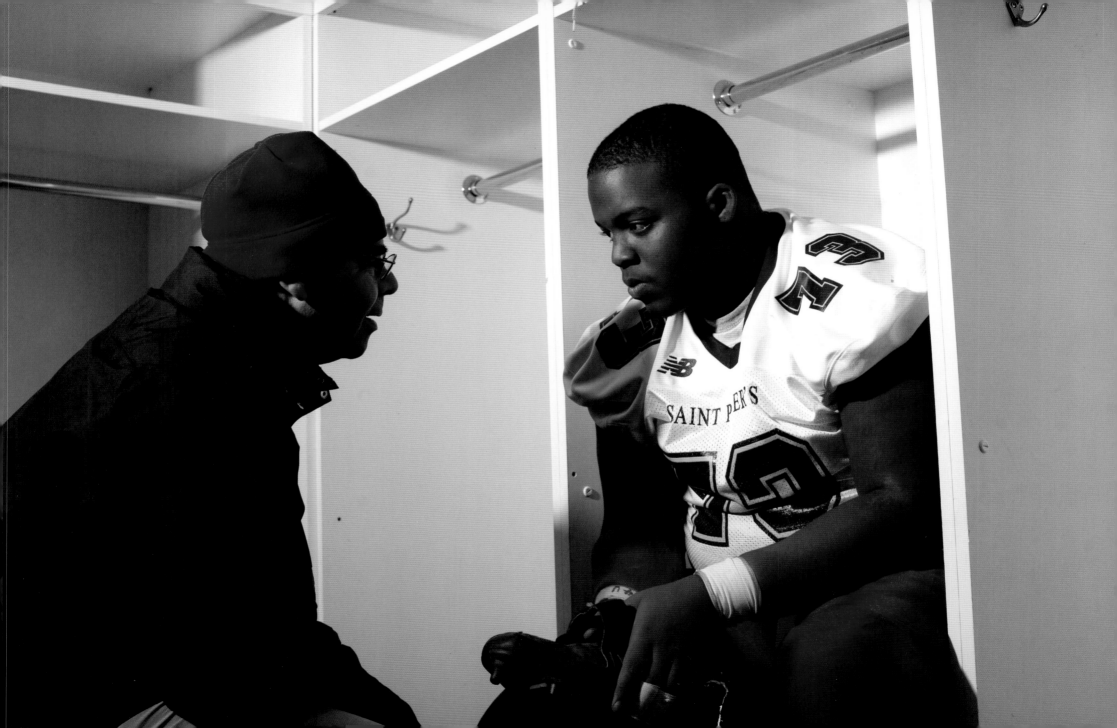

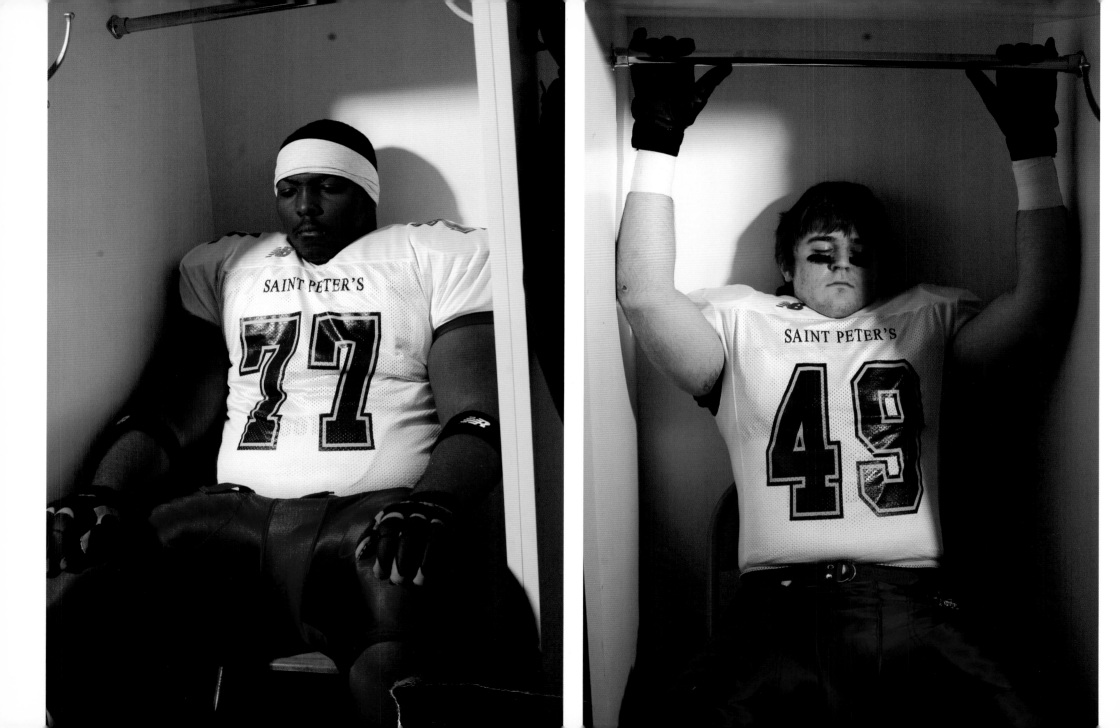

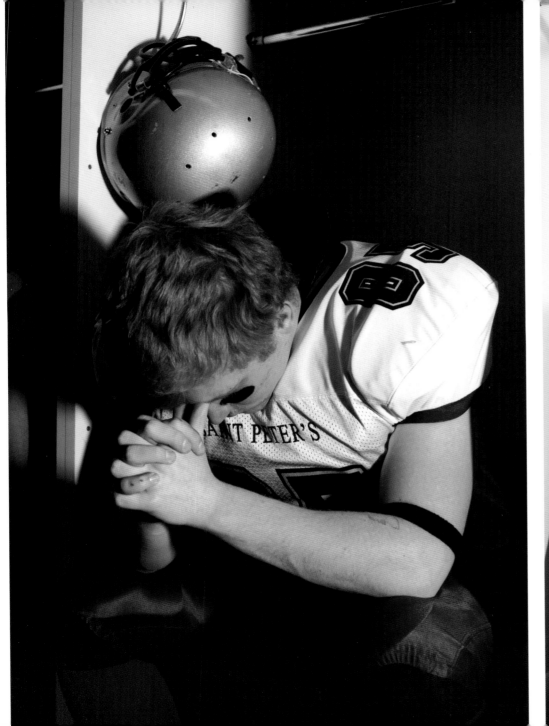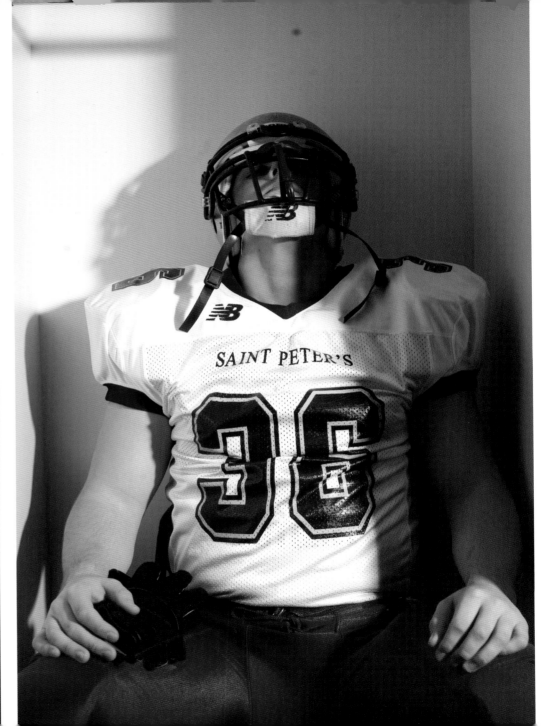

CHARACTER IS WHAT YOU DO

WHEN NOBODY IS WATCHING

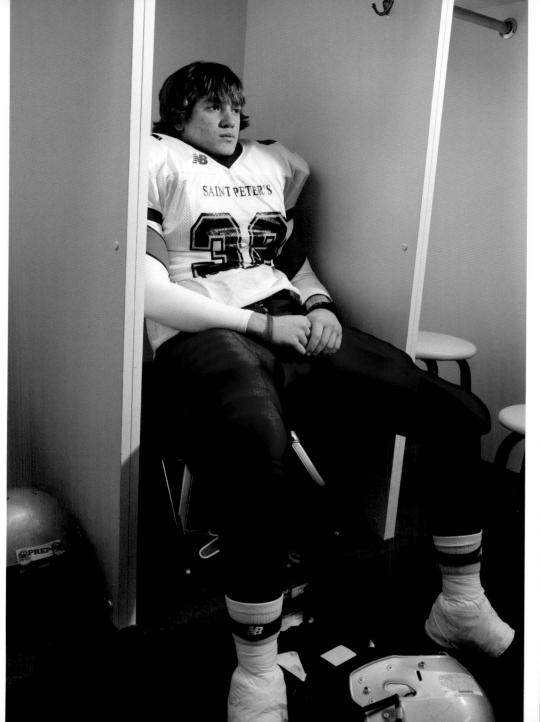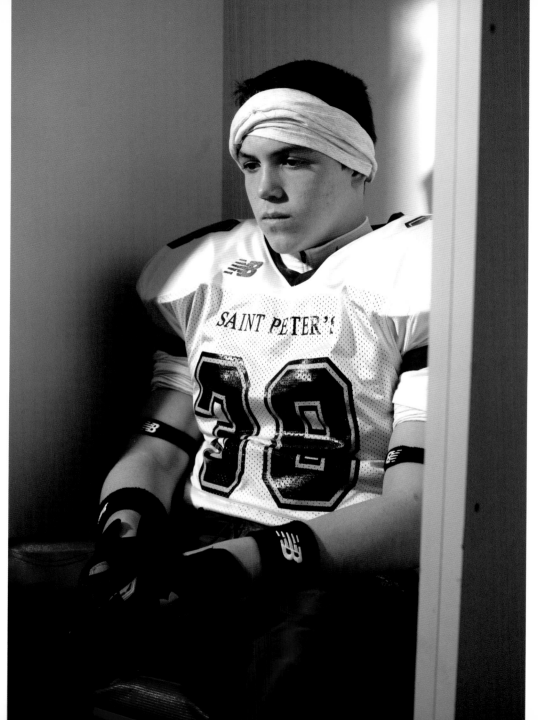

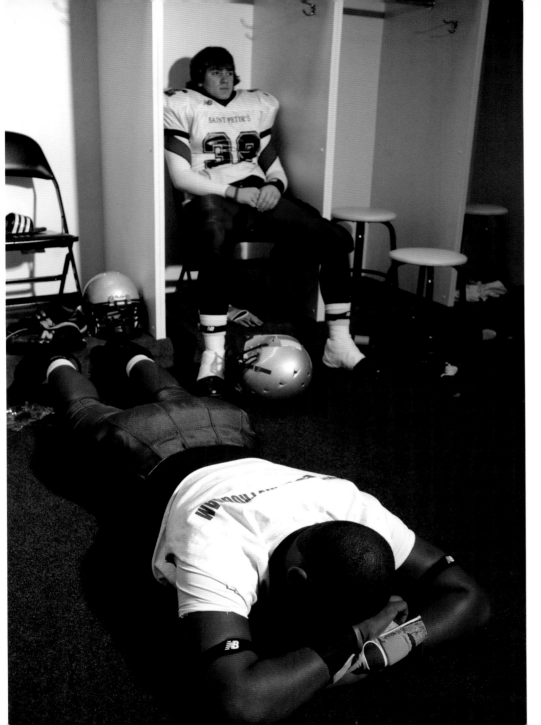
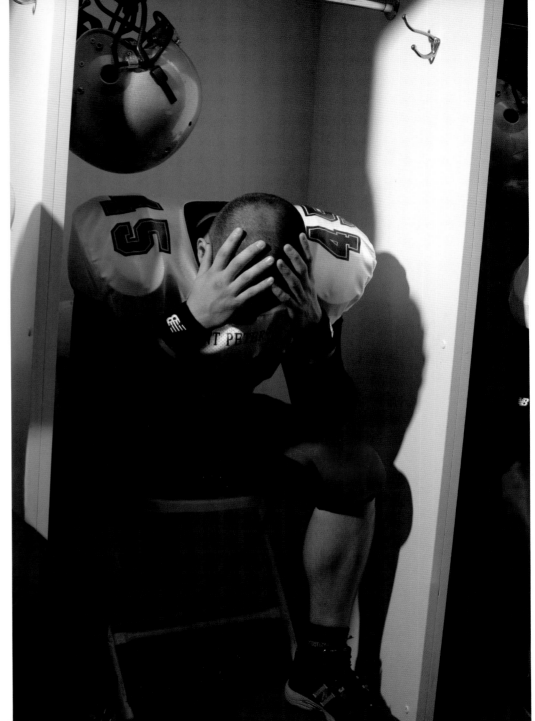

STEP OUT, STEP UP, TAKE OWNERSHIP

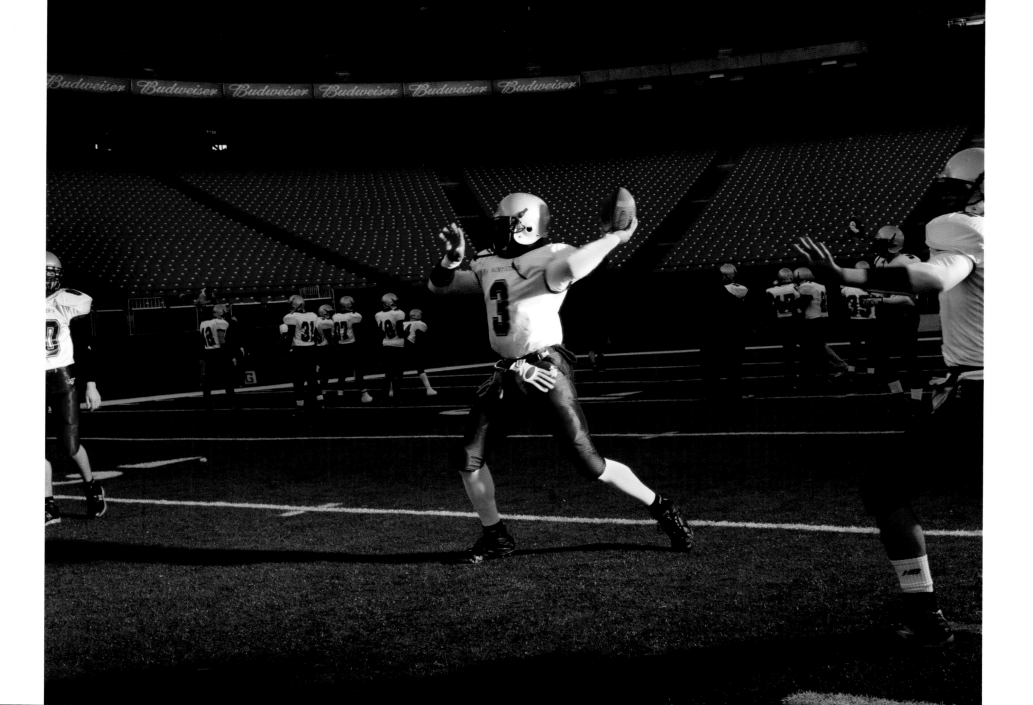

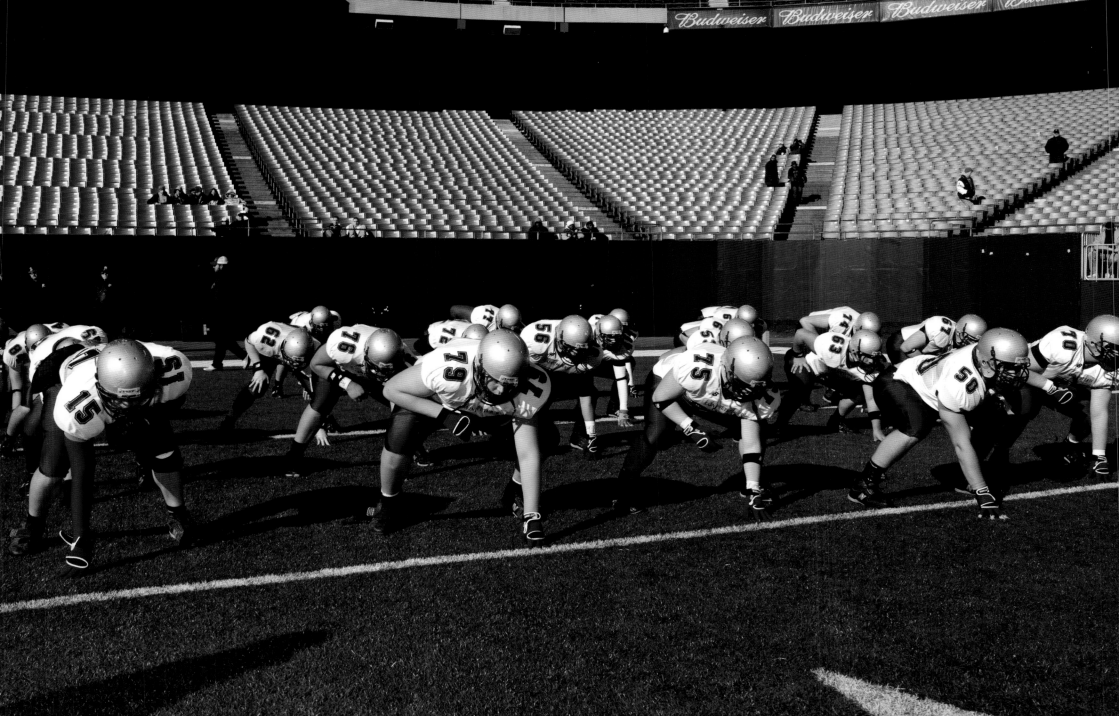

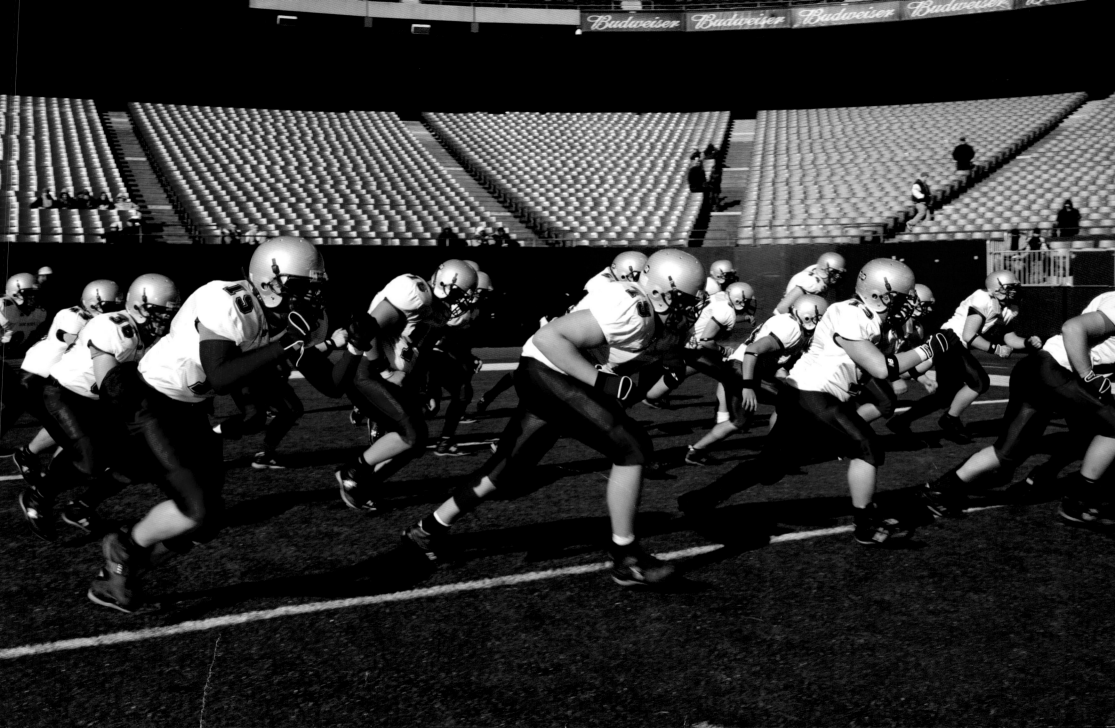

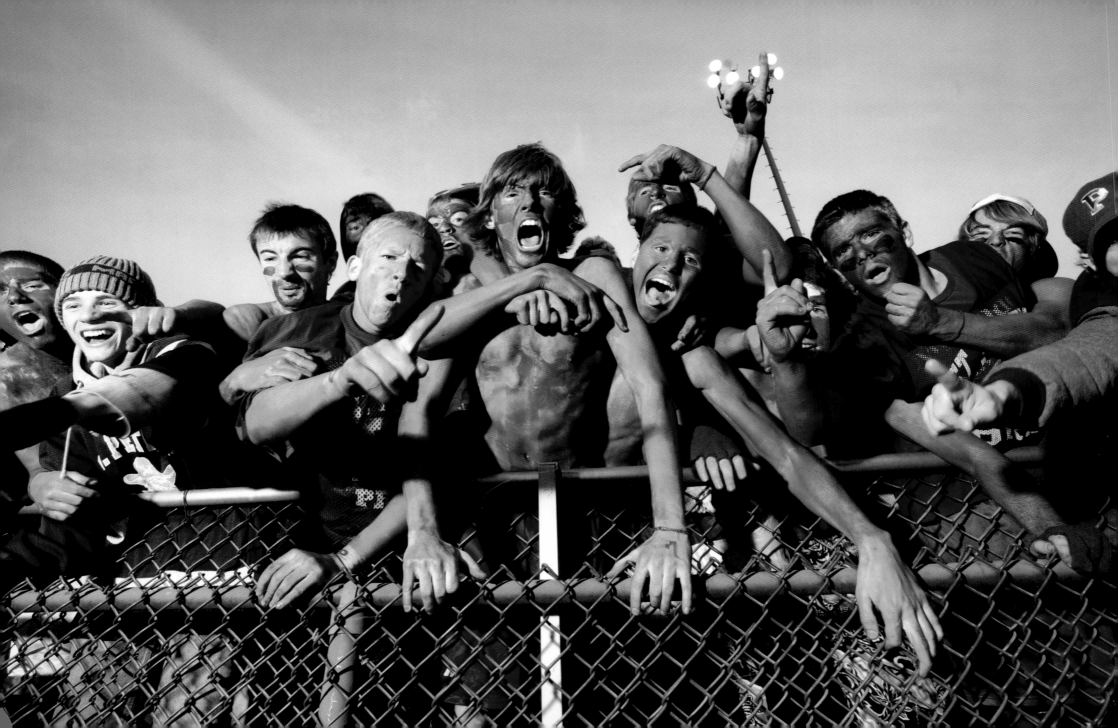

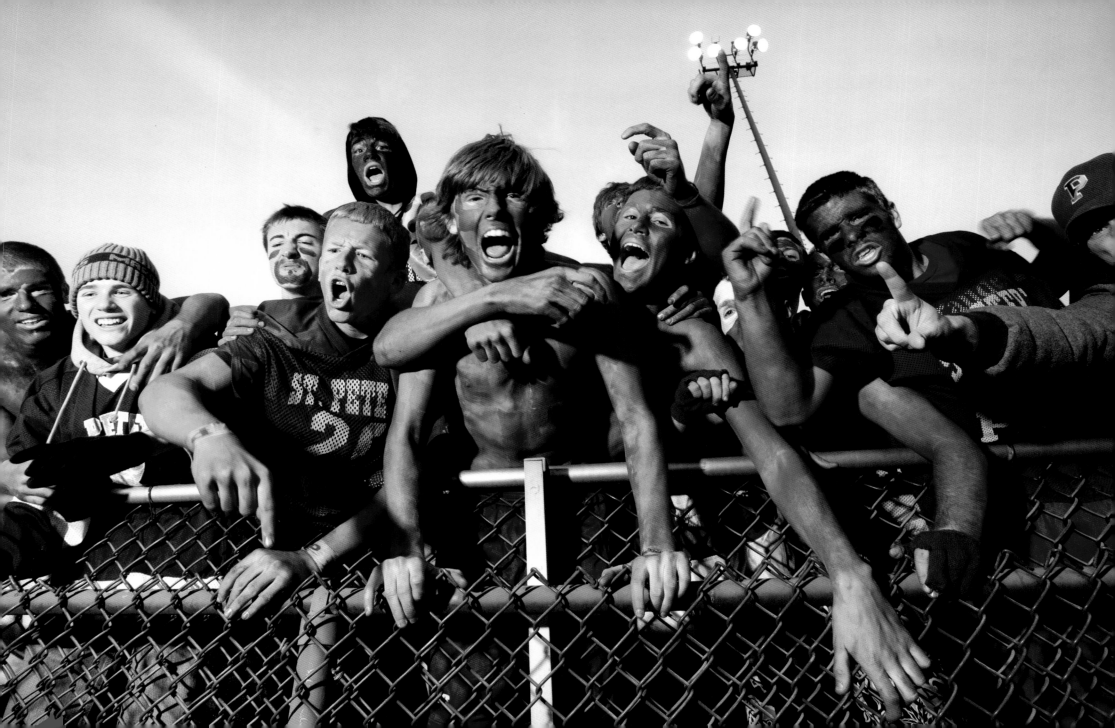

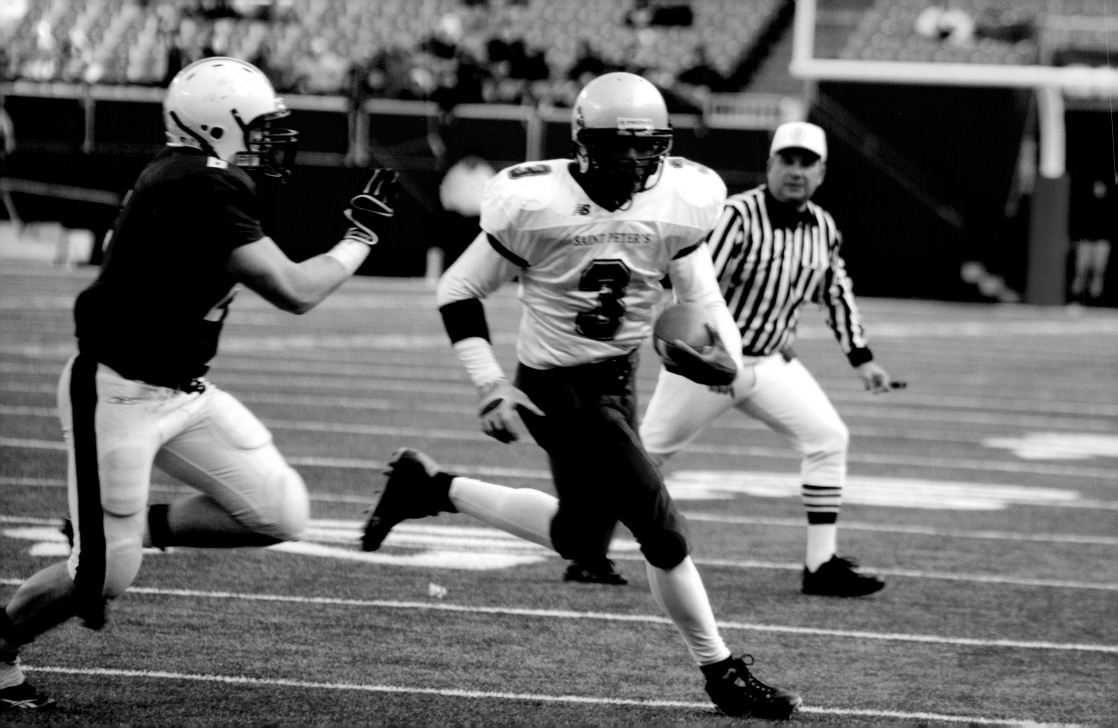

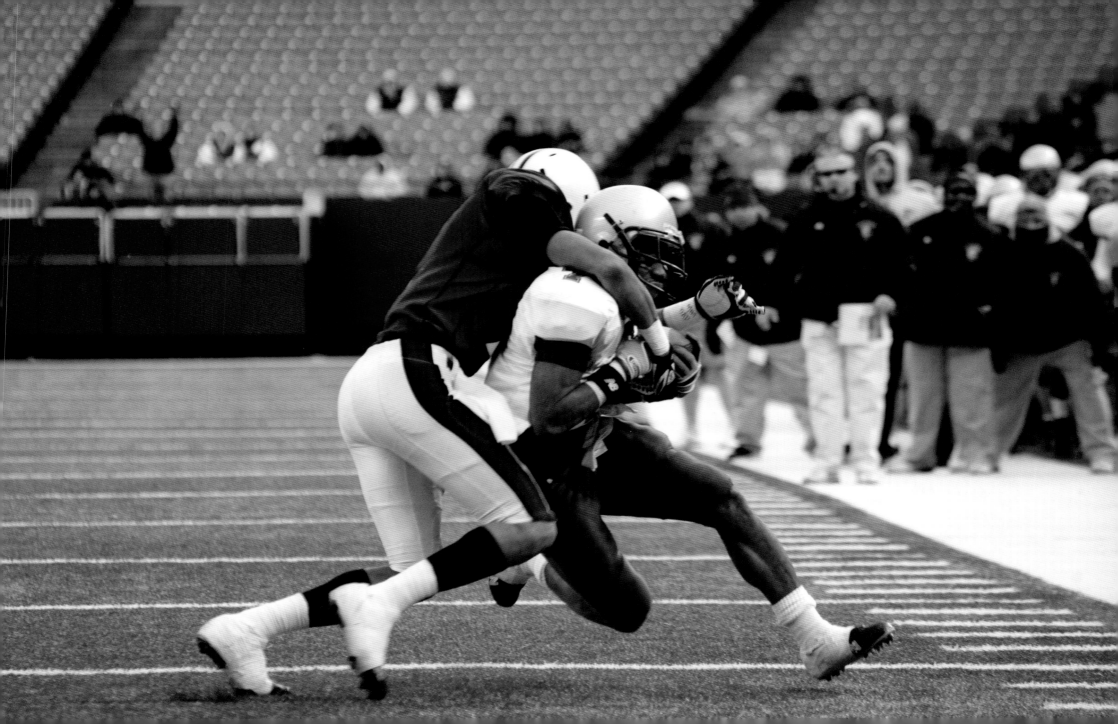

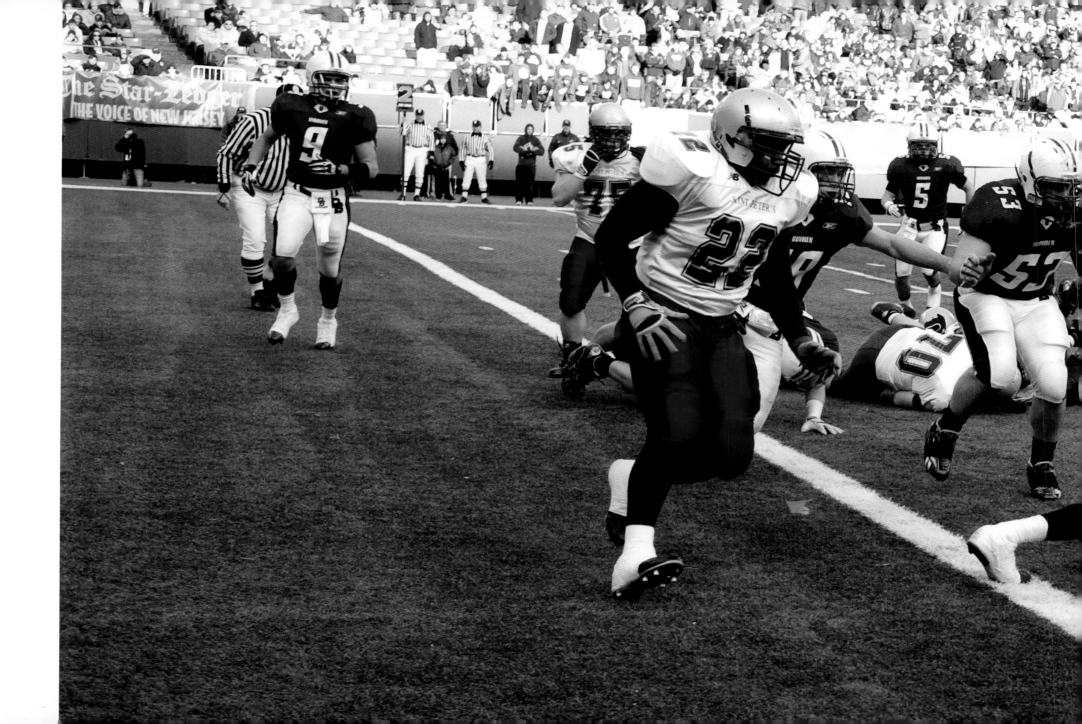

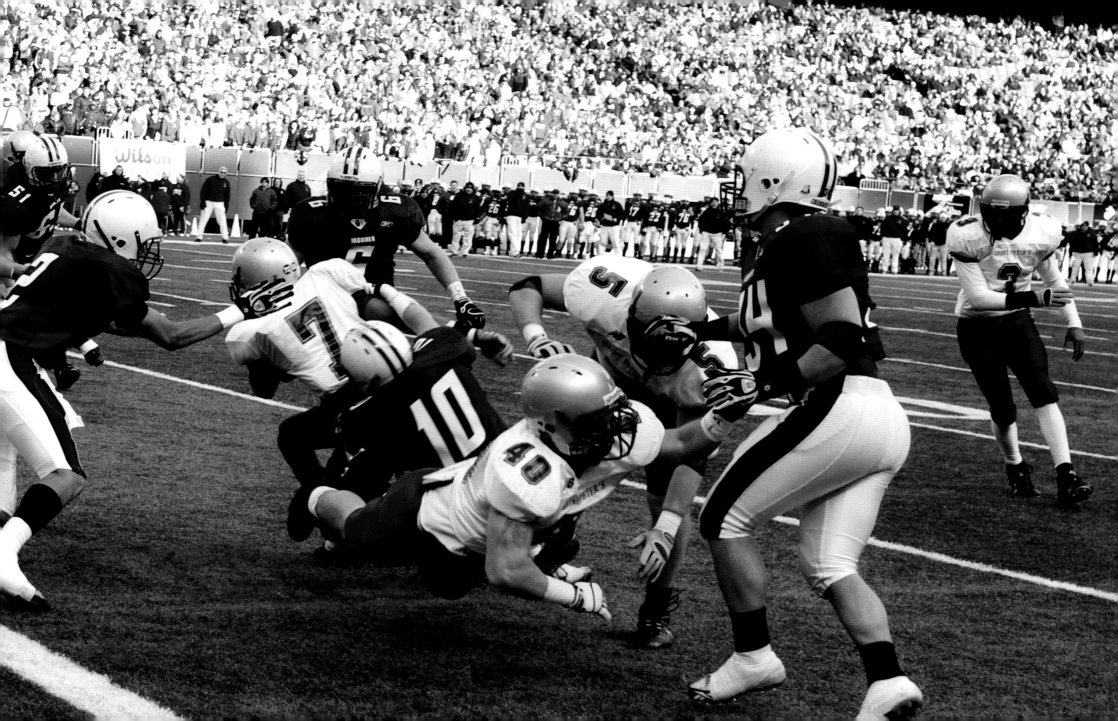

What are you going to do
to put the exclamation point
on who you are in this program?

What are you going to do
to make it right?

THAT IS THE QUESTION.

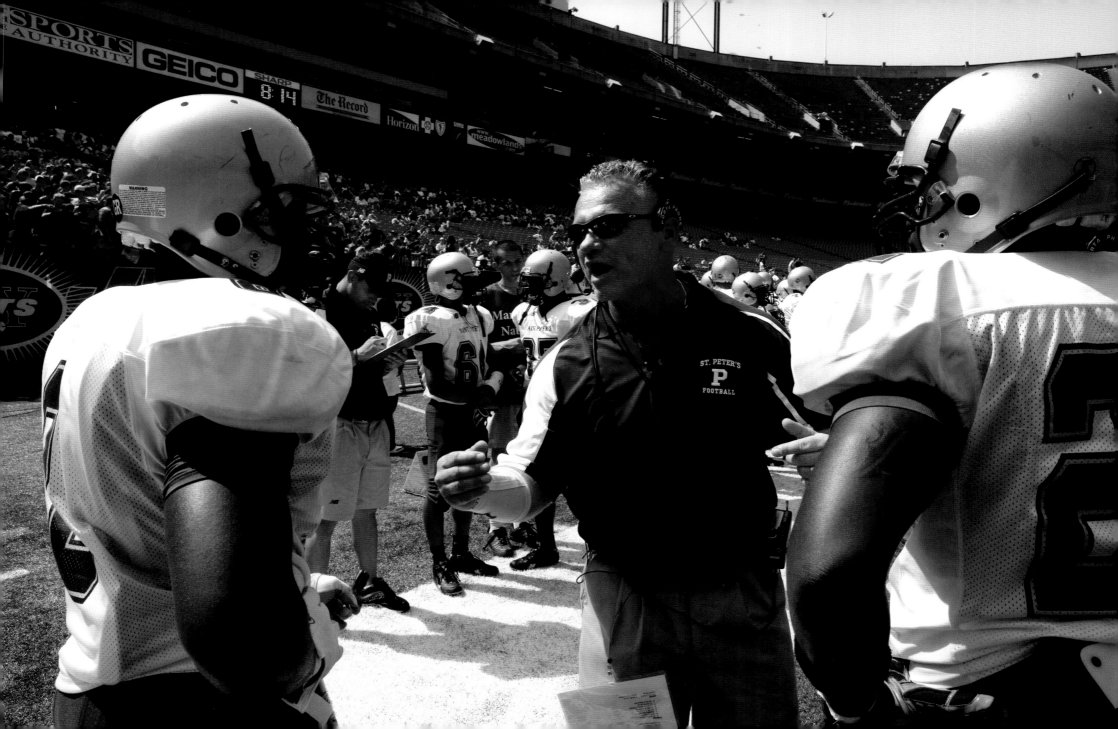

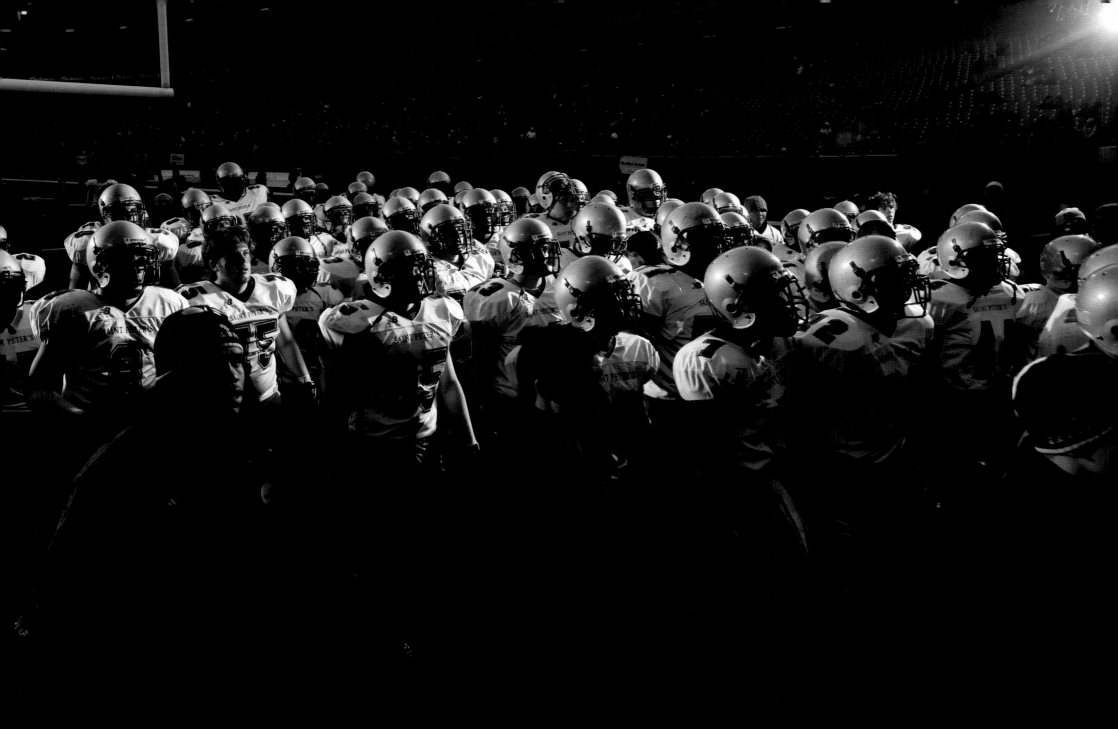

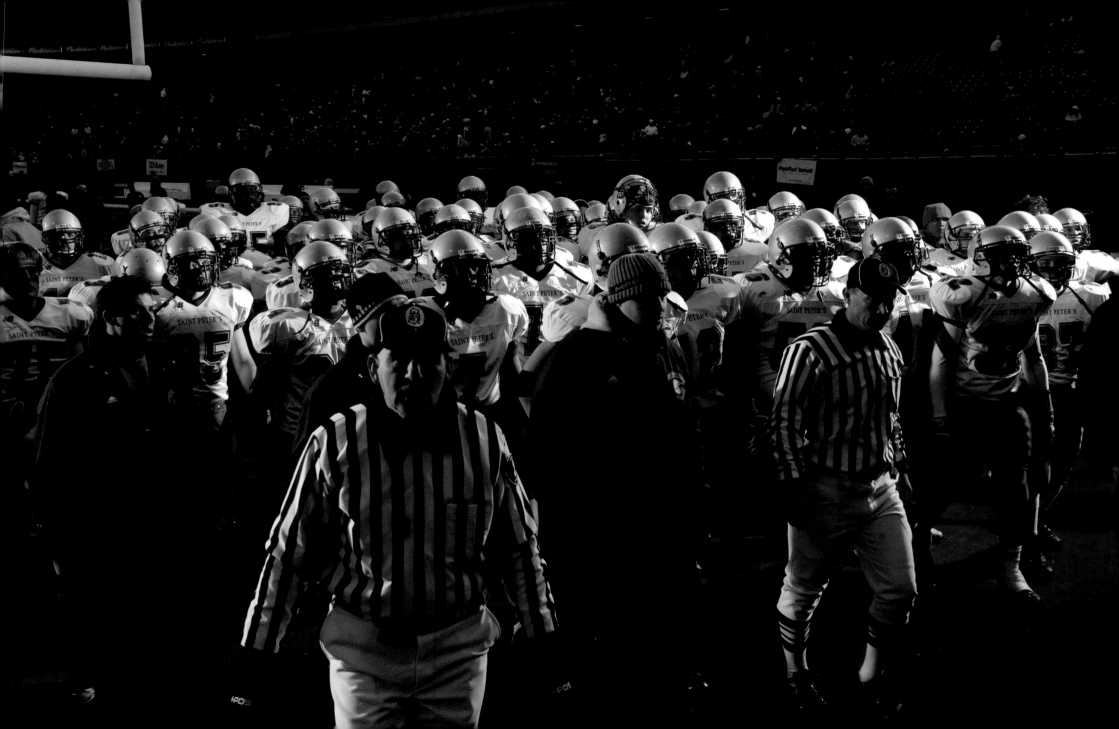

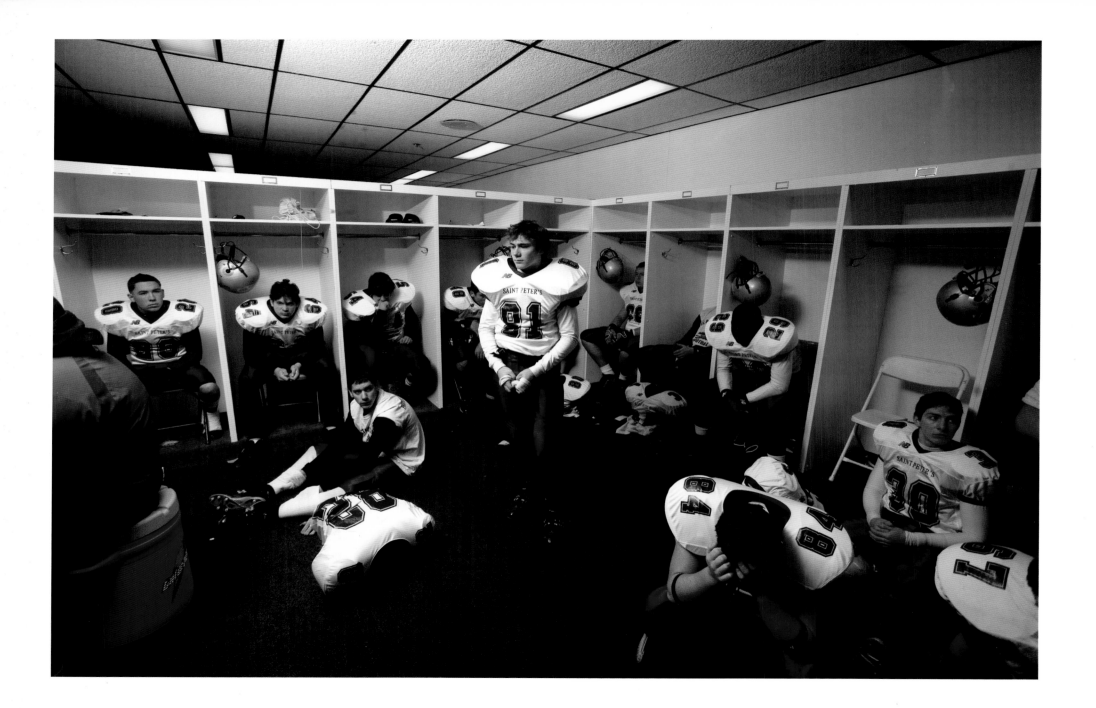

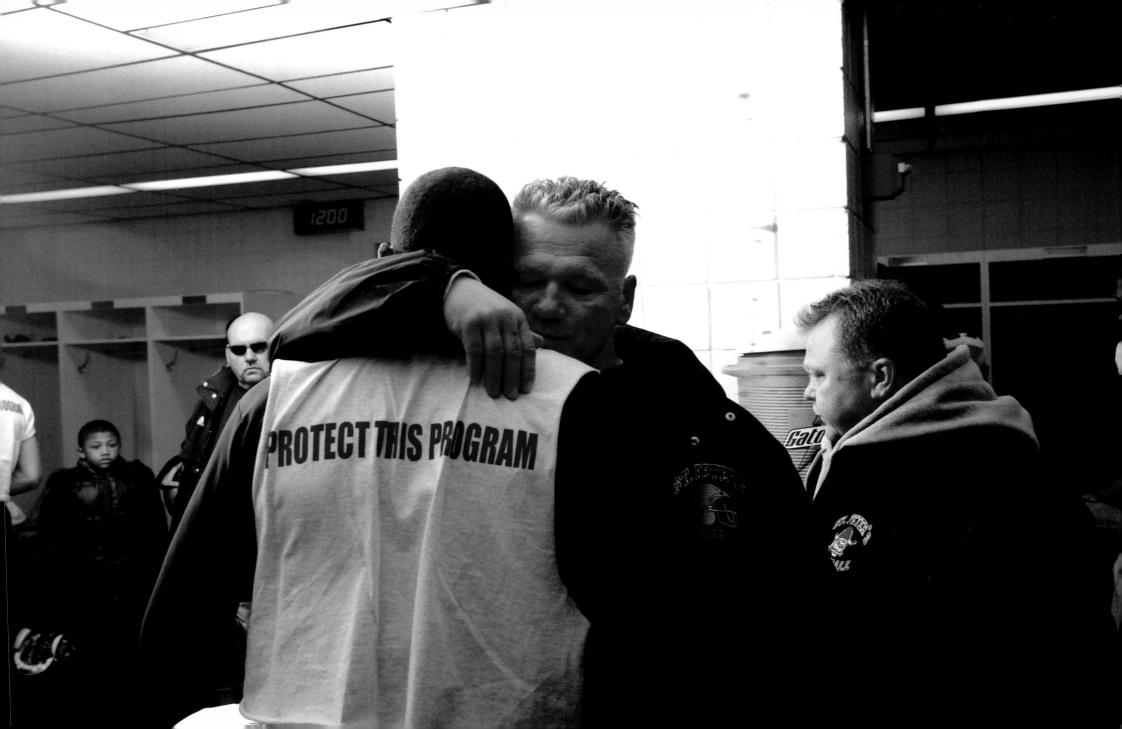

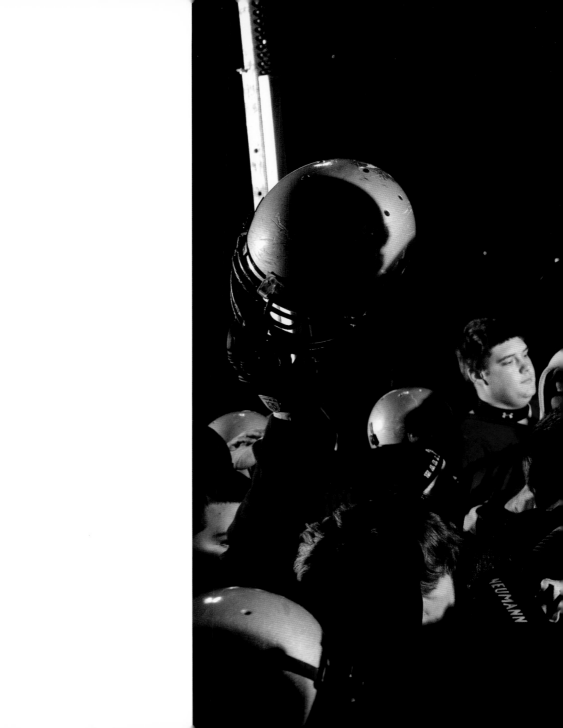

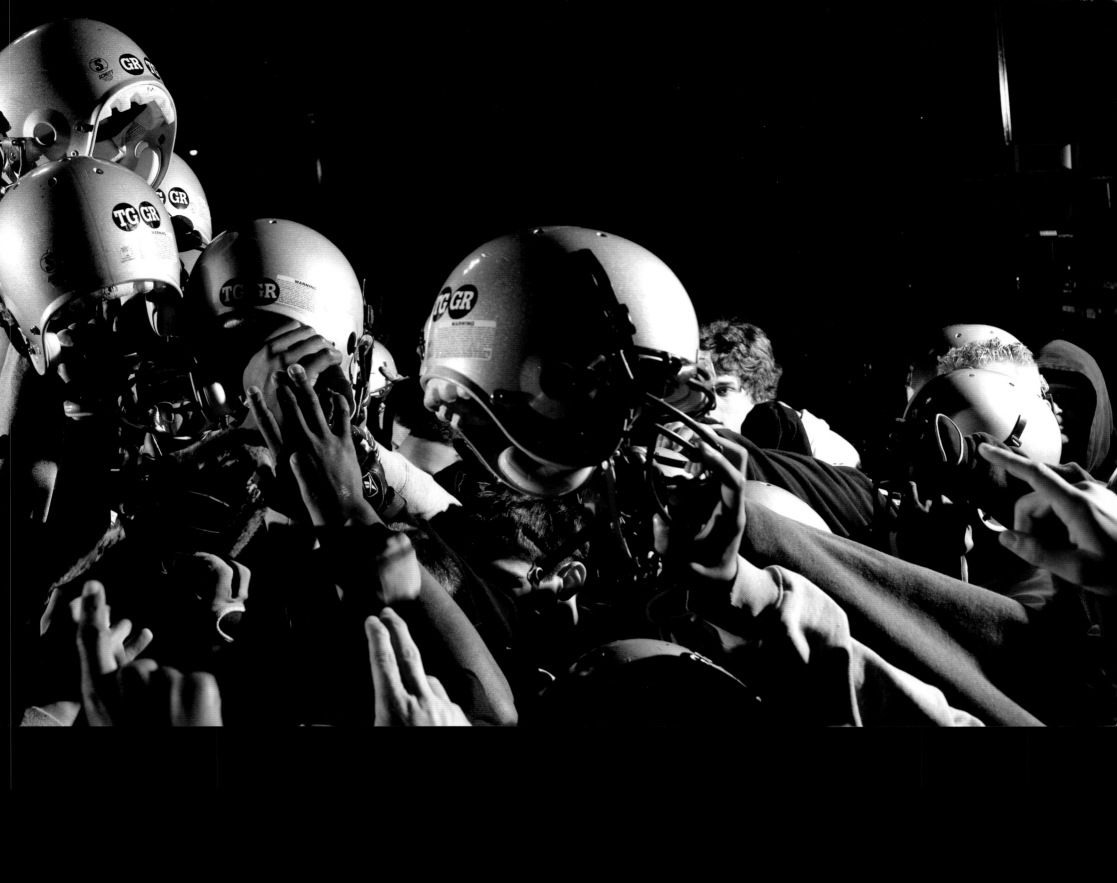

When we walk out of this locker room
and it is all said and done,
we will ALWAYS have one another.

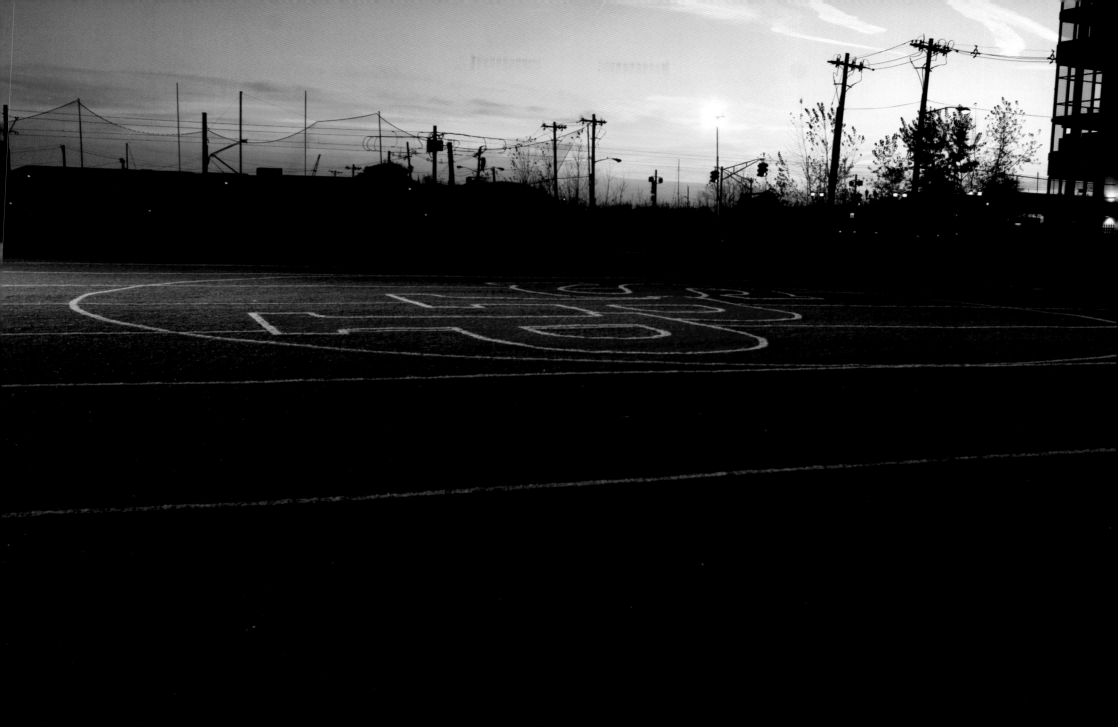

SAINT PETER'S FOOTBALL 2007 Varsity Roster

2006 Hudson County Champions / 2006 HCIAA Champions / 2006 NJSIAA Finalists / Tri-State #2

#	PLAYER	HEIGHT	WEIGHT	POSITION	YEAR
1	Cirino, Eric	5' 7	165	WR/DB	12
3	Hill, Willie	6' 3	205	QB/DB	12
4	Zrowka, Steve	6' 0	185	QB/P	11
5	Alvarez, Joseph	6' 1	220	TE/OLB	12
7	Oliver, Nyshier	5' 11	175	RB/DB	11
8	Smith, Kenneth	5' 11	220	RB/OLB	11
9	Roman, Bill	6' 0	195	RB/DB	12
10	Colucci, Andrew	5' 10	190	WR/DB	12
11	Holder, Joseph	6' 2	185	WR/DB	12
12	Perez, Justin	5' 10	185	QB/P	11
13	Ortiz, Raphael	6' 2	180	QB/DB	10
14	Giannobile, Anthony	5' 10	185	RB/ILB	12
15	Hussey, Joe	6' 4	215	TE/DL	12
16	Baudhuin, Pat	5' 11	150	WR/DB	10
17	Farrar, Malcolm	5' 8	185	WR/DB	11
20	Dolaghan, Nolan	5' 10	165	WR/DB	10
21	Cummings, Keith	5' 7	180	RB/OLB	10
22	Graham, Andre	6' 1	230	RB/OLB	12
23	Meliado, Chris	6' 0	185	WR/DB	11
24	Davis, Corey	5' 7	150	RB/DB	10
25	Nadolny, Mike	5' 11	175	WR/DB	11

#	PLAYER	HEIGHT	WEIGHT	POSITION	YEAR
27	Dietz, Chris	5' 8	160	RB/DB	10
28	Dolaghan, Brendan	5' 11	165	WR/DB	10
29	Siocha, Mark	6' 0	170	WR/DB	11
30	Kelley, John	6' 0	180	WR/DB	10
31	McLaughlin, Gianni	5' 10	175	RB/ILB	10
32	Hansen, Dan	5' 10	180	RB/ILB	11
33	Santuccio, Sal	5' 9	185	RB/DB	11
34	Short, Daniel	5' 10	160	WR/DB	11
35	Hyacinthe, Ducarmel	5' 2	125	RB/DB	10
36	Dokus, Sam	6' 0	220	TE/DL	12
37	Huggins, Savon	5' 9	160	RB/DB	9
40	Martino, Paul	5' 10	210	RB/ILB	11
41	Dougherty, John	5' 8	185	RB/OLB	11
42	Kohles, Greg	5' 11	185	RB/DB	11
43	Manning, Tevin	5' 9	135	WR/DB	10
44	Dobson, Alfred	5' 10	200	TE/OLB	10
45	Cruz, Christopher	5' 9	190	TE/OLB	11
46	Grapstul, Matt	6' 1	180	TE/ILB	10
47	Flannery, Tim	5' 7	205	RB/ILB	10
48	Ortiz, Edwin	5' 8	155	WR/DB	10
49	Innis, Kevin	6' 0	215	TE/ILB	10

#	PLAYER	HEIGHT	WEIGHT	POSITION	YEAR
50	Rodger, Ed	6' 3	245	OL/DL	12
51	Grant, Corlando	5' 4	170	OL/DL	12
52	Alvarez, Joshua	5' 8	190	OL/ILB	11
53	Oquendo, Joel	5' 8	200	OL/OLB	11
54	Maly, Sean	5' 6	200	OL/ILB	11
55	Soares, Rui	5' 6	180	OL/DL	11
56	Ormiston, Dillon	6' 2	240	OL/DL	10
58	Hetherington, Chris	5' 8	170	OL/DL	12
59	Harold, Eddie	5' 10	250	OL/DL	10
60	Maracle, Charles	5' 11	250	OL/DL	12
61	Nakar, Julian	5' 11	230	OL/DL	10
63	Cerami, Rocco	5' 8	240	OL/DL	12
65	Lumpkin, Keith	6' 7	260	OL/DL	9
66	Gomez, Chike	6' 0	280	OL/DL	10
67	Stickno, Alan	6' 2	240	OL/DL	10
68	Pardo, Darren	6' 1	210	OL/DL	10
69	Feeney, Matt	6' 3	210	OL/DL	10
70	Alfieri, Daniel	6' 1	255	OL/DL	12
71	Wilkes, Khalil	6' 3	290	OL/DL	11
72	Figueroa, DJ	6' 0	215	OL/DL	12
73	Greene, Daryl	6' 0	315	OL/DL	11
74	Kaufman, Jake	6' 7	315	OL/DL	10
75	Milne, Harold	5' 10	240	OL/DL	12

#	PLAYER	HEIGHT	WEIGHT	POSITION	YEAR
76	Rivas, Mark	6' 4	260	OL/DL	10
77	Wilkens, Anthony	6' 5	345	OL/DL	10
78	Roake, Matt	5' 11	215	OL/DL	10
79	Pearson, Sean	6' 5	290	OL/DL	11
80	Walter, Ken	5' 11	140	WR/DB	10
81	Pestana, Frank	5' 7	130	WR/DB	10
82	Perez, Alex	5' 11	150	WR/DB	10
84	Lanning, Zachary	5' 11	200	TE/ILB	10
85	Crawford, Kevin	5' 11	195	TE/OLB	11
86	Zadroga, Rich	6' 1	210	TE/DL	12
87	Ngo, Bao	5' 9	160	WR/DB	11
89	Rivera, Adrian	5' 8	175	WR/DB	10
91	Blake, Anthony	6' 1	245	OL/DL	11

HEAD COACH/ATHLETIC DIRECTOR: Rich Hansen

DB/WR: Will Wilkes '86; **QB**: Mike Guasconi '71; **OL/DL**: Anthony Locricchio '96; **OL/DL**: Scott Paltos;
OL/DL: Mike Rich; **LB/RB**: Carmine Martino; **LB/RB**: Rich Hansen, Jr. '03; **DB/WR**: Keith Price;
LB/FB: Dom Lucignano; **Equipment Manager**: John O'Donnell; **Medical Consultant**: Dr. Kevin Julian

Student Managers: Andrew McGlynn, Steven Zolli, James Forker
Freshman Staff: Ed Roselle, Juan Arteaga, Joe Perrenod, Doug Peterson,
Kellen Williams '00, Chris Nunez '03, Kevin Murray '03

ADMINISTRATION
President: Fr. Robert Reiser, S.J.
Principal: Jim C. DeAngelo

ACKNOWLEDGEMENTS

Thank you to all the players and coaches who allowed me into their world and treated me with generosity and respect. A special thank you to Coach Hansen, who granted me total access and inspired me on a daily basis. To Reverend Robert E. Reiser, President of Saint Peter's Prep, a special thanks for your enthusiasm and continued support. Deepest gratitude to my dear friend and collaborator Yolanda Cuomo, whose ideas, design, and spirit made this project so memorable. Thank you David Schinman, my friend and assistant, who consistently makes my work stronger. Thanks to In Kim, whose technical assistance and curiosity motivate me consistently. Thanks to Lindsay Foster, who is the backbone of my studio and makes it all happen. Thank you to Kristi Norgaard, whose work ethic and graphic design made such a difference. Many thanks to Ms. Erica Rivera, who made my communication with Coach Hansen much more effective. Thank you to powerHouse Books, who embraced this project from the very beginning. Warmest thanks to my wife, Patricia, whose support has and will continue to inspire me for a lifetime. To William, my son, you will always drive me to be a better person and continue to be my biggest inspiration. **RICHARD CORMAN**

Many thanks to: President Rev. Robert E. Reiser, S.J., Principal Jim C. DeAngelo, Prep football players and coaches, and Secretary to the Athletic Director Erica Rivera. Special thanks to ticket sellers: Maryphyllis Locricchio, Jim Dondero, Cecelia Collins, Grace Gualario, and Janice Martineau; maintenance: Rocco Tejada, Arvind Sawh, and Lincoln Henriquez-Castillo; and finance: Robert Nodine, Catherine Ford, Diane McCabe, and Renee Rivera. Thanks to the Prep moms (who help out before the game), Academy Bus Company, and the workers at Caven Point. **COACH HANSEN**

Special thanks to Joe and Luca and especially Gianni whose stories of Coach Hansen were the inspiration for this book. **YOLANDA CUOMO**

PREP The Spirit of a High School Football Team

Published in the United States by powerHouse Books,
a division of powerHouse Cultural Entertainment, Inc.
37 Main Street, Brooklyn, NY 11201-1021
telephone 212 604 9074, fax 212 366 5247
e-mail: prep@powerHouseBooks.com
website: www.powerHouseBooks.com

First edition, 2008

Library of Congress Cataloging-in-Publication Data:

Corman, Richard.
 Prep : the spirit of a high school football team / photographs by Richard
Corman ; introduction by Joe Paterno. -- 1st ed.
 p. cm.
 ISBN 978-1-57687-458-5
 1. St. Peter's Preparatory High School (Jersey City, N.J.)--Football. 2.
St. Peter's Preparatory High School (Jersey City, N.J.)--Football--Pictorial
works. 3. Football players--United States--Portraits. I. Title.
 GV958.S7C67 2008
 796.332'620974927--dc22

 2008063155

Hardcover ISBN 978-1-57687-458-5

Printing and binding by Sun Fung Offset Binding Company, Limited, China

Book design by Yolanda Cuomo, NYC

A complete catalog of powerHouse Books and Limited Editions is available upon request;
please call, write, or visualize, believe, and achieve on our website.

10 9 8 7 6 5 4 3 2 1

Printed and bound in China